THE MEANING OF ART

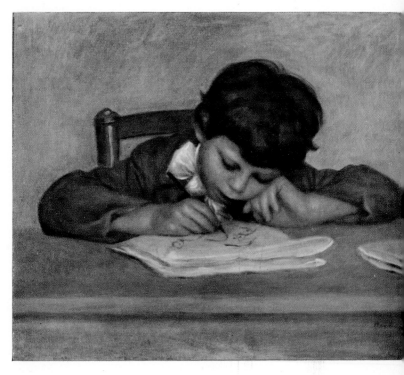

Jean Renoir Writing. By Pierre Auguste Renoir (1841–1919).
Basil Barlow Collection

THE
MEANING OF ART

BY
HERBERT READ

A true taste is never a half taste.
—Constable

FABER & FABER LIMITED
24 RUSSELL SQUARE
LONDON

First published in 1931
by Faber and Faber Limited
24 *Russell Square London WC* 1
Second edition 1936
Reprinted 1943, 1945, 1946
Third edition, revised and enlarged, 1951
Reprinted 1955 *and* 1962
Pelican editions and impressions: 1949, 1950, 1951, 1954,
1956, 1959, 1961, 1963, 1964, 1966
New and revised edition 1968
Printed in Great Britain by
R. MacLehose and Company Limited
The University Press Glasgow
All rights reserved

*Some of the revisions contained in the present
text first appeared in the Pelican
edition in* 1959

PREFACE TO THIS NEW EDITION

This book began as a series of articles contributed to *The Listener*, the weekly literary journal of the British Broadcasting Corporation. For the first edition (1931) I selected passages from these articles, added to them, and so ordered them as to form what is, I hope, a fairly consistent argument. In subsequent editions further sections were added for the sake of theoretical and historical completeness. With the exception of the paragraphs on Chinese art (42), Turner (67), Expressionism (80b), Kandinsky (80c), Tachism (81c), and modern sculpture (81d) these additions were again adapted from articles that first appeared in *The Listener*. I have throughout made minor corrections in the text in the interests of clarity and accuracy.

H. R.

June, 1968

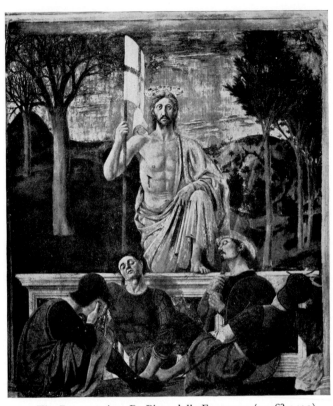

1. The Resurrection. By Piero della Francesca (1416?-1492).
Fresco at Borgo San Sepolcro.

CONTENTS

I

CONTENTS

CONTENTS

CONTENTS

III

A LIST OF THE FIGURES

NOTE: The illustrations are not necessarily referred to in the text, but are intended rather as a supplement to it; they carry on the discussion in another medium.

I wish to thank Mr. Ashley Havinden, Mr. Henry Moore, Mrs. and Miss Rutherston, Mr. Curt Valentin, the Keeper of the Ashmolean Museum (Oxford), the Keeper of the Hunterian Books and MSS. (University of Glasgow), and the Librarian of Trinity College, Dublin, for permission to illustrate objects in their collections or care. The late Professor G. Baldwin Brown and Sir George Hill very kindly lent me photographs, and my acknowledgments are also gratefully given to the Committee of the Egypt Exploration Society, Editions Albert Morancé (publishers of *Les Arts Sauvages—Afrique*), and to Pantheon Casa Editrice S.A. (publishers of *Bushman Art*) for permission to reproduce illustrations from their publication. Plate 23 is reproduced from a photograph supplied by Photo-Verlag K. Gundermann, Würzburg, and Plate 29 by permission of the Berkeley Galleries, London. Plates 1 and 16 are Anderson (Rome) photographs, and Plate 15 is an Alinari photograph. The rest of my plates are reproduced from official photographs by kind permission of the Directors of the British Museum, the Victoria and Albert Museum, the National Gallery (London), the National Gallery of Scotland (Edinburgh), the Freer Gallery of Art (Washington), the Philips Memorial Gallery (Washington), the Museum of Modern Art (New York), the National Gallery (Berlin), the Wallraf-Richartz Museum (Cologne), the Museum für Kunst und Gewerbe (Hamburg), the Pinacoteca (Turin), the Archaeological

Museum (Florence), and the Musées des Beaux-Arts at Brussels and Antwerp.

Jean Renoir Writing. By Pierre Auguste Renoir (1841-1919). *Basil Barlow Collection.* *frontispiece*

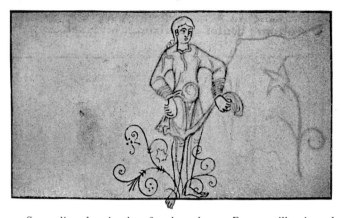

2. Sensuality plunging barefoot into thorns. From an illuminated MS. of the Psychomachia of Prudentius. English; 11th century. *British Museum.*

I

¶1 The simple word 'art' is most usually associated with those arts which we distinguish as 'plastic' or 'visual', but properly speaking it should include the arts of literature and music. There are certain characteristics common to all the arts, and though in these notes we are concerned only with the plastic arts, a definition of what is common to all the arts is the best starting-point of our enquiry.

It was Schopenhauer who first said that all arts aspire to the condition of music; that remark has often been repeated, and has been the cause of a good deal of mis-understanding, but it does express an important truth. Schopenhauer was thinking of the abstract qualities of music; in music, and almost in music alone, it is possible for the artist to appeal to his audience directly, without

the intervention of a medium of communication in common use for other purposes. The architect must express himself in buildings which have some utilitarian purpose. The poet must use words which are bandied about in the daily give-and-take of conversation. The painter usually expresses himself by the representation of the visible world. Only the composer of music is perfectly free to create a work of art out of his own consciousness, and with no other aim than to please. But all artists have this same intention, the desire to please; and art is most simply and most usually defined as an attempt to create pleasing forms. Such forms satisfy our sense of beauty and the sense of beauty is satisfied when we are able to appreciate a unity or harmony of formal relations among our sense-perceptions.

¶ 2. Any general theory of art must *begin* with this supposition: that man responds to the shape and surface and mass of things present to his senses, and that certain arrangements in the proportion of the shape and surface and mass of things result in a pleasurable sensation, whilst the lack of such arrangement leads to indifference or even to positive discomfort and revulsion. The sense of pleasurable relations is the sense of beauty; the opposite sense is the sense of ugliness. It is possible, of course, that some people are quite unaware of proportions in the physical aspect of things. Just as some people are colour-blind, so others may be blind to shape and surface and mass. But just as people who are colour-blind are comparatively rare, so there is every reason to believe that people wholly unaware of the other visible properties of objects are equally rare. They are more likely to be undeveloped.

¶ 3. There are at least a dozen current definitions of

beauty, but the merely physical one I have already given (beauty is a unity of formal relations among our sense-perceptions) is the only essential one, and from this basis we can build up a theory of art which is as inclusive as any theory of art need be. But it is perhaps important to emphasize at the outset the extreme relativity of this term beauty. The only alternative is to say that art has no necessary connection with beauty—a perfectly logical position to hold if we confine the term to that concept of beauty established by the Greeks and continued by the classical tradition in Europe. My own preference is to regard the sense of beauty as a very fluctuating phenomenon, with manifestations in the course of history that are very uncertain and often very baffling. Art should include all such manifestations, and the test of a serious student of art is that, whatever his own sense of beauty, he is willing to admit into the realm of art the genuine manifestations of that sense in other people at other periods. For him, Primitive, Classical and Gothic are of equal interest, and he is not so much concerned to assess the relative merits of such periodical manifestations of the sense of beauty as to distinguish between the genuine and false of all periods.

¶4. Most of our misconceptions of art arise from a lack of consistency in the use of the words art and beauty. It might be said that we are only consistent in our misuse of them. We always assume that all that is beautiful is art, or that all art is beautiful, that what is not beautiful is not art, and that ugliness is the negation of art. This identification of art and beauty is at the bottom of all our difficulties in the appreciation of art, and even in people who are acutely sensitive to aesthetic impressions in general, this assumption acts like an unconscious

censor in particular cases when art is not beauty. For art is not necessarily beauty: that cannot be said too often or too blatantly. Whether we look at the problem historically (considering what art has been in past ages) or sociologically (considering what art actually is in its

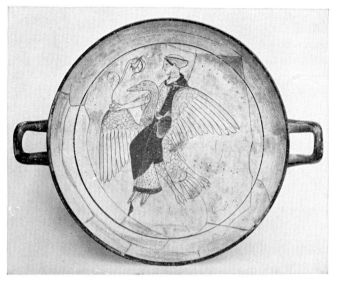

3. Aphrodite riding on a goose. Bowl (Kylix), painted over a white ground. Greek; 5th century B.C. *British Museum.*

present-day manifestations all over the world) we find that art often has been or often is a thing of no beauty. ¶5. Beauty, as I have already said, is generally and most simply defined as that which gives pleasure; and thus people are driven into admitting that eating and smelling and other physical sensations can be regarded as arts. Though this theory can quickly be reduced to absurdity, a whole school of aesthetics is

founded on it, and until lately this school was even the predominant one. It has now been superseded in the main by a theory of aesthetics derived from Benedetto Croce, and though Croce's theory has met with a flood of criticism, its general tenet, that art is perfectly defined when simply defined as *intuition*, has proved to be much more illuminating than any previous theory. The difficulty has been to apply a theory depending on such vague terms as 'intuition' and 'lyricism'. But the point to note immediately is, that this elaborate and inclusive theory of the arts gets on very well without the word 'beauty'.

¶6. The concept of beauty is, indeed, of limited historical significance. It arose in ancient Greece and was the offspring of a particular philosophy of life. That philosophy was anthropomorphic in kind; it exalted all human values and saw in the gods nothing but man writ large. Art, as well as religion, was an idealization of nature, and especially of man as the culminating point of the process of nature. Typical examples of classical art are the Apollo Belvedere or the Aphrodite of Melos—perfect or ideal types of humanity, perfectly formed, perfectly proportioned, noble and serene; in one word, beautiful. This type of beauty was inherited by Rome, and revived at the Renaissance. We still live in the tradition of the Renaissance, and for us beauty is inevitably associated with the idealization of a type of humanity evolved by an ancient people in a far land, remote from the actual conditions of our daily life. Perhaps as an ideal it is as good as any other; but we ought to realize that it is only one of several possible ideals. It differs from the Byzantine ideal, which was divine rather than human, intellectual and anti-vital, abstract. It differs from the Primitive ideal, which was perhaps no ideal at

all, but rather a propitiation, an expression of fear in the face of a mysterious and implacable world. It differs also from the Oriental ideal, which is abstract

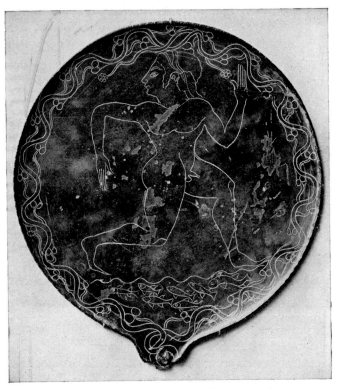

4. Orion crossing the sea. Bronze mirror. Etruscan; about 500 B.C. *British Museum.*

too, non-human, metaphysical, yet instinctive rather than intellectual. But our habits of thought are so dependent on our outfit of words, that we try, often enough in vain, to force this one word 'beauty' into the

service of all these ideals as expressed in art. If we are honest with ourselves, we are bound to feel guilty sooner or later of verbal distortion. A Greek Aphrodite, a Byzantine Madonna and a savage idol from New Guinea or the Ivory Coast cannot one and all belong to this classical concept of beauty. The last one at least, if words are to have any precise meaning, we must confess to be unbeautiful, or ugly. And yet, whether beautiful or ugly, all these objects may be legitimately described as works of art.

¶ 7. Art, we must admit, is not the expression in plastic form of any one particular ideal. It is the expression of any ideal that the artist can realize in plastic form. And though I think that every work of art has some principle of form or coherent structure, I would not stress this element in any obvious sense, because the more one studies the structure of works of art which live in virtue of their direct and instinctive appeal, the more difficult it becomes to reduce them to simple and explicable formulae. That 'there is no excellent beauty that hath not some strangeness in the proportion' was evident even to a Renaissance moralist.

¶ 8. However we define the sense of beauty, we must immediately qualify it as theoretical; the abstract sense of beauty is merely the elementary basis of the artistic activity. The exponents of this activity are living men and their activity is subject to all the cross-currents of life. There are three stages: first, the mere perception of material qualities—colours, sounds, gestures, and many more complex and undefined physical reactions; second, the arrangement of such perceptions into pleasing shapes and patterns. The aesthetic sense may be said to end with these two processes, but there may be a third stage which comes when such an arrangement of percep-

tions is made to correspond with a previously existing state of emotion or feeling. Then we say that the emotion or feeling is given *expression*. In this sense it is true to say with Benedetto Croce that 'art is expression'. According to Croce expression is the basic creative act in all the arts. The work of art comes into existence with the act of incarnation—that is to say, at the moment the artist finds the words (or other media) to express his emotion or 'state of mind'. Emotion and expression are then an organic unity that cannot be separated.

Croce does not make a clear distinction between expression that has the formal qualities we call beautiful and expression that has the informal qualities we call ugly. A formless or informal expression may or may not deserve to be called a work of art. It may produce effects of terror or horror which are powerful and even sublime and then, as Longinus was the first to claim, we are in the presence of a work of art. Croce dismisses all such 'modification of the beautiful' as aesthetic pseudo-concepts, and indeed they may be so incoherent that they express nothing but chaos and dark nothingness.

¶9. The permanent element in mankind that corresponds to the element of form in art is man's aesthetic sensibility. Sensibility as such we may assume static. What is variable is the interpretation which man gives to the forms of art, which are said to be 'expressive' when they correspond to his immediate feelings. But the same forms may have a different expressive value, not only for different people, but also for different periods of civilization. Expression is a very ambiguous word. It is used to denote natural emotional reactions, but the very discipline or restraint by which the artist achieves form is itself a mode of expression. Form, though it can be

analysed into intellectual terms like measure, balance, rhythm and harmony, is really intuitive in origin; it is not in the actual practice of artists an intellectual product. It is rather emotion directed and defined, and when we describe art as 'the will to form' we are not imagining an exclusively intellectual activity, but rather an exclusively intuitive one. For this reason I do not think we can say that Primitive art is lower in the scale of beauty than Greek art, because although it may represent an earlier stage of civilization, it may express an equal or even a finer instinct for form. The art of a period is a standard only so long as we learn to distinguish between the elements of form, which are universal, and the elements of expression, which are temporal. Still less can we say that in *form* Giotto is inferior to Michelangelo. He may be less complicated, but form is not valued for its degree of complexity. Frankly, I do not know how we are to judge form except by the same instinct that creates it.

¶ 10. Since the early days of Greek philosophy men have tried to find in art a geometrical law, for if art (which they identify with beauty) is harmony, and harmony is the due observance of proportions, it seems reasonable to assume that these proportions are fixed. The geometrical proportion known as the Golden Section has for centuries been regarded as such a key to the mysteries of art, and so universal is its application, not only in art but also in nature, that it has at times been treated with religious veneration. More than one writer in the sixteenth century related its three parts to the Trinity. It is formulated in two propositions of Euclid: Book II, proposition 11 ('To cut a given straight line so that the rectangle contained by the whole and one of the segments is equal to the square

in the remaining segment'), and Book VI, proposition 30 ('To cut a given finite line in extreme and mean ratio'). The usual formula is: to cut a finite line so that

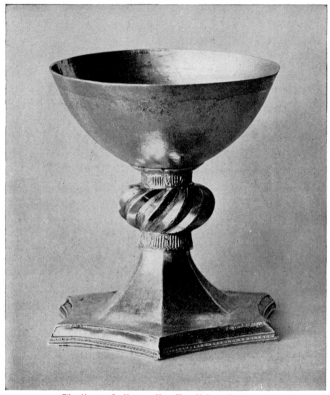

5. Chalice of silver-gilt. English; about 1350.
Hamstall Ridware Church.

the shorter part is to the longer part as the longer part is to the whole. The resulting section is roughly in the proportion of 5 to 8 (or 8 to 13, 13 to 21, and so on), but never exactly so: it is always what is known in mathe-

matics as an irrational, and this has added not a little to its mystical reputation. There is a considerable literature on the subject, and from about the middle of the last century it begins to be treated with great seriousness. A German writer, Zeising, tried to prove that the Golden Section is the key to all morphology, both in nature and in art; and Gustav Theodor Fechner, the founder of experimental aesthetics, whose principal works were published in the 'seventies, made it one of the foremost objects of his research. Since then, practically every work on aesthetics includes some consideration of the problem.

An extremist like Zeising claimed that the section prevailed everywhere in works of art, but subsequent investigation has not upheld his claim. We can assume either that the good artist consciously applies the section in the structure of his work, or that he inevitably comes to it by his instinctive sense of form. Use is often made of the Golden Section to secure the right proportion between length and breadth in the rectangles made by windows and doors, by picture-frames and by the page of a book or a journal. It is said that every part of a well-made violin obeys the same law. The pyramids of Egypt have been explained by it, and the Gothic cathedral is easily interpreted in its proportions: the relation of the length of transept to nave, of column to arch, of spire to tower, and so on. The proportion is also used very frequently in pictorial art: the relation of the space above the skyline to the space below, of foreground to background, and equally of various lateral divisions, follows the Golden Section. The paintings of Piero della Francesca are extreme examples of geometric organization (see *Figures* 1 & 17).

¶ 11. Not only the Golden Section, but other geometrical ratios, such as the square of the width of a rectangle within the rectangle are employed in almost endless combination to secure a perfect harmony. It is the relative endlessness of such combinations which precludes any mechanistic explanation of the total harmony of a work of art; for although the counters in the game are rigid, it requires instinct and sensibility to use them for a fine effect. I would also like to suggest an hypothesis based on the analogy of poetry. It is well known that a perfectly regular metre in verse is so monotonous as to become intolerable. Poets have therefore taken liberties with their measure; feet are reversed within the metre, and the whole rhythm may be counterpointed. The result is incomparably more beautiful. In the same way, in the plastic arts certain geometrical proportions, which are the proportions inherent in the structure of the world, may be the regular measure from which art departs in subtle degrees. The extent of that departure, like the poet's variation of his rhythm and metre, is determined not by laws, but by the instinct or sensibility of the artist. I feel that such an hypothesis is confirmed rather than contradicted by an analysis like that of the Greek vase undertaken by Mr. Jay Hambidge (*Dynamic Symmetry*, Oxford University Press, 1920), by far the most successful and exact geometrical analysis of an art that I know. Greek vases do conform to exact geometric laws, and that is why their perfection is so cold and lifeless. There is often more vitality and more joy in an unsophisticated peasant pot. The Japanese, indeed, often deliberately mar the perfect shape which evolves naturally on the potter's wheel, because they feel that true beauty is not so regular.

¶ 12. Distortion may mean a departure from regular geometrical harmony, or, more generally, it implies a disregard for the proportions given in the natural world.

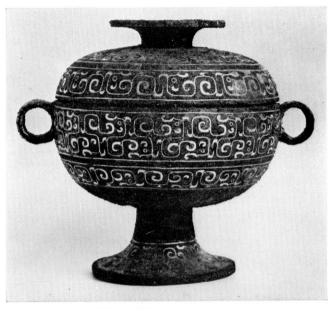

6. Bronze vessel. Chinese (Chou dynasty); 12th-3rd century B.C. *Courtesy of the Smithsonian Institution and the Freer Gallery of Art, Washington, D.C.*

Distortion of some kind, we may therefore say, is present in a very general and perhaps paradoxical way in all art. Even classical Greek sculpture was distorted in the interests of the ideal. The line of brow and nose was never in reality so straight, the face so oval, the breasts so round, as they are represented in, say, the Aphrodite of Melos. Indeed, it is difficult to find any work of art before the Italian Renaissance which does not depart in

some way or other from actuality. In the sixteenth century, largely from a misunderstanding of the purpose of classical art, a representational literalness did become common. But it did not last for long: the seventeenth

7. Carved wooden post from the Oseberg ship. Viking; about A.D. 800. *University Museum, Oslo.*

and eighteenth centuries for one reason or another forsook the Renaissance conception of art, and it was only in the nineteenth century, that age of sham revivals, that literal representation once more became normal.

There are, however, various degrees of distortion and no one, it will be said, objects to the idealization of real-

ity. It is only when nature is outraged that the spectator must protest. The line of brow and nose can be made straight, but the leg must not be twisted into an impossible shape. It is a question of degree, but it is arguable that the degree makes all the difference. But where can we draw a line? If we leave Greek art and consider early Celtic or Chinese art, we shall find that the distortion has proceeded so far that the representational motive has been entirely lost, and we are left with noth-

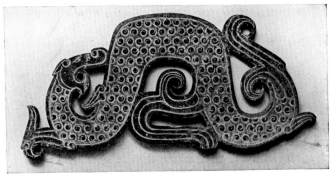

8. Dragon of carved jade. Chinese (Chou dynasty); 12th to 3rd century B.C. *Rutherston Collection.*

ing but a geometrical pattern. In Byzantine art we find that the desire to give symbolic representation to an idea has deprived all human figures of their humanity. Christ on the Virgin's lap is not a child, but a miniature representation of the glory, majesty and dignity of Christ the man. In Gothic art everything is made to contribute to the cathedral's single effort to express the transcendent nature of religious feeling; the idealism of Greek art is blended with the symbolism of Byzantine art; the result is not representational. In Chinese art, in

Persian art, in Oriental art generally, motives are used, not realistically, but sensuously—that is to say, they merely contribute to the general rhythm and vitality of the artist's pattern.

All these departures from exact imitation are purposive. They are dictated either by the artist's will to form, his desire for a balanced or unified pattern or mass; or they are dictated by his desire to make a symbol for his inner feelings. But not everything in a work of art must necessarily be attributed to the artist. Few works of art are so impressive as the Byzantine churches at Ravenna; but their appeal to us is partly the work of time. The impression we receive is partly historical, partly religious, partly environmental, and to that extent must not be credited to the power of the artist.

¶ 13. The spontaneous motives that lead an artist (and the artist in all of us) to express himself in formal patterns are obscure, though no doubt they can be explained physiologically. The instinct that leads us to put unnecessary buttons on our clothes, to match our socks and ties or hats and coats, that makes us put the clock in the middle of the mantelpiece and the parsley round the cold mutton, is the primitive and uneducated stirrings of the instinct that makes the artist arrange his motives in a pattern. The carver of the Chinese horse illustrated in *Figure* 66 might without much trouble have made his horse more realistic; but he was not interested in the anatomy of the horse, for the horse had suggested to him a certain pattern of curved masses, and the twist of the neck, the curls of the mane, the curves of the haunches and legs had to be distorted in the interests of this pattern. The result was not very much like a

horse—in fact, this horse is often mistaken for a lion—but it is a very impressive work of art.

The Chinese horse happens to belong to the greatest period of Chinese art; it must be all right, the sceptic is willing to admit. But when it comes to a modern work of art, to a painting like 'Le Repos du Modèle' by Henri Matisse (*Figure* 58), then for some reason a deep sense of hostility is aroused. The principle involved, however, is exactly the same. Matisse is not interested in the model as a living being ; nor in the scene for the sake of its architectural properties; but these things have suggested a pattern, and the pattern achieved is not only a legitimate work of art, but also an intuitive apprehension of the subject far more vivid than any imitative representation could make it.

Pattern alone does not constitute a work of art. Provisionally we may say that although a work of art always involves a pattern of some kind, all patterns are not necessarily works of art. Such a statement needs some definition of its terms. A 'work of art' generally implies a certain degree of complexity; we refuse the term to a simple geometrical design of circles and triangles, and even to the intricate but accomplished design of a machine-made carpet, although such patterns may be well-balanced or symmetrical.

¶ 14. What we really expect in a work of art is a certain personal element—we expect the artist to have, if not a distinguished mind, at least a distinguished sensibility. We expect him to reveal something to us that is original —a unique and private vision of the world. It is this expectation which, blinding the plain man to all other considerations, leads to a confirmed misunderstanding of the nature of art. Such a man becomes so intent on

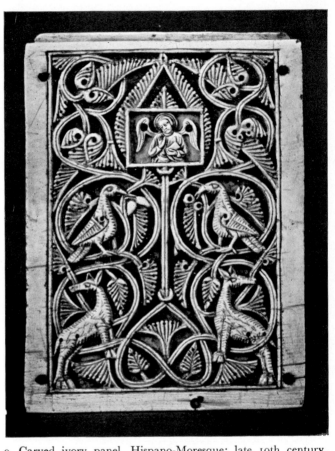

9. Carved ivory panel. Hispano-Moresque; late 10th century.
Victoria and Albert Museum.

the meaning or message of a picture that he forgets that sensibility is a passive function of the human frame, and that the objects received in sensibility have their objective existence. The artist is mainly concerned with the affirmation of this objective existence. When he passes from sensibility to moral indignation or extra-sensuous states of any kind, then the work of art to that extent becomes impure. This means that a work of art is fairly adequately defined as pattern informed by sensibility.

¶ 15. Perhaps the word 'pattern' ought to be defined a little more concisely. In its ordinary use—the pattern of a piece of cloth, for example—it implies the distribution of line and colour in certain definite repetitions. Pattern implies some degree of regularity within a limited frame of reference—in a picture, this is quite literally the picture-frame. Beyond this simple conception of pattern we get increasing degrees of complexity, the first of which is symmetry; instead of repeating a design in parallel series, the design is reversed or counter-changed. The method was perhaps evolved from certain technical conveniences in the process of weaving. Instead of repetition, we find symmetrical balance, as in the motive of confronted animals so common in Oriental art. The next complexity was to abandon symmetrical balance in favour of distributed balance. The work of art has an imaginary point of reference (analogous to a centre of gravity) and around this point the lines, surfaces and masses are distributed in such a way that they *rest* in perfect equilibrium. The structural aim of all these modes is harmony, and harmony is the satisfaction of our sense of beauty.

¶ 16. Form will be defined later (see ¶ 26d), but there is really nothing mysterious in the term. The dictionary

35

gives the meaning as 'shape, arrangement of parts, visible aspect', and the form of a work of art is nothing more than its shape, the arrangement of its parts, its *visible* aspect. There is form as soon as there is shape, as soon as there are two or more parts gathered together to make an arrangement. But of course it is implied, when we speak of the form of a work of art, that it is in some way *special* form, form that affects us in some way.

Form does not imply regularity, or symmetry, or any kind of fixed proportion. We speak of the form of an athlete and we mean very much the same when we speak of the form of a work of art. An athlete is in good form when he carries no superfluous flesh; when his muscles are strong, his carriage good, his movements economical. We might say exactly the same of a statue or a picture. Let us take a picture for an example, and see what happens when we look at it. We will assume that it is a good picture, and that *it moves us* when we contemplate it.

¶ 17. The example I will take is a colour print (*Figure* 10) by the great Japanese artist, Katsushika Hokusai (1760-1849). Besides assuming that the picture is a good one, we must assume that the person who is going to look at it is in a right state of mind. All that is necessary is that he should have a perfectly *open* mind. He must not be expecting to see a particular kind of picture, or even a picture as such. He just walks round a corner, thinking of nothing in particular, and comes to a standstill before this object. What happens outwardly is then very much a matter of nationality, and of sex. But we will take the problem in its most obscure manifestation, and suppose that our spectator is an average Englishman. A trained observer, carefully hidden behind a screen, might notice a dila-

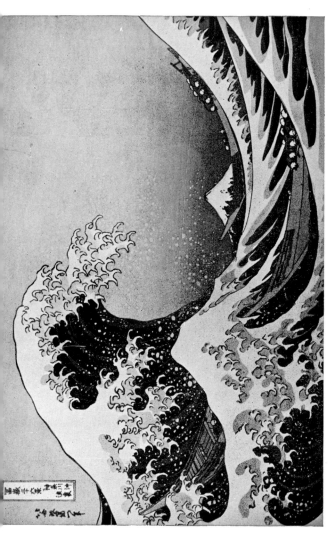

10. The Great Wave. Colour woodcut by Katsushika Hokusai (1760-1849).
Victoria and Albert Museum

tion in his eyes, even an intake of his breath, perhaps a grunt. He would be held there, perhaps thirty seconds, perhaps five minutes; then he would go on his way, and later would perhaps write a letter in which the shock of joy he had so passively received would be finally dissipated in a flow of extravagant superlatives.

¶ 18. Many theories have been invented to explain the workings of the mind in such a situation, but most of them err, in my opinion, by overlooking the instantaneity of the event. I do not believe that a person of real sensibility ever stands before a picture and, after a long process of analysis, pronounces himself pleased. We either like at first sight, or not at all. Naturally there are occasions when for some reason or another it is not possible to receive an instantaneous impression: the work of art cannot always be isolated. Many works of art —for example, the exterior of a Gothic cathedral—are a complex structure of many separate works of art, and only rarely a unity in conception or execution. But that is the only qualification that need be made. We say that a work of art 'moves' us, and this expression is accurate. The process that takes place in the onlooker is emotional: it is accompanied by all the involuntary reflexes which a psychologist would associate with an emotion. But as Spinoza was perhaps the first to point out (in the Fifth Part of his *Ethics*, Proposition III), an emotion ceases to be an emotion as soon as we form a clear and distinct idea of it. Of the theories that accept the instantaneous nature of aesthetic appreciation, the most successful is the theory of Einfühlung. The literature of this theory is immense, but it was given its classical expression by Theodor Lipps, one of the greatest of all writers on aesthetics. The word 'Einfühlung' has been translated as

'empathy', on the analogy of 'sympathy', and just as 'sympathy' means feeling *with*, so 'empathy' means feeling *into*. When we feel sympathy for the afflicted we re-enact in ourselves the feelings of others; when we contemplate a work of art, we project ourselves into the form of the work of art, and our feelings are determined by what we find there, by the dimensions we occupy. This experience is not necessarily confined to our observation of works of art; naturally we can 'feel ourselves into' any object we observe, but when generalized like this, there is little or no distinction between empathy and sympathy. If we look at this Japanese print, our attention might be taken by the men in the boats, and we should then feel sympathy for them in their danger; but contemplating the print as a work of art, our feelings are absorbed by the sweep of the enormous wave. We enter into its upwelling movement, we feel the tension between its heave and the force of gravity, and as the crest breaks into foam, we feel that we ourselves are stretching angry claws against the alien objects beneath us.

¶ 19. The work of art is in some sense a liberation of the personality; normally our feelings are inhibited and repressed. We contemplate a work of art, and immediately there is a release; and not only a release—sympathy is a release of feelings—but also a heightening, a tautening, a sublimation. Here is the essential difference between art and sentimentality: sentimentality is a release, but also a loosening, a relaxing of the emotions; art is a release, but also a bracing. Art is the economy of feeling; it is emotion cultivating good form.

¶ 20. It is sometimes objected to the theory of Einfühlung that it applies only to formal art—that it does not

cover our aesthetic reactions to colour, for example. We are moved by the blue of the Italian sky, or the glow of a sunset, but these objects have no form into which our feelings can enter. But can we call such objects works of art? Are they not merely phenomena to which we

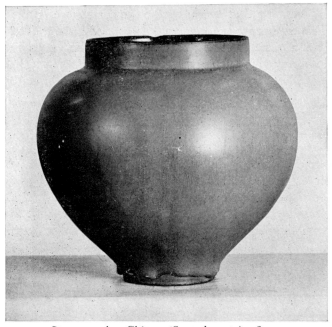

11. Stoneware jar. Chinese (Sung dynasty); 960-1279. *Victoria and Albert Museum.*

react sensuously? Juxtapose two or more colours, and immediately a formal relationship is created. All art is the development of formal relations, and where there is form there can be empathy. But whether, when we look at a picture, we always 'empathize'—that is another question. I began with assuming that we look

at the picture with a perfectly free mind, but that is a rare condition—as rare as that purity of heart which is the condition of seeing God.

¶ 21. So much for our individual reactions to the form of a work of art. But, of course, form is not necessarily all there is in a work of art, nor do we always react in this isolated personal way. A Gothic church was not built solely for the purpose of giving our sensibilities an uplift; it was many things besides—a hall for singing, an arena for ritual, a picture-house for illiterate people. It was all these things at one and the same time. And to go back to the Hokusai print: this can also be considered in the sympathetic sense I mentioned—as simply a picture of an immense wave overwhelming two boatloads of people. These aspects make up the *content* of the picture, and are best considered in an extreme development of the organic tradition (*see* ¶ 32). What we mean by 'content' may be best shown first by considering certain types of art that are quite devoid of it.

¶ 22. Pottery is at once the simplest and the most difficult of all arts. It is the simplest because it is the most elemental; it is the most difficult because it is the most abstract. Historically it is among the first of the arts. The earliest vessels were shaped by hand from crude clay dug out of the earth, and such vessels were dried in the sun and wind. Even at that stage, before man could write, before he had a literature or even a religion, he had this art, and the vessels then made can still move us by their expressive form. When fire was discovered, and man learned to make his pots hard and durable; and when the wheel was invented, and the potter could add rhythm and uprising movement to his concepts of form, then all the essentials of this most

abstract art were present. The art evolved from its humble origins until, in the fifth century before Christ, it became the representative art of the most sensitive and intellectual race that the world has ever known. A Greek vase is the type of all classical harmony. Then eastward another great civilization made pottery its best loved and most typical art, and even carried the art to rarer refinements than the Greeks had attained. A Greek vase is static harmony, but the Chinese vase, when once it has freed itself from the imposed influences of other cultures and other techniques, achieves dynamic harmony; it is not only a relation of numbers, but also a living movement. Not a crystal but a flower.

The perfect types of pottery, represented in the art of Greece and China, have their approximations in other lands: in Peru and Mexico, in mediaeval England and Spain, in Italy of the Renaissance, in eighteenth-century Germany—in fact, the art is so fundamental, so bound up with the elementary needs of civilization, that a national ethos must find its expression in this medium. Judge the art of a country, judge the fineness of its sensibility, by its pottery; it is a sure touchstone. Pottery is pure art; it is art freed from any imitative intention. Sculpture, to which it is most nearly related, had from the first an imitative intention, and is perhaps to that extent less free for the expression of the will to form than pottery; pottery is plastic art in its most abstract essence.

¶ 23. We must not be afraid of this word 'abstract'. All art is primarily abstract. For what is aesthetic experience, deprived of its incidental trappings and associations, but a response of the body and mind of man to invented or isolated harmonies? Art is an escape from

chaos. It is movement ordained in numbers; it is mass confined in measure; it is the indetermination of matter seeking the rhythm of life (*cf.* ¶82a).

¶24. For a perfect contrast to such 'abstract' art, we might take a work of the most humanistic phase of European art, such as the marble relief portrait of a youth by an Italian sculptor of the early sixteenth century (*Figure* 12). Ruskin once claimed that 'the best pictures that exist of the great schools are all portraits, or groups of portraits, often of very simple and in nowise noble persons. . . . Their real strength is tried to the utmost, and as far as I know, it is never elsewhere brought out so thoroughly as in painting one man or woman, and the soul that was in them. . . . Whatever is truly great in either Greek or Christian art, is also restrictedly human. . . .' Historically, the portrait, as Ruskin realized, is characteristic of certain periods which we call humanistic. In such periods man is the measure of all things, and all things are made to contribute to his awareness of his own vitality. Art is a tribute to man's own humanity. Such, no doubt, is the real basis of the popularity of portrait painting. This theory is not invalidated by the fact that painters often choose to paint their ugliest brethren; for to depart from the real to represent an ideal is to defeat the narcissistic impulse, which always exacts a faithful image.

The rise of the portrait corresponds fairly exactly with the rise of the novel. Portraits of Dante and others have been identified in the fresco ascribed to Giotto in the chapel of the Bargello, in Florence, which may be as late as 1337; Boccaccio wrote his first tale in 1339, and his *Decameron* nine years later. And just as at first the portrait in painting was a flat profile, so the character

43

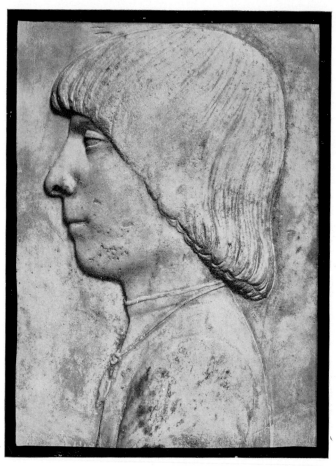

12. Head of a youth. Marble relief. Italian; 16th century.
Victoria and Albert Museum.

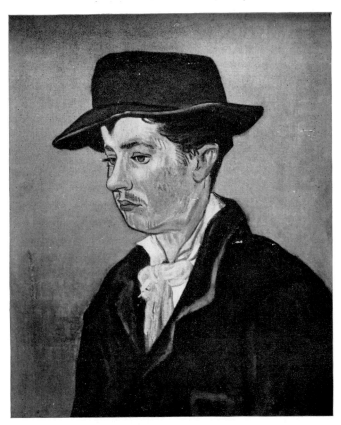

13. Portrait of a youth. By Vincent Van Gogh (1855-90)
Wallraf-Richartz Museum, Cologne.

in the early Italian novel was somewhat restricted in depth. One must not work the comparison too far: the novel, indeed, did not attain the psychological subtlety and precision already evident in portrait painting by the end of the fifteenth century until much later—perhaps not until the seventeenth century. But the general interest in character, common to both painting and the novel, was a continuous and rapid development from the early Renaissance, and still persists. We might draw a close parallel between Frith's 'Derby Day' and a novel like *The Pickwick Papers*. There is the same absence of formal values, the same concentration on human characters, the same sentimental kind of interest.

A good portrait in the humanistic sense may therefore be defined as a faithful portrayal of the character of an individual. The interest is psychological—that is to say, we make no moral judgments about the character of the individual portrayed. We are satisfied if the artist has realized the personality of his subject in its uniqueness, and by his dexterity and skill represented his knowledge and understanding in his plastic medium. Now it ought to be obvious that the 'thrill' we get from such a performance is not necessarily aesthetic. We are not concerned with an abstract quality of beauty, but with the recognition of something which we might even call scientific truth. The artist in such a case is merely a psychologist using paints, and many great portrait painters are of this kind. Many portraits, however, are admittedly great works of art, so that we have to ask ourselves finally what is it that distinguishes a portrait which is a psychological document from a portrait which is a work of art? One might answer: simply the aesthetic values, meaning the formal relations of space and colour

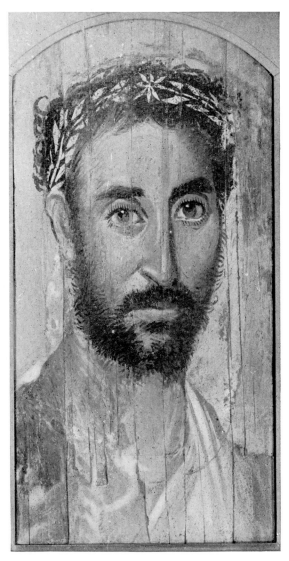

14. Portrait from a Fayum mummy-case. Egypto-Roman; 1st-3rd century A.D. *National Gallery, London.*

that constitute the structural organization of all works of art. In that sense a portrait might be accepted at its face value as a still-life, and we should be under no necessity to distinguish between the features of Hals's 'Laughing Cavalier' and the lovely lace ruff that adorns him. But actually we do make such a distinction, and it is something quite apart from the psychological interest I have already mentioned. It might be called the philosophical interest. In the best portraits the painter or the sculptor passes beyond the individual character of his sitter to certain universal implications. I can best illustrate my meaning by another literary analogy. The characters of Shakespeare's great plays are not merely individual characters, for all their realism and fidelity to life, but also prototypes of the passions and aspirations of humanity in general. From the heroes of Shakespeare's plays we derive not merely the sensuous impression of vitality, but also a sense of sublimity, which is the imaginative reaction from the sensuous impression.

¶ 25. We may conclude, therefore, that besides purely formal values, such as we find in a pot, there may be psychological values—the values arising out of our common human sympathies and interests, and even those arising out of our subconscious life; and beyond these, philosophical values which arise out of the range and depth of the artist's genius. These are perhaps rather vague words—at least, this word *genius*. But to put the statement in simpler words, we may say, that other things being equal—technical efficiency, economic opportunity, psychological insight—that artist will be the greatest whose intelligence is widest—a man who sees and feels, not only the object immediately before

48

him, but sees this object in its universal implications—sees the one in the many, the many in the one. But it cannot be too strongly emphasized that the plastic arts are visual arts, operating through the eyes, expressing and conveying a state of feeling. If we have *ideas* to express, the proper medium is language. The artist is impervious to ideas at his peril, but his business is not with the presentation of such ideas, but with the communication of his emotional reaction to them.

¶ 26. Let us now examine more closely the actual structure of a work of art. It is customary to take painting for this purpose, and it would only add to the reader's difficulties if we were to depart from this custom. But it should be remembered that painting is only one of the visual arts; its pre-eminence dates from the Renaissance and is therefore comparatively recent. There are signs that, in the future, interior decoration will tend to dispense with the picture on the wall, so that the relative importance of the art is already challenged. It should be possible to analyse the problem of style, the science of composition, and all the other questions which concern the structure of a work of art in the terms of architecture and sculpture, even of pottery and modelling or any other of the so-called 'minor' arts. The distinction between the 'fine' and 'applied' arts is a pernicious one; from what has already been said of the nature of beauty, it will be evident that this quality inheres in any work of art irrespective of its utilitarian purpose, or its size, or the preciousness of the material out of which it is made. To the sense of touch, ivory is more pleasant than bone, silk than wool, porphyry than plaster of Paris; but the work of art, in the very act of exploiting the qualities of the material out of which it is

constructed, transcends the disabilities of that material.

There are various ways in which we can analyse a work of art. We can take the physical elements in a particular picture, isolate them, consider them separately and in relation to one another. There are perhaps five such elements: rhythm of line, massing of forms, space, light and shade, and colour, and this is in most cases the order of their priority—not in absolute importance, but merely as successive stages in the artist's mind. A form must be defined by an outline, and this outline, unless it is to be lifeless, must have a rhythm of its own. The massing of forms, space, and light and shade should be considered in close relation. They are all aspects of the artist's feeling for space. Mass is solid space; light and shade are the effects of mass in relation to space. Space is merely the inverse of mass. This is especially clear in the art of building; a cathedral, for example, must be conceived either as so many walls enclosing a space, and as such must be viewed from within, or as so many surfaces defining a mass, and as such must be looked at from without. The Greek temple is an obvious example of the latter, the Gothic cathedral succeeds in combining both points of view, with a preference for the former. The Greek architect was always striving to avoid the impression of hollowness, the Gothic architect was always striving to give the impression of immaterial space and airiness. Both were considering together space, mass, light and shade. The same considerations arise in grouping figures or the details of a landscape on the surface of the canvas in painting.

¶26a. If we keep in mind all the historical manifestations of the visual arts, we shall find among them one or

more common denominators. Naturally, if we define the visual arts vaguely as anything which being seen gives pleasure, then, in our effort to find anything in common between the colour of a rose and the Parthenon, we shall be reduced to physiological factors in the nervous system. But art in the strict sense begins with definition— with the passage from vagueness to outline. And indeed we find that historically the first kind of art—the art of the cavemen—begins with an outline. Art began with the desire to delineate—and still so begins in the child. Delineation still remains one of the most essential elements in the visual arts—even in sculpture, which is not merely mass, but mass with outline. So fundamental is this quality that some artists have not hesitated to make it an essential of all art. Blake expressed this view with great force, in words quote more fully in ¶66:

'The great and golden rule of art, as well as of life, is this: That the more distinct, sharp and wiry the bounding line, the more perfect the work of art, and the less keen and sharp, the greater is the evidence of weak imagination, plagiarising, and bungling. . . . '

More amusingly he relates how 'a certain Portrait Painter said to me in a boasting way, "Since I have practised Painting I have lost all idea of drawing." Such a Man must know that I look'd upon him with contempt.' And this is one of the first things to realize about 'line'—it does not necessarily disappear in the passage from drawing to painting. Line is one of the methods of painting—Blake would have it that it was the only method.

But first let us note the potentiality of line for suggesting more than outline: in the hands of a master it can express both movement and mass. Movement is ex-

pressed, not only in the obvious sense of depicting objects in motion (that is an adaptation of the line to the selective observation of the eye) but more aesthetically by acquiring an autonomous movement of its own—by dancing on the page with a joy quite independent of any reproductive purpose. Although certain Western painters like Botticelli and Blake might be mentioned, this quality of line is best illustrated in oriental art—in Chinese and Japanese paintings, drawings and woodcuts—and when properly organized it results in *rhythm*. How the dancing line gives this rhythmical sense is perhaps easier to appreciate than to explain: it can be appreciated by musical and physical analogies, but to explain it in visual terms we need some such theory as that of *empathy*— our physical sensibility must in some way be projected into the line—for, after all, the line itself does not move or dance; it is we who imagine ourselves dancing along its course.

The most remarkable quality of line is its capacity to suggest mass or solid form. This is a quality it only acquires in the greatest masters, and is expressed in various subtle departures from the continuous outline—the line itself is nervous and sensitive to the edge of things, it is swift and instinctive, and instead of being continuous, breaks off at just the right points and re-enters the body of the design to suggest converging planes. It is, above all, selective, suggesting more than it states. Line, in fact, is often a very summary and abstract device for rendering a subject—a pictorial shorthand. It is amazing how abstract it can become without offending the *conventional* codes of representation—consider, for example, the various manners in which the foliage of trees is represented; and this only serves to show the pre-

dominant part played by conventions in our aesthetic experience.

Blake was probably right in having nothing but contempt for the painter who has lost all idea of drawing. The same instincts are involved in both activities, and all the great Renaissance painters, from Masaccio to Tiepolo, were superb draughtsmen. And a modern artist like Picasso, so baffling in the rapidity and apparent contradiction of his changing styles, is nowhere so convincingly proved a master as in his drawings, which with a minimum of effort express a vastness of three-dimensional form. We find the same graphic signature of genius wherever we look—in the East as in the West, in the remote past and in our own time. So universal is this quality in the visual arts that it is easy to fall into Blake's extreme attitude and imagine it the only essential quality. But the quality known as *tone* is also universal and perhaps an alternative of equal value as a mode of expression.

¶ 26b. 'Tone' is a word which does service for more than one art. Presumably its first use was musical; but from the beginnings of art criticism in the sixteenth century it was used of painting. Nowadays, to add to the confusion, a musical critic will return the compliment and actually combine a word like 'tone' with terms belonging to the art of painting. Thus we read in our newspaper that Miss X 'is too deficient in variety of *tone-colour* to make a good lieder singer'. The use made by musicians of the word 'chromatic' seems to be as venerable as the painter's use of 'tone'. These mutual raids can, however, become excessive, even absurd, as in this description of Leonardo's 'Adoration': 'The modelling of the plane tree in relation to the staccato notes of the palm, and to

the two trees growing on the ruin, gives a tone rhythm for the whole composition.'

Ruskin made an attempt, in *Modern Painters*, to define what is meant by tone in painting: 'I understand two things by the word *tone*: first, the exact relief and relation of objects against and to each other in substance and darkness, as they are nearer or more distant, and the perfect relation of the shades of all of them to the chief light in the picture . . . secondly, the exact relation of the colours of the shadows to the colour of the lights, so that they may be at once felt to be merely different degrees of the same light.' This is not a very clear definition, and perhaps the subject is best treated as one of technical development. After the problem of suggesting three-dimensional mass by outline came the problem of suggesting mass by lighting. Line is an abstraction: it bears no relation to the visual appearance of objects; it merely suggests that appearance. It can suggest the lighting of an object (most obviously by a variation in the thickness of the line), but its chief concern is with what we might call the objective reality of solid things. Light is fluid: it is a shifting phenomenon, always changing its degree of intensity and its angle of incidence. It cannot therefore be fully represented by anything so static and definite as line. And so we get the introduction of shading—light is represented by a gradation between the extremes of white and black; and even when colour is used, light can only be *realistically represented* by saturating its full brightness by some quantity of black pigment, to give the contrast of shade. That it can be *schematically suggested* by the sensitive juxtaposition of pure unsaturated colours, the paintings of Matisse can show.

This graded process of shading can be used to repre-

sent three quite distinct qualities: (1) the passage from light to shadow within the field of one colour or one mass; (2) in a monochrome representation, the relative intensity of different colours as distinguished from neutrality; (3) the actual degree of lightness or darkness in relation to the chief light in the picture—this is a relationship established for the picture as a whole. Before we note the elaboration of tone values in European painting, let us note that in Oriental graphic arts the whole matter was, as with line, subordinated to the abstract values of rhythm and form. This method is well described by Professor Pope in *The Painter's Modes of Expression* (Harvard University Press, 1931):

'. . . in Chinese and other Asiatic painting, the form is expressed mainly by line, with which alone . . . a surprising amount even of solid form may be shown; but the local tone of each object is also given by means of pigment spread over its field in the painting. This is ordinarily flat in each field; but there may be variation of gradation if, as in the petal of a flower or the wing of a bird, the local tone is itself varied or graded. Moreover, arbitrary gradation may be used in order to accent edges, and thus assist the expression of form by the lines.' The Japanese colour-print shown in *Figure* 10 is a simple illustration of this use of local tone.

When the effects of light began to be studied by the early Italian painters of the Renaissance, just as they found difficulty in representing space unless they stratified it (as we shall explain in ¶26d), so they felt unable to represent light except by isolating it, or focusing it separately on each object depicted. The result gives light an equal value over the whole picture, and the painting has consequently the appearance of a

55

low relief in which each object is modelled in even light and shade. A painting by Mantegna or Andrea del Castagno illustrates this quality perfectly.

It is doubtful if the Italian school ever completely realized the visual effect of an all-enveloping lucent atmosphere. Even Leonardo, who carried the science of light and shade to its limits, confessed: 'Although the things confronting the eye, as they gradually recede, touch each other in uninterrupted contact, nevertheless I shall base my rule (of distance) on spaces of 20 ells, just as musicians, although the tones unite in one whole, have set a few gradations from tone to tone.' (*Trattato della pittura*.) The ideal of 'the open window', as it has been called, the complete illusion of a uniform spatial atmosphere, was to be achieved by the tradition which began with the Van Eycks in Flanders and reached its perfection in a painter like Vermeer. This ideal proved to have its limitations: it encouraged manual dexterity and a scientific aim at the expense of feeling and an aesthetic aim. But intermediately there was a stage, represented by such artists as Titian, Tintoretto, and Correggio in Italy, and by Rembrandt in the North, in which the artist, in perfect control of his distribution of light and shade, uses it for purely dramatic and aesthetic effects. The pattern of the picture, that is to say, becomes a pattern of light and shadow, each deliberately stressed to give contrast; and this pattern may run right across the architectural composition of the picture in a kind of counterpoint (to steal a musical term). A good example of this is Rembrandt's 'The Good Samaritan', where the simple planimetric structure of the composition is totally obliterated in a free rhythm and balance of emphatic lights and shadows.

15. The Good Samaritan. By Rembrandt. 1648. *Louvre, Paris.*

¶ 26c. I now turn to the part played by colour in painting. It adds one further element to the complexity of the complete work of art. Line has given us clarity and dynamic rhythm and has suggested, perhaps, the mass or solid form to which tone gives full spatial expression. Colour is added to these, and the easiest explanation of its function regards it as an enhancement of the verisimilitude of the painting. This use of colour might be called *natural*, but it is far from being the only use. Indeed, with the exception of Constable in his sketches and of the photographic painters of the second half of the nineteenth century, a natural use of colour is extremely rare in the history of art, and as the experiments of Turner and the Impressionists were to show, is extremely difficult to determine. When we see the *real* colours in nature, we are apt to complain of their unreality. Apart from this natural use of colour we can distinguish three modes which I will call the heraldic, the harmonic and the pure. The *heraldic* use of colour is perhaps the most primitive—even the coloured rock-paintings of the Stone Age can hardly be described as natural. In this mode colour is employed for its symbolical significance. A child, for example, if he has a free choice of colours, always paints a tree green, a volcano red and the sky blue, though a tree may be brown, a volcano black and his habitual sky grey. In mediaeval art, apart from the representation of nature, which follows the childlike mode, the colours are apt to be governed by the most rigid rules—rules not determined by the artist, but by the custom and authority of the Church. The robe of the Virgin must always be blue, her cloak red, and so on; and these elements being fixed, the colours in the rest of the painting must conform, just as the colours of

the quarterings in heraldry. That this limitation was not necessarily a disadvantage is proved by the extraordinary beauty, balance and clarity of the colours in mediaeval painting.

The heraldic mode, as I have called it, continued until the end of the fifteenth century, when more intellectual and scientific notions of colour began to supplant the mediaeval tradition. But before passing on to these modes, I would like to emphasize the freedom and gaiety of the heraldic mode at its best: in the Quattrocento the use of colour became extremely free and arbitrary and definite, and so emancipated from formalism that it really becomes the pure mode of colour which I am going to describe presently. But first let me note the mode I have called *harmonic*. This is due mainly to those considerations of tone values which I dealt with in my last section. Once the painter begins to look at his objects in relation to light and shadow, then he must consider the tone value or relative intensity which the various colours have in relation to the general light of the painting. This involves, in effect, regulating the colours to conform to a restricted scale; the dominant tone of the painting is selected (perhaps arbitrarily, but more often in conformity with some 'style' or workshop tradition) and all the other colours are scaled up or down to a restricted distance from this dominant tone. The general practice from the sixteenth to the eighteenth centuries was to work from a scaled palette, your colours neatly laid out within a narrow range which you could not depart from without deserting your palette. It is only when this is understood that we can appreciate the eighteenth-century connoisseur's enthusiasm for paintings whose original colouring showed only dimly through a glaze the

colour of brown gravy. That the next step should be to paint in brown gravy was only natural, and it was then time for Constable to revolt against the whole harmonic tradition. That he did not carry his revolt to its logical conclusions may be shown by a comparison of his *plein air* sketches and his finished pictures, which still make a considerable concession to the demands of tonal harmony. Turner in this respect was a more thorough-going revolutionary, and undoubtedly the greatest natural colourist the world has known.

Cézanne's use of colour, which I deal with more fully in ¶ 73, is neither completely natural, like Turner's, nor pseudo-scientific, like that of the *pointillistes*. It is almost symbolical. 'When colour has its richness, form has its plenitude', is his own description of his method. In this sense colour defines form, not by any modification of its own purity, but by being so arranged in its relative intensities that it creates the illusion of three-dimensional form (for colours in the same plane do not necessarily seem at the same distance from us). The form is conveyed directly by the colour, irrespective of light and shadow (chiaroscuro). This approaches the third mode, which I have called the *pure* use of colour. In this mode colour is used for its own sake, and not even for the sake of form. The mode is illustrated most notably by the miniature painters of Persia and in this century by Matisse. Colours are taken in their purest intensity and a pattern is built up in contrasts of relative intensity and relative area. Spatial sense is conveyed, as in Cézanne, by gradation of the tonal values of the colours, but only sufficiently to secure a focus and a balance over the whole composition. The main object being decorative, questions of verisimilitude are secondary. Colour is thus

reduced to its most direct sensuous appeal. What that appeal means to us may best be described in the words of Ruskin: 'All men, completely organized and justly tempered, enjoy colour; it is meant for the perpetual comfort and delight of the human heart; it is richly bestowed on the highest works of creation, and the eminent sign and seal of perfection in them; being associated with *life* in the human body, with *light* in the sky, with *purity* and hardness in the earth—death, night, and pollution of all kinds being colourless'.

¶26d. Form is the most difficult of the four elements which go to the making of a work of art in painting: it involves questions of a metaphysical nature. Plato, for example, distinguishes between relative and absolute form, and I think this distinction must be applied to the analysis of pictorial form. By relative form Plato meant form whose ratio or beauty was inherent in the nature of living things and in imitations of living things; by absolute form he meant a shape or abstraction consisting of 'straight lines and curves and the surfaces or solid forms' produced out of such living things by means of 'lathes and rulers and squares', and this immutable, natural and absolute beauty of shape he compared to a single pure and smooth tone of sound, which is not beautiful relatively to anything else, but only in its own proper nature (cf. *Philebus*, 51 B). Following this hint of a distinction (it is perhaps no more), we can, I think, divide the forms which successful works of art achieve into two types, one which may be called *architectural*, or architectonic, the other *symbolic*, abstract or absolute. The only trouble is that, when we consider the form of an architectural composition apart from its content, we tend to reduce all form to something abstract or absolute, even symbolic.

The obvious necessity in a composition is simply that it shall cohere by some principle—in physical terms, that it should not distract the eye by its unease, or lack of balance. So the painter proceeds to build up his figures and other objects upon some structural basis of a stable kind, such as a pyramid. All so-called 'classical' painting, that is to say, painting of the High Renaissance, is of this kind. The general effect is one of static or 'closed' composition. Opposed to this type, and generally alternating with it period by period, is a form of composition which, whilst still architectonic, ' built-up,' is nevertheless dynamic and 'open'. The limits of the frame of the picture are ignored, the actual plane of the canvas is ignored: a spatial sense is achieved which flows into or out from the picture, at any rate *beyond*, and the lines of movement, whilst proceeding as it were from a common source, are equal and opposite: the lines of force are centrifugal, but balanced. Such is the form of the typical compositions of the Baroque period.

In building up his composition, the artist may proceed intellectually or instinctively, or perhaps more often partly by one method and partly by the other. But most of the great artists of the Renaissance—Piero della Francesca, Leonardo, Raphael—had a definite bias towards an intellectual construction, often based, like Greek sculpture or architecture, on a definite, mathematical ratio. But when we come to a Baroque composition like El Greco's 'Conversion of St. Maurice', the scheme is so intricate, so amazing in its repeated relations, so masterly in the reinforcement which form gives to intention, that the form itself, as often the solution of some mathematical problem, must have been an intuition. But in such form we are still experiencing the kind of pleasure

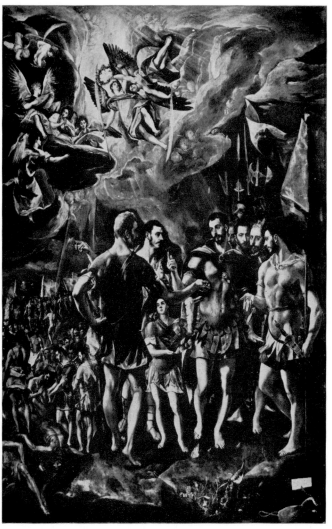

16. The Conversion of St. Maurice. By El Greco (1545-1614).
Escorial, Madrid.

we derive from architecture, and there is, of course, a clear parallelism between form in Baroque painting and form in Baroque architecture—between the form in all the arts at any one period. And along these lines we might discover the true relation between the artist and the civilization of his period, which is one of the problems that so much concern us to-day. The period, the civilization, 'gives' the form and even dictates the content of a work of art; but the power that fuses form and content and raises them to the scale and intensity of genius—that is determined by the individual psyche of the artist alone.

It is under this aspect of architectural form that I would include that characteristic of composition sometimes called 'rhythm'. Rhythm in a painting may be produced, not merely by the contour of line, but by the repetition of masses, usually in a diminishing sequence. That such sequences should so often be triads is due to nothing more mysterious than the fact that three is the first number at which a sequence becomes perceptible, and that a sequence of more than three masses would, in a painting, tend to be too obvious.

Symbolic form is much more difficult to explain. It depends on a psychological hypothesis for which Jung and other psycho-analysts have of late years provided a good deal of evidence. Roger Fry has put forward the hypothesis as it applies to art in the following words:

'In art there is, I think, an affective quality which . . . is not a mere recognition of order and inter-relation; every part, as well as the whole, becomes suffused with an emotional tone. Now, from our definition of this pure beauty, the emotional tone is not due to any recognizable reminiscence or suggestion of the emotional experi-

ences of life; but I sometimes wonder if it nevertheless does not get its force from arousing some very deep, very vague, and immensely generalized reminiscences. It looks as though art had got access to the substratum of all the emotional colours of life, to something which underlies all the particular and specialized emotions of actual life. It seems to derive an emotional energy from the very conditions of our existence by its revelation of an emotional significance in time and space. Or it may be that art really calls up, as it were, the residual traces left on the spirit by the different emotions of life, without, however, recalling the actual experiences, so that we get an echo of the emotion without the limitation and particular direction which it had in experience.'[1]

It is quite evident, as we may learn from a study of anthropology or religion, that a symbol may be a form of quite arbitrary origin: merely a concretion, into something having shape and definiteness, of vague, subjective emotions. It seems quite certain that much art, in its formal aspects, derives its appeal from the creation, perhaps unconsciously, of such symbolic form.

¶ 27. In a perfect work of art all the elements are interrelated; they cohere to form a unity which has a value greater than the mere sum of these elements. Whistler said that he mixed his paints with his brains; in Germany they say a man paints with his blood; these phrases imply that the elements of a picture cohere by virtue of the personality which dominates them and moulds them into a unity which is the unity of the painter's direct emotional apprehension of the subject before him. When we have finished analysing all the physical elements in a picture, we have still to account

[1] *The Artist and Psycho-analysis.* (Hogarth Press, London, 1924)

for this intangible element which is the expression of the artist's individuality, and which, when everything else is shared in common—subject, period, generation and materials—still leads to totally different results. It is possible that since the Renaissance we have tended to exaggerate the importance of this element of personality; the great religious types of art—Gothic and Buddhist—are almost entirely impersonal. Another critic[1] has gone so far as to suggest that we are really concerned with two entirely different conceptions of art—art produced in the service of religion, and art pursued as a consciously held idea. This distinction is useful for descriptive purposes, but it can hardly be pressed to the extremes that Mr. Wilenski would propose. It amounts in effect to judging a work of art in the light of its intention, a course that leads to the intrusion of all kinds of irrelevant prejudices. The Chinese Lohan in the British Museum, a figure from the West Portal of Chartres Cathedral, and the latest work of Epstein or Henry Moore must be related to the same sensibility, though admittedly that sensibility stands more chance of being liberated in the spectator if he has a prior understanding of the artist's intention in each case. But it should always be remembered that the appeal of art is not to conscious perception at all, but to intuitive apprehension. A work of art is not present in thought, but in feeling; it is a symbol rather than a direct statement of truth. That is why the deliberate analysis of a work of art, such as I have been suggesting here *only by way of explanation*, cannot in itself lead to the pleasure to be derived from that work of art. Such pleasure is a

[1] R. H. Wilenski, *The Modern Movement in Art*. (London, Faber & Faber, 1927.)

17. The Flagellation of Jesus. By Piero della Francesca (1416?-1492).
Ducal Palace, Urbino.

18. Christ driving the Traders from the Temple. By El Greco (1545-1614).
National Gallery. London.

direct communication from the work of art as a whole. A work of art always surprises us; *it has worked its effect before we have become conscious of its presence.*

¶ 28. The structure of a work of art is not always obvious; it may be a subtle balance of irregularly disposed units. But generally speaking a painter, for example, of sufficient boldness will seize on some easily apprehended scheme and dispose his masses accordingly. The pyramidal scheme already mentioned is very common because it gives a solid weight at the base of the picture and the eye is carried up to a culmination where it most naturally expects to find it. A similar structural scheme is an arrangement or repetition of triangles. In the picture by El Greco illustrated (*Figure* 18) we have a wheeling rhythm which flickers like spokes outwards from the axle-gesture of Christ and gives a wonderful sense of vitality to the whole composition. Every line in the composition is made to contribute to this impressive rhythm.

These structural motives are very important in the making of a picture or any other plastic work of art, though they are not necessarily a deliberate choice of the artist. They reveal, more clearly than anything, the predominating rhythm of the period. The fact that Rubens, for example, so often adopted a spiral motive was no casual happening; a spiral is the typical dynamic rhythm of his period. He was engaged in an effort to break down the static architectural compositions of the earlier Renaissance tradition.

In a landscape, the composition is more likely to be conditioned by the practical problems of suggesting distance, perspective and atmospheric conditions. In the landscape by Claude, for example (*Figure* 46), there is

no striving after a schematic rhythm. The lines are fully employed in suggesting the extent of the landscape, without encroaching too much on the relative mass of sky and land, or on the atmospheric effect of the play of light and shade. The structural vitality of the picture must be sought within the subject itself, instead of being laid down like a steel-framework on to which the subject has to be fitted. The alternative is to construct an imaginary landscape free from representational restrictions, which is the method typical of modern artists like Kandinsky or Max Ernst (*Figure* 64).

19. The La Grèze bison. Stone Age (Aurignacian period); perhaps 20,000 B.C. From a photograph by G. Baldwin Brown.

II

¶29 That the aesthetic sense is inherent in most people irrespective of their intellectual standing is clearly shown by a consideration of the art of primitive peoples. (It is also shown in the unconsciously aesthetic appreciation which the man in the street will betray in the presence of a six-cylinder Cadillac or indeed in the presence of any beautiful building or machine which he is not asked to look upon as 'a work of art'.) Much research in this field has been done in recent years, and we now have a fairly definite knowledge of the art of some of the most primitive of men known to the anthropologist (from 30,000 to 10,000 B.C.). The surviving examples of this 'prehistoric' art

of the Palaeolithic period fall into three geographical groups (Franco-Cantabrian, Eastern Spanish and North African), but the famous cave-drawings of animals at Altamira in Spain are the most important. Parallel in development with such prehistoric art we have the much more recent art of the Bushmen of Southern Rhodesia and South-West Africa. All these groups have certain features in common. The representations (usually drawings on the walls of caves) show no attempt at perspective: the purpose is rather to represent the most expressive aspect of each element in an object—the side view of the foot, for example, being combined with the front view of the eyes. In other respects, too, the art of these primitive peoples is not naturalistic. There is a definite abandonment of detail in favour of what we may call symbolism. The details of natural forms are rejected or distorted in order to suggest the prime significance of the object represented; for example, the body of a bull is elongated to suggest the act of leaping; it is coloured in flat washes differentiated (as between light and dark) in such a way as to emphasize the lines of movement in the animal's body. Palaeolithic art shows a definite development from a linear or two-dimensional mode of representation in the Aurignacian period to a plastic or three-dimensional mode in the Magdalenian period; but in the Neolithic period this plastic sensibility disappears. A more significant development is seen in the Eastern Spanish and Bushman types; when a group of objects is represented we can see that the group has been conceived as an integral whole, not merely as an aggregation of individual parts.

¶ 30. Bushman paintings are found on the face of bare

rocks, in caves and semi-grottoes, and were executed, probably, with a stub or spatula of sharpened bone, in oil colours carefully manufactured from earth pigments and animal fats. There is evidence to show that the paintings have been often repainted, and that the places where they are found were in some way regarded as sacred by the Bushmen.

Some of the paintings are of quite recent origin, and Dr. Kühn[1] is of the opinion that Bushman painting was still at its zenith a few centuries ago, the period of decline comprising the last century or two—'during which the Bushmen, as a result of Negro as well as of white influence, lost their territory, together with a great part of their traditions and customs'. But the date of the paintings is actually of little significance; what matters is their place in the cultural history of the human race. There can be no doubt that we have in the art of the Bushmen a survival of the art that flourished over a much wider area thousands of years ago—the art, in fact, of the pre-historic period. Incidentally, the similarity of the Bushmen pictures to the cave drawings found in Eastern Spain cannot, in the opinion of Dr. Kühn, be altogether accidental, and he suggests that the Bushmen are actually a race allied to the so-called Capsian culture of Eastern Spain and Northern Africa. But I must leave on one side the very interesting ethnological questions raised by the character and distribution of Bushman art, and confine myself to its aesthetic significance.

Firstly, one should not imagine that any old Bushman could paint these pictures. Records of the accounts

[1] *Bushman Art.* By Hugo Obermaier and Herbert Kühn. (Oxford University Press. 1930.)

given by the early Boer settlers point to the existence of an office in the nature of court painter; and even if such records were wanting, we might be quite sure on *a priori* grounds that the aesthetic sensibility revealed in the paintings was an exceptional attribute. For aesthetically the paintings are very remarkable; they are even 'beautiful' in the special sense I have given to that word (¶3). They are, therefore, to be sharply distinguished from Negro art, and that is the first point made by Dr. Kühn in his chapter of 'The Spirit of Bushman Art'. 'The most prominent feature of the art of the Bushmen,' he writes, 'is the naturalistic and sensory character of its informing spirit. . . . If the art of the Bushman is placed alongside that of the African Negro, excluding the art of Benin and Yoruba, Bushman art will then be seen to be much closer to the natural model; it is more strictly realistic and truer to nature. . . . The Bushman, more closely related to nature, experiences more strongly the plastic character of the object; its form, colour and movement. To him the object is reality, not symbolism or essential meaning, as it is to the animistically-inclined Negro.' Instead, therefore, of the stylizations and abstractions which we get in an antivital art like that of the Negro, the Byzantine artist, or the modern Cubist, we have an art in which every line expresses movement and life. Most of the paintings represent running animals or hunting scenes, but even when the subjects are at rest, as in the example I have selected for reproduction (*Figure* 20), they are extraordinarily alive. Could the alertness of suspicious animals be more successfully represented by all the accumulated skill of civilized art ?

The paintings are generally monochrome, though

74

there is a fair range of colours, and they do occur in combinations of two or more colours. They are invariably two-dimensional, without any kind of shading or modelling. When different tones of colour occur, they are not used to suggest the modifications of light and

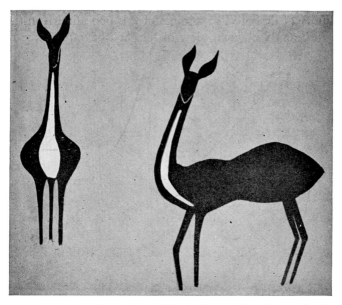

20. Bushman rock-paintings. Tsisab Gorge (Brandberg, South-West Africa). From *Bushman Art* by Hugo Obermaier and Herbert Kühn.

shade, nor even naturalistically; they are used to emphasize rhythm and movement. In the group of paintings dealt with by Obermaier and Kühn, there is a very evident aim at composition. Dr. Kühn observes that 'the primary thing is the unity, not the multiplicity. The design is conceived as an integral whole, not as a function of its individual parts. The members lead no separate

life of their own: they have their significance only in the composition. Thus it is the composition, the structure of the thing as a whole, deriving from the unity of a pictorial scene, which stands pre-eminent in this art.'

This is a large claim, and one naturally looks for some emotional force which would urge the artist to such a unity of design. The authors of this book find it in the Bushman's magical view of life. We have evidence of magical ritual in the survivals of the Bushman's dances, songs and legends. It is clear that the pictures are not without meaning. Therefore, concludes Dr. Kühn, 'not only have they an aesthetic value; but, like the pictures of the Middle Ages in Europe, a significance in religious, or, if one is unwilling to regard magic as a form of religious expression, in magical experience'.

¶31. By the symbolical representation of an event, primitive man thinks he can secure the actual occurrence of that event. The desire for progeny, for the death of an enemy, for survival after death, or for the exorcism or propitiation of an evil spirit, is the motive for the creation of an adequate symbol. It follows that in primitive art we are concerned with art in the full sense of the word: with formal arrangements expressive of emotional attitudes. Indeed, it has been said with truth by Count Gobineau that the Negro possesses in the highest degree that sensual faculty which our civilized instincts tend to destroy, but without which no art is possible. It is certainly true that from a study of the art of the Negro and the Bushman we are led to an understanding of art in its most elementary form, and the elementary is always the most vital.

¶32. For primitive man artistic creation meant an escape from the arbitrariness of life. He lived from day to day,

76

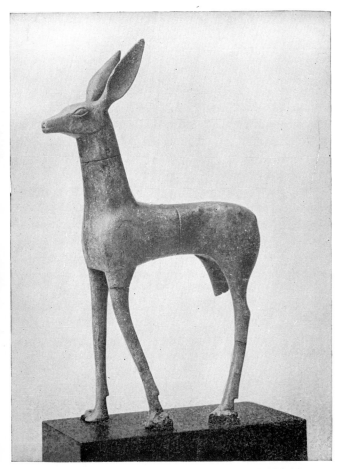

21. **Bronze deer.** Iberian; 8th or 7th century B.C. *British Museum.*

and from hand to mouth, in the exact meaning of the phrases. There was no permanency in his life, no sense of duration. Even to-day, among races in touch with civilization, it is impossible to get a native to understand the meaning of a promise. He does not reason beyond the immediate situation, but acts instinctively at every turn of events. When, therefore, he creates a work of art, as an act of magic propitiation, he escapes from the otherwise prevailing arbitrariness of his existence, and creates what is for him a visible expression of the absolute. For a moment he has arrested the flux of existence and has made a solid and stable object; out of time he has created space, and he has defined this space with an outline, and under the stress of his emotion this outline has taken on an expressive shape; has become an order, a unity, a formal equivalent to his emotion.

There are these two distinct modes of securing this desired result—the organic and the geometrical. It has been suggested that fundamentally these two opposed types are determined by contrasted environments. Where the forces of nature are felt to be inimical, as in the frozen north and the tropical desert, art takes the form of an escape not only from the flux of existence, but even from anything symbolical of it. The organic curve, to reduce it to its simplest element, is regarded as unsympathetic; the artist therefore geometricizes everything, makes everything as unnatural as possible. Nevertheless, a work of art must be dynamic—it must arrest the attention of the onlooker, move him, infect him. The geometry of this abstract art is therefore very agitated: it is mechanical, but it moves. The vital art of primitive people, on the other hand, is sympathetic towards nature. It adopts the organic curve, enhances its liveli-

ness. It is the art of temperate shores and fruitful lands. It is the art of joy in living, of confidence in the world. Plants, animals, the human form itself, are portrayed with loving care, and in so far as art departs from exact imitation, it is in the direction of the enhancement of a vitalistic urge.

In its origins Greek art of the classical period is essentially the same as Palaeolithic and Bushman art —that is to say, it is organic art. It differs from its primitive relations only in the degree of its organization, the complexity of its associations, and the superior technical achievements of its accompanying civilization. But there is this reservation to be made: the Greeks were a very scientific or intellectual race. Not content with the vitality of nature and art, they sought to explain this vitality by formulas. They discovered, or thought they discovered, certain fixed ratios both in nature and in art. These ratios, once discovered, were deliberately applied. The Golden Section, as we have already noted, was discovered by them and persists as an element of the classical tradition right down to the present day.

¶33. The two types of contrasted art—geometrical and organic—persist all through the history of art. Naturally, as civilizations spread and races interpenetrate, fusion takes place, and indeed the main current of art eventually expresses just such a compromise. But before taking up this main current, let us notice that both the geometrical and the organic types continually tend to reappear in all their original purity, in pre-historical as well as historical times. To take comparatively modern examples, we get the reappearance of geometrical art in the so-called Saracenic style—the style developed by

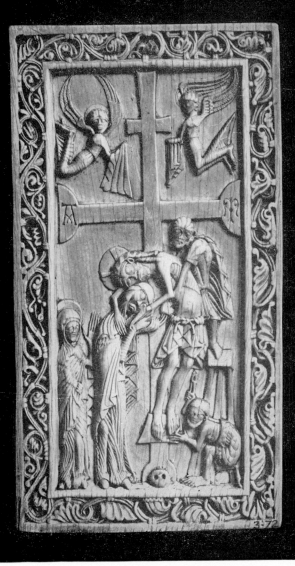

22. The Descent from the Cross. Carved ivory. Spanish;
11th century. *Victoria and Albert Museum.*

the mathematically minded Arabians in Spain and Egypt; we get it above all, in its finest manifestation, in Byzantine and Romanesque art; we get it also, far away from these influences, in the art of Peru and Mexico, Java and Japan. It reappears in modern Cubist art. The organic style is less intermittent; it persisted in Egypt side by side with a geometrical art: the geometrical was the art of the priests, the organic art the art of the people. The early Christian art of the catacombs shows the organic impulse in all its innocency again, and with the humanism and naturalism of the Italian Renaissance we have, of course, the great triumph of this style.

But the triumph of the organic style (in the Western world only, of course) had been preceded by the establishment of a great compromise. Both Gothic art and Oriental art, in their general aspects, represent a fusion of the geometrical and organic principles. The abstract principle was characteristic of the northern nomadic races and geometrical art stretched across the continents of Europe and Asia from Ireland to Siberia. Now one of the recurring phenomena in economic history may be generalized as the raiding of the peasant peoples by the hunting peoples. The impoverished nomadic races confined to the less fruitful tracts of the earth's surface organize themselves into bands and descend to batten on the more temperate and productive lands of the earth. They bring with them their geometrical ornament, their ingenious weapons, their religious mysticism. The process is extremely complicated; it has a background of rising or falling dynasties, of economic cycles and natural catastrophes, of religious revivals or persecutions. But art penetrates all these,

and out of the turmoil there emerge the great historical phases of art—Minoan, Sasanian, Islamic, Oriental, Gothic, and many subdivisions and offsprings of these.

¶ 34. The history of art from the primitive stage (but we must remember that what is the primitive is not necessarily inferior) to its most civilized achievement in Classical or Gothic art accompanies and depends on the parallel evolution of man's emotional attitude towards the universe—the evolution from magic and animism to religion. The immense distance between a Negro statue and a statue by Praxiteles is the immense distance between a Negro's animistic religion and the intellectual insight of a Greek at the highest point of their civilization. The Greeks attained a religious equilibrium which can only be called felicity; they lost all fear of the external world—they actually turned sympathetically towards this world, and their art became an expression of what they saw with friendly eyes—an idealization of nature. Man now saw beauty everywhere in living things, and the organic rhythm of life was the quality he tried to express in his art.

The relation between art and religion is one of the most difficult questions that we have to face. We look back into the past and see art and religion emerging hand in hand from the dim recesses of pre-history. For many centuries they seem to remain indissolubly linked; and then, in Europe, about five hundred years ago, the first signs of a definite breach appear. It widens, and with the High Renaissance we have an art essentially free and independent, individualistic in its origins, and aiming to express nothing beyond the artist's own personality. The history of Western art since the Renaissance is checkered and discordant; at times we think that

the highest point has been reached in some particular masterpiece, at times there seems to be no art at all, and finally we begin to think that there can be no great art, or great periods of art, without an intimate link between art and religion. Even where great artists have created their masterpieces in apparent isolation from any religious faith, the more closely we look into their lives the more likely we are to discover the presence of what we can only call religious sensibility. The life of Van Gogh is a case in point.

Nevertheless, I think it would be too hasty to conclude that the connection between art and religion is inevitable and necessary. It depends, of course, what we mean by art and what we mean by religion. The essential element in the artist, the only element we can certainly never dispense with, is a modicum of sensibility—we need not be afraid to call it sensuality. In the art of primitive man, as in his religion, it is this element which is worked on. The difficulty, at this stage, is to make any separation between art and religion. The cults of the one exact the inventions of the other. The magicians and priests of religion are identical with the creative artists, and art only exists as a function of worship or propitiation. Such art, from the standpoint of our later civilization, is drastically limited; it expresses only a very narrow range of emotions, and these are mainly emotions of fear. The sense of glory, which is the offspring of spiritual courage, is entirely absent in the art of primitive man. It is this sense, followed in different directions, which leads to the highest attainments both of Classical art and of the Christian art of the Middle Ages.

Meanwhile, in the change from the art of primitive

man to the art of the civilized man, there has been no real change in the psychological workings of the artist's mind. The formal values of the Negro mask illustrated (*Figure* 24) and the head of Adam by Riemenschneider (*Figure* 23) are nearly equivalent. What makes the difference is the expression of a different scale of transcendental values. That is to say, the difference in value between the art of primitive man and the art of the civilized man of the Middle Ages is a difference in the values of their respective religions, not in the degree of their artistic sensibility. It would lead to some curious anomalies if we were to regard the quality of the art of a religious community as in any way a test of the validity or intensity of its religious experience.

¶35. The position is really no different during the complicated period we call the Renaissance. This period is marked on the one hand by a revival of classical humanism, definitely pagan in its ideals, and on the other hand by what we might call a humanization of the Christian religion itself, as expressed, for example, in the lyricism of Fra Angelico and St. Francis. But the paganism of the Renaissance is, for our present consideration, just as much a religion as Christianity. That is to say, the artist in giving expression to the ideals of classical humanism is making his art the servant of an ideal in exactly the same manner as the primitive magician and the Christian artist.

During the course of the sixteenth and seventeenth centuries, humanism loses its idealistic element. Civilization grows more and more materialistic, and the artist finally ends, in the eighteenth century, by becoming either the servant of this materialistic society or simply his own master. In the former case he is in no better

position than the primitive artist; he has merely exchanged one kind of fear for another. The second case brings us to the real issue: can the artist, on the basis of his own sensibility, and without the aid of mass-emotions and traditional ideals—can such an artist, 'good, great and joyous, beautiful and free', create works of art which will hold their own with the greatest creations of religious art?

I am not going to answer that question in any very positive manner. No two persons can agree on what is good art, so it is not possible to make a sheep-and-goat division between religious and individualistic art. Nevertheless, I think it might be possible to agree about one or two relevant observations. In the first place, it is fairly obvious that no artist can work well without the sense of an audience. The theory that art is self-expression will not carry us far; for what is the 'self' that is expressed? The fantasies of the sub-conscious mind? That is the usual answer to this question. But what is the value—the positive value apart from formal aesthetic values, which are common to other kinds of art—of such fantasies? We know very little about the make-up of the sub-conscious mind, but, by its very definition, it can have none of the values attaching to the universal ideals that distinguish civilized man from his primitive forbears. Art is communication, and though it works by and with the sensibility, there is simply no reason why it should not communicate a sense of values. The answer to the question whether great art can exist independently of religion will therefore depend on our scale of values. The court of judgment is sooner or later the community. It would seem, therefore, that the artist, to achieve greatness, must in some way appeal to a

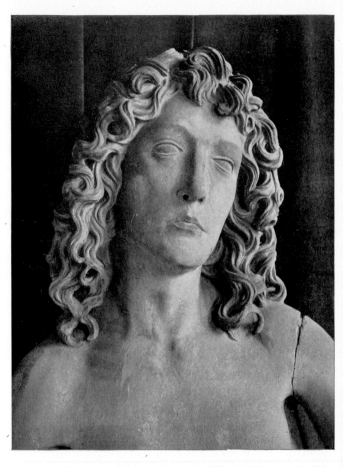

23. Adam. Detail of the stone figure by Tilman Riemenschneider from the Marienkirche, Würzburg. German; 1491-93.

24. Carved wooden mask from the Ivory Coast, Africa. From *Les Arts Sauvages—Afrique* by A. Portier and F. Poncetton.

community-feeling. Hitherto the highest form of community-feeling has been religious: it is for those who deny the necessary connection between religion and art to discover some equivalent form of community-feeling

25. Bowl of peasant pottery. Greek Islands; 19th century. *Victoria and Albert Museum.*

which will, in the long run, ensure an historic continuity for the art that is not religious.

¶36. In any consideration of the elements of art, we should take into account not only the art of primitive man, but also that primitive form of art historically much nearer to us—the art of simple, unsophisticated people generally known as 'Peasant Art'. The name in common usage is made to include too much, and so the significance of the phenomenon is not so clearly recog-

88

nized as it should be. Peasant art is not art made by peasants in imitation of the art of more cultured classes—that is to say, it is not a crude reflection of the art of sophisticated people; much less is it the art that springs from a sophisticated love of simplicity and the simple life. To be precise, the term should be limited to objects made by uncultured peoples in accordance with a native and indigenous tradition owing nothing to outside influences—at least, nothing to the vertical influences of another grade of society; lateral influences from another country are possible, though not often probable.

Peasant art as so defined has various characteristics. In the first place, it is never what an odious distinction calls a 'fine' art; it is always 'applied'. It springs from a desire to impart colour and gaiety to objects of daily use—dress, furniture, pottery, carpets and so forth. It is not regarded by those who practise it as an activity justified for its own sake. In the second place, it shows a surprising tendency towards abstraction—either towards geometric abstraction, as in the rugs of Finland, the embroidery of Rumania, the pottery of Peru; or towards a rhythmical stylization of naturalistic motives, as in the pottery of Central Europe, the carved wood-work of Polynesia, and the embroidery of Czechoslo-vakia. In many cases, for example in the Greek Islands and Italy, both tendencies go hand-in-hand. The explanation of the tendency towards abstraction is to some extent to be found in the nature of the technique and materials of decoration. Certain methods of weaving, for instance, lead naturally to geometric patterns as 'the easiest way out'; the rotation of a potter's wheel, and the use of liquid 'slip' in pottery decoration,

similarly tend towards curvilinear patterns; delicate
needle-work or lace-work is most effective in naturalistic
motives. But direct representational art of the type dear
to the academic artist is almost unknown in peasant art;
the peasant never seems to have found it serve his pur-
pose of making his world a pleasanter place to live in.
He prefers to *add* something to his life, rather than act
as a mirror to its drab actuality.

A third characteristic of peasant art is its conserva-
tism. Of all art it is the most difficult to date with any
accuracy. Simple motives are evolved and persist for
centuries. There is no restless desire in the peasant mind
for novelty; he only asks that an object should be gay,
and he seems to realize instinctively that an infinite
variety of effects can be obtained from the combination
of a very few motives and colours.

But perhaps the most amazing characteristic of
peasant art is its universality. The same motives, the
same modes of abstraction, the same form and the same
techniques seem to spring up spontaneously out of the
soil in every part of the world. I have seen pottery made
in Somerset in the eighteenth century which was almost
indistinguishable from pottery made in China in the
tenth century. The woodcarving of Norway is very near
in style to the woodcarving of the natives of New Zea-
land; there is no essential difference between the samp-
lers of England and those of Bulgaria or Greece. There
are wool-embroidered cloths from the burying-ground
of Egypt that might have been worked by an English
cottager in Queen Victoria's reign. These are casual
examples, and over and above this basic similarity there
exists, of course, an almost endless counter-change of
details; the universal elements lend themselves to the

creation of many individual styles, determined by climate, customs and economic conditions.

Something, certainly, must be conceded to the innate capacities of materials and processes. The peasant, weaving with different coloured wools, will *inevitably* create certain geometrical patterns, and such patterns may quite probably be repeated in different parts of the world at different times without any direct influence. The machine is the artist, and machines repeat themselves. A famous German sociologist, Gottfried Semper, was so pleased with this idea that he made it the basis of a completely materialistic theory of the origin of style and ornament.

The characteristics of peasant art bear directly on any discussion of the nature of art. They reveal that the artistic impulse is a natural impulse implanted in even the least cultured of folk; so much we had concluded from the evidence of Bushman art. But Bushman art did not fully reveal (as Negro art does) the non-representational character of unsophisticated art. It is not abstraction that is artificial, but the photographic bias of the academy picture. It should be noted, too, that peasant art is rarely the expression of a religious mood. There are many objects in peasant art, such as holy-water stoups and icons, that are decorated with religious symbols. But the object in making the work of art is never the religious one of propitiation or sacrifice or even service, but the thoroughly human, everyday aim of 'brightening things up a bit'.

¶ 37. The types of art we have been considering in the last few paragraphs are all universal types—primitive art, savage art, peasant art: their characteristics are not confined to one people or one country. It is in Asia, Crete

26. Head of Amenemhet III. Carved obsidian. Ancient Egyptian; XIIth dynasty (1995-1790 B.C.). From the *Journal of Egyptian Archaeology*.

and Egypt that we first find the emergence of static civilizations and therefore of art that can be described as national, and Egyptian art in particular, because of its long duration and wide influence, may be taken as a national type. During a period of seventy centuries, Egypt has provided economic conditions which make for a continuous culture; and though the Egyptian racial type may have suffered 'sea changes', in this it differs from no other normal type, and can hardly have been so diluted as many other national stocks. Therefore, amidst all its transformations and fluctuations, we ought to be able to discern certain fixed traits due to permanent influences of race and soil; or if these fixities are not present, we must form some hypothesis which will discount such influences in the history of art.

The continuity of Egyptian civilization is doubtless due to economic factors, particularly to the annual renewal of fertility that follows the flooding of the Nile. The fact that this fertility was strictly limited in extent, and at the same time continuous with the river on which it depended, made for an unusual degree of coherence. This coherence was physical and economic, but it was reflected in religion and art. In the art of Western Europe it is possible to see the peculiarities of a decade in the history of art; a century often covers a complete revolution in taste. In Egypt 2000 years can pass without bringing any very obvious change in style. But here it becomes necessary to differentiate between two types of art which have persisted side by side in Egypt; a hieratic art depending on a very exclusive priesthood, and a popular art which developed along with this hieratic art, but entirely independent of it. Unfortun-

ately the survivals of this latter type are very scanty; it has not been sheltered by tombs and temples like hieratic art. But we know that it existed, and that it was more lyrical and intimate than the art of the priests. In the reign of Tutankhamen, a romantic interlude in the history of art in ancient Egypt, this lyrical feeling seems to have invaded the official sphere, and the effect is one of decadence.

¶ 38. It is with the Coptic period, beginning at the end of the fourth century A.D., that we finally get rid of the hieratic principle in the art of Egypt; a democratic religion, Christianity, begins to inspire the democratic art of the people, and lifts it to a plane higher than it had ever occupied before. But though it is a Christian art, part of an attitude towards life that was spreading far and wide in the East and West, the Christian art of Egypt is still Egyptian. Mr. Stephen Gaselee, who contributes an interesting essay on the Coptic period to a survey of Egyptian art,[1] draws attention to the peculiar form Christianity took in Egypt—monasticism. It was not a form that made many demands on art, and Mr. Gaselee does not hesitate to describe the period in general as one of artistic decline. Nevertheless, after fifty centuries of inhuman rigidity, it is with a feeling of relief that one comes across the first signs of decorative freedom, of human fancy, which distinguish the ivory carvings, the textiles and the illuminated manuscripts of the Coptic period. The full development of these tendencies came with the Muslim period, which begins in the ninth century. Cairo was founded in 969. From that time, until the coming of the 'fatal influence' of Euro-

[1] *The Art of Egypt through the Ages.* By various writers. (London, The Studio, 1931.)

27. The miracle at Cana. Carved ivory. Coptic; 6th century A.D.
Victoria and Albert Museum.

pean art in the early nineteenth century, Egypt once more enjoyed a continuous development in art. To say that it was a very great development is perhaps only to express a personal view, but any fair-minded student must accept Captain Cresswell's conclusion, which may be found in the book already mentioned. 'The neglect from which the study of the Muslim architecture of Egypt has hitherto suffered is chiefly due to the rival glamour of the immensely old monuments of ancient Egypt. There are few visitors, however, who can fail to be thrilled by the charm of Islamic art, the splendid façades of the fourteenth and fifteenth centuries, the beautiful forms of its innumerable domes and minarets, and the extraordinary refinement of its ornament.'

It seems at first sight that the art of the Muslim period is the art of a new world, that it cannot have any connection with the art of ancient Egypt. Behind that early art there was a powerful impulse that never made any contact with the life of the people; deprived of that power, the art of the people never rose above a decorative prettiness. But when at last that power was released and became communal, it combined with the latent sensibility of the people at large and gave birth to an art that is one of the supreme aesthetic achievements of the human race.

¶ 39. The Pyramids stand as the eternal symbols of ancient Egyptian art, but we may, I think, question their aesthetic value. A pyramid is a simple geometric figure. The Pyramids themselves are said to gain enormously from their impressive size, from the contrast they afford to the even planes of the desert, from the decisive accents they create in the brilliant sunlight; but all these are adventitious aids, and not essentially artistic. The Pyramids in themselves are wholly rational, and what

is wholly rational (the criticism applies to certain kinds of modern art) cannot entirely satisfy the aesthetic sensibility. It has always been the function of art to stretch the mind some distance beyond the limits of the understanding. That 'distance beyond' may be spiritual or transcendental, or, perhaps, merely fantastical; somewhere it will overstep the limits of the rational. This does not mean that art will outwit harmony; that it must always, in Bacon's phrase, have something strange in its proportion. Gothic architecture is an art that achieves its most transcendental effects whilst obeying geometrical laws as strict as those which control the Pyramids; but in Gothic architecture geometry is the servant of art, and not its master.

¶40. Egyptian sculpture is the most representative of the arts of Ancient Egypt and, particularly in the sculpture of the Old Kingdom, we find a much freer play of aesthetic sensibility than is ever evident in Egyptian architecture. But here again the static quality of Egyptian art is evident, and this age-long torpidity is discerned, not so much in spiritual qualities, as in those unessential conventions appertaining to art which in other countries change as often as social conventions. Such conventions in art arise either from technical necessities, or from artistic inability—difficulties in objectifying visual perceptions. Of the former kind, for example, was a device which originated in the need of supporting the weight of the upper part of the body when modelling in clay.[1] Originally this support was probably a bundle of papyrus stems lashed together and covered with clay—the papyrus being very stiff and firm. When statues were

[1] Cf. *Egyptian Sculpture*, by Margaret Alice Murray, *passim.* (Duckworth. 1930.)

cut in stone, this device, although unnecessary, was slavishly copied in the firmer material. For a decade or two, even a generation or two, such a phenomenon is

28. Ivory pastoral staff head. English; 12th century.
Ashmolean Museum, Oxford.

perhaps understandable. We have had examples of these brief survivals in our own civilization: Samuel Butler pointed to the little protuberance at the bottom of the bowl of a tobacco pipe, a rudimentary organ which survived in briar pipes from a time when it had

served a useful function in clay pipes (it formed a harmless rest for the hot bowl). But in Egypt, rudimentary organs of this kind survived for thousands of years. Of the second type of convention, we may take the habit of putting a front-view eye into a profile face, a convention found in all primitive art. Such a convention is not merely an expression of the artist's lack of skill; it is quite possible that primitive man had an instinctive desire so to represent the human face; it has an odd kind of animation. But while in a nation like the Greeks this convention satisfied the spiritual needs of only one phase of their civilization, in Egypt it was eternal.

¶40a. Of all phases of the history of art, that of Ancient America remains the most mysterious, the least accessible, and we might say the least appreciated of all. In this country comparatively few examples of this art are available to the public, and none of these is of monumental size. Whole aspects of this art are unknown because the objects have perished (brightly coloured feathers, for example, were a characteristic but exceedingly fragile medium of expression) or because they were destroyed by the Spanish conquistadores, the most ruthless vandals the world has ever known.

The historical development of the Pre-Columban cultures of America is still very obscure. Mr. Irwin Bullock tells us[1] that it is now generally accepted that Man first entered America by way of the Behring Straits from North-East Asia, and very gradually migrated southward. The cultures we are concerned with developed in two main areas—Mexico and the adjacent countries

[1] In a foreword to the catalogue of an exhibition of Pre-Columban art held at the Berkeley Galleries, London, 1947.

(Nicaragua, Costa Rica and Panama) and the northern coastal strip of South America (Colombia and Peru). Chronology is guesswork, but in the Valley of Mexico the Archaic Period is supposed to date from about 500 B.C. Tribes and dynasties rose and fell with bewildering frequency, but in the Mexican area there emerged, some time before the beginning of our era, the Mayas, described by Mr. Bullock as 'a notably intellectual people, possessing an elaborate religion and exact calendar system founded upon accurate astronomical observations and an unusual knowledge of mathematical calculations'. But this 'intellectual' people never evolved a phonetic alphabet, did not discover the true arch, or invent the wheel. In the south there emerged, some centuries later, the dominant culture of the Incas, which was still in a state of almost Utopian perfection when the Spaniards obliterated it.

What is of such extraordinary interest in the whole of this isolated historical development is the light it throws on the evolution of art itself. I do not feel myself that foreign influences are altogether excluded—there are certain carved stone bowls from Mexico which have a startling resemblance to Chinese (Chou) bronzes. But such influences must have been very rare and sporadic, and what we have virtually in Pre-Columban art is a *parallel* development of the artistic impulse which affords most illuminating comparisons with the development of the same impulse in other civilizations. In particular, the contrast with our own humanistic tradition is most instructive.

Late Peruvian art shows some exceptions, but broadly speaking we may say of the whole of this art of Ancient America that it never developed an intellectual content.

This fact is probably connected with the failure of this civilization to develop a phonetic script, or, indeed, any literature of any kind. These people were, as far as we can see, without any system of conceptual thought. They could manipulate symbols, as their astronomical calculations prove. They were capable of science, but not of philosophy. They did not *idealize*, and their religion seems to have been an elaborate structure of ritual and sacrifice, and in no sense metaphysical or transcendental. They did not even idealize themselves, as human beings, but everywhere showed a complete contempt, not merely for human life, but for any human emotions. One looks in vain for erotic motives in this art, or for anything corresponding to the maternity motive which plays so great a part in European art. The dominant motive is not love, but fear; and art everywhere celebrates, not life, but death.

All this makes for a certain repulsive quality in Pre-Columban art, but this has nothing to do with its aesthetic qualities. We have to admit, if we allow our sensuous faculties free play, that the art of these cultures is among the most beautiful ever produced by man. Roger Fry once said of an early Mayan statue from Copan (Honduras) which is in the British Museum that he did not know 'whether even in the greatest sculpture of Europe one could find anything exactly like this in its equilibrium between system and sensibility, in its power at once to suggest all the complexity of nature and to keep every form within a common unifying principle, i.e., each form taking up and modifying the same theme'. (*Last Lectures*, p. 87.) The pottery figure from Tarascan (Western Mexico) which is illustrated here (*Figure* 29) is a work of a different order, but here again we have 'the

expression of a sensibility of a very high order', a subtlety of modelling which pervades the whole object and endows it with an uncanny vitality. The Aztec stone masks (over which, it is said, were stretched the skins of human sacrifices) are almost intolerable, so suggestive are they of terror, but again their plastic sensibility is of the rarest and most refined order.

Before we dismiss such art as merely sadistic, we might ask ourselves what a Mexican or Incan of the sixteenth century would have thought of the crucifixions and tortured martyrs which he would have found everywhere depicted in European art of the same period. Indeed, the Christian artist added one refinement which is unknown in the art of Ancient America—a gross realism (the tortured faces of the Ecce Homo, the streaming wounds of the Pietà, the unravelled guts and severed breasts of the Saints). Mexican sadism is intense, but it is also restrained. It is dominated by the aesthetic impulse, and perhaps thereby exorcized. Before we can condemn sadism in art, we must know more about sadism in the human being. We know that it is a typical ingredient of all kinds of mythology and folk-lore (in fairy tales, for example), and though we may recoil in horror from its expression in art, we must nevertheless consider what happens to these impulses if they are not expressed in works of art—discharged, as we might say, into some insentient piece of stone or metal. Art may be sadistic, religious sacrifices may be sadistic, but the people who project their sadistic impulses in this way may be peaceful and affectionate. We know too little about the daily life of these civilizations and too much about our own, to justify any righteous dogmatism in this matter.

It may be that the practice of a disinterested apprecia-
tion of art ('a state of passive receptiveness', as Roger
Fry called it) is not possible for everyone: art's worst
enemy is the faculty of association. But if in art we are
content with the representation in plastic form of ob-
scure intuitions, of repressed instincts, and if these are
everywhere given the impress of the artist's sensibility to
material and form, then we shall find endless pleasure in
the art of Ancient America.

¶41. The origins of Christian art are not easily traced.
We know that Greek influence penetrated eastward to
Persia, India and China, and westward to Italy, Spain,
Germany and even England. We know also that there
was an art common to the northern regions stretching
from Iceland through Scandinavia to Siberia, and we can
trace the southern connections of this art in Southern
Russia, Persia and Asia Minor. Central Asia was a stream
of circulating forces out of which arose the great Christian
art of the West, beginning with Byzantine art and lasting
until the Renaissance, reaching its highest expression
about the twelfth century. Out of the same stream arose
the great art of the East, differing in essentials from the
art of the West—differing, indeed, in the degree that
Oriental religion differs from Christianity. We might
say that wherever the streams of artistic influence went,
they were taken up by the religions they met, and
adapted to the purposes of those religions. We meet the
same artistic conventions in Chinese art and in Euro-
pean art; they came from the same source, but they are
made to serve widely different purposes. Their appeal
to our sense of beauty is still identical.

¶42. The history of Chinese art is more consistent, and
even more persistent, than the art of Egypt. It is, how-

ever, something more than national. It begins about the thirtieth century B.C. and continues, with periods of darkness and uncertainty, right down to the present

29. Pottery figure. Mexican (Tarascan). *Henry Moore Collection.*

century. No other country in the world can display such a wealth of artistic activity, and no other country, all things considered, has anything to equal the highest attainments of this art. It is an art that has its limitations; for reasons which we will presently consider, it

has never cultivated the grandiose, and has therefore never had an architecture to compare with Greek or Gothic. But in all other arts, including painting and sculpture, it achieved, not once but repeatedly, a formal beauty as near perfection as we can conceive.

To the average Westerner, the East has always been the land of mystery, and though modern means of com-

30. Bronze ornament. Central Asian (? Sarmatian); 3rd or 2nd century B.C. *British Museum.*

munication and modern methods of transmitting information, especially the camera, television and the cinema, are making him familiar with the external features of Oriental civilization, its inward spirit still remains strange and remote. When we are concerned with specifically spiritual things—a religion like Buddhism or a philosophy like Taoism—we are generally content to remain outside, perhaps sympathetic but essentially passive spectators of a way of thought and

life which is beyond us. But when we are concerned with material and objective things like works of art—statues and paintings, pottery and textiles—we do not have the same humility. Art, we feel, is an international language, appealing directly to the senses, and we ought to be able to appreciate Eastern art as easily as the art of our own civilization. There is a good deal of vague speculation about the universality of art which encourages this easy confidence, and from the seventeenth century down to the present time Oriental art has periodically been a popular craze, and has even inspired our own artists and craftsmen.

There can be no doubt, however, that these fashions have been based on a complete misunderstanding of the art of the East, not only imitating merely the superficial features of that art, but selecting for imitation and enthusiasm the worst periods and the worst styles. We are slowly learning to discriminate more in accord with the best Oriental taste, and in our museums those ornate and ingenious curios which our fathers admired are being quietly relegated to the background, or buried in the cellars, and the authentic art of the East is being acquired and displayed. But it yields its secret slowly, and one may say that in order to appreciate these works of art to the full, one has to acquire new eyes and a new way of looking at the world. For it may be said that, without exception, the Oriental artist is never looking at the world from our point of view.

To come near to his point of view, we may approach his art from two directions. The first, and perhaps the most difficult direction, is that of technique. European painting, of course, has its technique, and though it has nothing like the historical consistency of the Chinese

technique, it is a difficult discipline to learn. It involves a knowledge of the theory of colours, of the mixing of paints, the preparation of grounds, the different effects that a brush can secure—a complex assembly of practical facts. By comparison the Chinese technique is amazingly simple: it involves the knowledge of the use of one brush and one colour. But that brush used with such delicacy and that colour exploited with such subtlety, that only years of arduous training can produce anything approaching mastery. As is well known, the Chinese normally write with a brush, and a brush is as familiar to them as a pen or a pencil is to us. The first fact to realize about Chinese painting is that it is an extension of Chinese handwriting. The whole quality of beauty, for the Chinese, can inhere in a beautifully written character. And if a man can write well, it follows that he can paint well. All Chinese painting of the classical periods is linear, and the lines which constitute its essential form are judged, appreciated and enjoyed, as written lines.

Now, just as we affect to judge a person's character by his handwriting, the Chinese, with much more science and practice, judge the quality of an artist by the refinement of his line—its infinite expressiveness. So much is fairly easy to understand of the art of painting. But from this art of painting we must proceed to the other arts—sculpture, pottery, bronzes, lacquer—and in each of them we shall find a similar technical quality—a quality of infinite subtlety which reflects the personality of the artist. In pottery, for example, it is found in the *galbe* or outline which the pot makes and in the relation of this outline to the thickness and volume of the pot. As the clay passes through the potter's fingers on the revolving wheel, it is

expressing his sensibility as surely and as subtly as the brush charged with ink expresses the sensibility of the painter. In every work of art there is the personal signature of the artist—not a vulgar self-conscious scrawl, but the well-mannered product of centuries of tradition.

So much for the technical approach to Chinese art. The other approach can only be called the metaphysical approach, and what is difficult to understand and appreciate is the fact that so personal a technique as we have described has to be combined with a content of extreme impersonality and abstraction. It is sometimes said that the Chinese artist attempts to express in his work the harmony of the universe, and some such cosmic phraseology is necessary to describe his aim. In any case, that aim has nothing in common with the usual aim of Western art, which is to represent the particularities of natural appearances. The Chinese painter will, of course, paint representations of natural phenomena: he is famous for his landscapes, and they are the product of careful observation. But they are never merely the particular landscape and nothing more; behind the particular is the general—

> a sense sublime
> Of something far more deeply interfused,
> Whose dwelling is the light of setting suns,
> And the round ocean, and the living air,
> And the blue sky and in the mind of man,
> A motion and a spirit, that impels
> All thinking things, all objects of all thought,
> And rolls through all things.

Those lines of Wordsworth's express more nearly than anything in the whole range of Western culture the spirit of Eastern art. Naturally, that spirit undergoes transformations during the long history of Chinese art;

to the early T'ang artists the spirit that impelled all things was a terrible spirit, to be enclosed in forms of brutal energy, whilst to the later and more sophisticated artists of the Sung period that same cosmic spirit was tender and lyrical.

Throughout its history, then, Chinese art conceives nature as animated by an immanent force, and the object of the artists is to put themselves in communion with this force, and then to convey its quality to the spectator. Such an aim in Western art would lead to all kinds of dubious romanticism and mysticism, but as if by a miracle the Chinese artist is always saved from such troughs of sentimentality. This may be partly due to the highly philosophical nature of the Chinese religions, though artists are not necessarily given to the intellectual discipline that saves the philosopher from sentimentality. But the Chinese artist is given to the technical discipline which I have already described, and in that discipline we must seek an explanation of the integrity and probity of Chinese art even at its most cosmical. If a Chinese artist departed from the intellectual dignity of his tradition, his handwriting would betray him.

In its long history Chinese art was submitted to various vicissitudes. Barbarians invaded the country from the north and west, and introduced for a time an element of their geometrical style. But the most distinctive variations are due to religious influences, to Buddhism and Confucianism. No doubt, as always, these religions gave a tremendous impetus to artistic activities of all kinds. But they also did a lot of harm—Buddhism by its insistence on a dogmatic symbolism, always a bad element in art; and Confucianism by its

doctrine of ancestor worship, which was interpreted in art as crude traditionalism, requiring the strict imitation of ancestral art. But in spite of these limitations, perhaps in some sense because of them, Chinese art maintained its vitality, reaching its highest development in the Sung period, a period which corresponds roughly in time, and even more strikingly in mannerisms, with the early Gothic period in Europe.

¶43. Persia illustrates, perhaps better than any other

31. Tiger in gold. Siberian or Chinese (Han dynasty); perhaps 2nd century B.C. *Rutherston Collection.*

country, the inadequacy of geographical distinctions in the history of art. Since the beginnings of its history in the seventh century B.C. its borders have varied in a most disconcerting fashion; it has suffered repeated invasions, immigrations and emigrations; and for something like fifteen centuries, or about two-thirds of its history, it has been under the domination of foreign rulers. If apart from such considerations we take into account the fact that Persian artists more than any others in the world have possessed the instinct for mer-

32. Cut velvet brocade. Persian; early 17th century. *Victoria and Albert Museum.*

cenary service (like the Swiss in military affairs), the confusion, or possibility of confusion, is complete.

This is not to deny that something definite can be meant by the word Persian when applied to a work of art. But it is not until the fifteenth century, and particularly not until the Safavid dynasty (1502-1736), that the word acquires a precise connotation. Before this time there are great artistic phases in which Persia is involved: there is especially the Sasanian period (A.D. 212-650), which, so far as one can judge from its survivals, was aesthetically the greatest of all; but the more this period is studied the more it is realized that it drew its inspiration from the great reservoirs of Central Asia; and in any case the Sasanian Empire spread far beyond the confines of Persia proper. It would be merely wilful and chauvinistic to see in its characteristic art any racial element retained throughout the later Persian periods, though naturally in such periods the artists adopted many of the conventions of Sasanian art, for an artist will use formal conventions just as a poet will use formal metres. But just as the same metres are found in more than one language, so artistic conventions are common to more than one nation, and are certainly no criterion of nationality.

The Sasanian Empire was destroyed by the Arabs, and very few of its monuments survived their fanatic zeal. A clean start was made with Persia as a province of the Islamic Empire, but the art of this period (661-1258) owes its unity, not to this or that geographical centre, but to the patronage of the Arabian caliphs. Under this patronage the art took on an international character. It is true that the Persians retained much of their independence, especially under the Abbasid caliphs, and

were allowed to practise their own religion on the payment of a poll-tax; but that religion never, like the Christian religion, became the primary force of an art; both under the Arab domination and under the succeeding reigns of Turkish and Mongolian conquerors—that is to say, for a period of eight centuries—the Persians in reality became a race of servile and mobile artists. Their aesthetic sensibility was recognized by their rulers, who were for the most part insensitive themselves, and Persian artists were sent to every part of the Saracen dominions; from the borders of India in the east to Spain in the west and Africa in the south, wherever they went they carried their conventions—their wild fantasy of animal motives, their graceful arabesques and flowery diapers—and where they planted these conventions, an indigenous art, inspired perhaps by local religion or nationalism, grew up and incorporated them. This art we call Persian is, therefore, in a sense the most ubiquitous of all arts; its influence penetrated over the whole of the civilized world. It is also the most elusive of all arts, because it can never be fixed to one period or one place. The most we can say is that the artists of one race were the bearers of it, that they found it in the mysterious plains of Central Asia, and, in the course of their wanderings and influence, made it an international style.

That is, I think, the most important phase of Persian art. Another phase begins with the re-establishment, at the beginning of the sixteenth century, of a 'national' dynasty, that of the Safavids. A national religion was established, and Persia, as it were, turned in upon herself. Now, if at all, we get a national art in the strict sense, and it is with the paintings in particular of this

period that we most often associate the words 'Persian art'. But it is difficult for Westerners to discern the religious element in Persian art, even in the Safavid period, chiefly because we are too accustomed to expect in religious art the anthropomorphic symbols of a religion of humanity. For many centuries these were forbidden in the religions of Persia, with the result that their art was more remote and impersonal than Christian art, and even when the ban on the representation of human figures was no longer in force, even then the decorative tradition was so strong that it remained the controlling motive with the artist. Because I dislike the distinction between the fine and decorative arts, and believe that all art is one, I would rather say that the Persian artist had none of the egotism or conceit which has led the European artist since the Renaissance to create a medium of expression independent of the common needs of men. The Persian artist was primarily a maker of useful things—of pottery and metalwork, of textiles, illuminated books and scientific instruments. Those who look for 'human interest' in Persian art will be greatly disappointed; but what they will find are the works of one of the most sensitive and cultured races that the world has ever known, and the fact that these works take the form of familiar everyday things is one of the most profound lessons that the Western world can learn.

¶44. The Byzantine period is the vaguest of all historical periods in general conception and in particular treatment; one might almost say that the term has never been properly defined. Until quite a few years ago, Byzantine art was the art of the Dark Ages—almost non-existent except to a few archaeologists.

33. The Annunciation. Miniature mosaic. Byzantine; 13th – 14th century. *Victoria and Albert Museum.*

Ruskin, it is true, had praised it for its colour, and I think it must be admitted that all our present enthusiasm for Byzantine art springs ultimately from Ruskin's original sensibility. But Ruskin, still fast bound to classical standards of beauty, could only praise Byzantine art half-heartedly. He could pay full homage to its sensuous wealth of colour, and to the unified, aesthetic impression that it was capable of achieving. But in the end he had to criticize its barbarity; it was merely a half-way house between Greek clarity and Gothic transcendentalism.

We can no longer look on Byzantine art in that way. We are no longer so prejudiced by classical standards; we also have too much evidence of positive will and actual achievements in Byzantine art to regard it as merely a compromise between various extraneous influences. As a first consideration, let us take its historical vitality, its mere duration as an effective style. The Emperor Constantine laid the foundations of his new capital on the Bosphorus in the year A.D. 330, and that may be taken as a sufficiently precise date for the beginning of the Byzantine period in art. Constantinople was finally taken and sacked by the Turks in 1453. Not less than these eleven centuries will suffice for the history of Byzantine art; for even before 330 various influences were converging to form the style, and for two or three centuries after the fall of Constantinople the style survived in Russia and Greece. From the seventh to the twelfth centuries it may be said to have been at its zenith, and it is within this period that we find its purest manifestations.

It is Gibbon, with his false emphasis on decadence, and his inability to appreciate Christian values, who

more than anyone else has retarded the true apprecia-
tion of Byzantine art. It is also curious that the apolo-
gists of Christianity, who have been willing enough to
glorify Gothic art because it corresponded with the
worldly glory of the Church, should not have enquired
into the arts that accompanied the rise and early
vigour of this same Church. Both in its early develop-
ment in the Near East and in its gradual pervasion
throughout the Mediterranean world, Byzantine art
went step by step with Christianity, and it is as a re-
ligious art that it must primarily be considered. It is the
purest form of religious art that Christianity has ex-
perienced, for Gothic art soon became tinged with
humanism, and what is human cannot be wholly divine
or sacred. Byzantine art is sacred art, and though a good
deal of it was made to the glory of the Emperor rather
than to the glory of God, yet, by virtue of the dogma of
divine right, the earthly glory was seen as a steady re-
flection of the heavenly.

It is possible to insist too much on the religious, the
dogmatic, or the hieratic quality of Byzantine art, for
these qualities can be understood without any exercise
of real aesthetic sensibility, and we shall then be in
danger of a purely pedantic and intellectual apprecia-
tion. It is better to insist on the 'lyrical' character of
Byzantine art—better to rely on its direct sensuous
appeal, whether of form or colour or of that more inde-
finite quality which we sometimes inadequately call
'atmosphere'. No art (except certain kinds of Oriental
art, to which Byzantine art is nearly related) can so
move us with an irrational command of our instincts.
The mood in us is perhaps prepared by our readiness to
consider this art in its integrity, and free from predis-

positions foreign to its essence. But granted that mood, we surrender to this art with that immediate joy-in-perception which is the first and final sanction of aesthetic experience.

¶ 44a. Celtic art is one of the most intrinsically interesting phases in the whole history of art. By various historical accidents, the extreme Northern parts of Europe —Ireland, Scotland, Iceland and Northern Scandinavia —became the preserve of an indigenous prehistoric style. This style, which originated in the Middle Rhine area, was brought to the British Isles by the retreating Celtic tribes, and here preserved its characteristics whilst successive waves of tribal invasion swept across the rest of Europe.

The development of European art during the so-called 'Dark Ages' (A.D. 400 to 1000) is extremely complicated, and Celtic art is involved in the general uncertainty. But in spite of the rarity of survivals from the period, it seems certain that the early Celtic art of the pre-Roman period survived as a continuous tradition in Ireland until a new influence appeared in the North in the form of Christianity. In Britain, the introduction of Christianity was a very slow process, lasting over a period of 200 years at least. There is but slight evidence of the prevalence of Christianity in Britain during the Roman period; its real history in this country begins with the mission of St. Ninian, a disciple of St. Martin of Tours, who built a church at Whithorn, Wigtownshire, in A.D. 412. Not long after, Ireland was converted by St. Patrick, and during the sixth century the process of conversion spread to Wales, to the Picts in the north of Scotland, and then to the Saxons in England. During the sixth and seventh centuries this northern church became the shelter of Christianity in Europe; and at this period,

one of the most important and significant for the whole
development of art in Europe, direct contact was esta-
blished between the North and the East. As a recent
historian of the Celtic Church has expressed it:

'Through what St. Ninian derived from St. Martin,
who received the benefit of St. Hilary's Eastern experi-
ences, the Church that became the Church of Scotland
was also made familiar, from the beginning, with East-
ern texts of the Scriptures, Eastern forms of prayer and
praise, as well as Eastern missionary methods.'[1] And
made familiar, we may add, with Eastern types of art.

The whole range of Celtic art therefore divides itself
into two distinct periods—the early, pre-Christian period,
deriving its style direct from the Neolithic Age, and the
later post-Christian period, during which stylistic influ-
ences from the East were incorporated. Dr. Mahr, in his
book on *Christian Art in Ancient Ireland* (Dublin, 1932),
has subdivided this post-Christian period into (1) the
Vernacular style, from the seventh century to the ap-
pearance of the Vikings about 850; (2) the Hiberno-
Viking style from 850 to 1000, the period of Viking
domination in Ireland; (3) the last animal style, from
1000 to 1125; and (4) the Hiberno-Romanesque style,
1125 to the Anglo-Norman Conquest.

The ornament of the early Celtic period is linear, geo-
metric and abstract; the type most familiar is the inter-
laced ribbon or plaited ornament vulgarized in present-
day 'Celtic' tombstones. It is seen in all its purity in the
Book of Kells, the eighth-century manuscript belonging
to Trinity College, Dublin (*Figure* 34). The real nature
of this ornament has been well described by a German

[1] *The Rise and Relations of the Church of Scotland.* By Archibald B.
Scott, M.A., D.D.

historian of art, Lamprecht, in the following words:

'There are certain simple motives whose interweaving and commingling determine the character of this ornament. At first there is only the dot, the line, the ribbon; later the curve, the circle, the spiral, the zigzag, and an S-shaped decoration are employed. Truly, no great wealth of motives! But what variety is attained by the manner of their employment! Here they run parallel, then entwined, now latticed, now knotted, now plaited, then again brought through one another in a symmetrical checker of knotting and plaiting. Fantastically confused patterns are thus evolved, whose puzzle asks to be unravelled, whose convolutions seem alternately to seek and avoid each other, whose component parts, endowed as it were with sensibility, captivate sight and sense in passionately vital movement.'

I have described the significance of this non-organic, super-natural type of art in ¶ 32. It is a mode of expression in direct contrast to the classical mode, which is organic, naturalistic, serene and satisfying. The significance of the Northern mode lies precisely in its life-denying qualities, its completely abstract character; and in this character, these qualities, we must see a reflection of the spiritual life of these Northern people—'the heavily oppressed inner life of Northern humanity', as Worringer has called it.

Into this gloomy and abstract field of art the symbols of Christianity come like visitants from an exotic land. In a prickly nest of geometrical lines, two birds of paradise will settle, carrying in their beaks a bunch of Eastern grapes. David comes with his harp, and the three children in the furnace; Adam and Eve, and the sacrifice of Isaac, are represented in panels reserved

34. Illuminated page from the Book of Kells. 8th century.
Trinity College, Dublin.

among the bands of abstract ornament; and finally the stone is dominated by Christ in Glory and the company of angels. Such stones still stand where they were erected centuries ago in Ireland and Scotland; and no monuments in the world are so moving in their implications; they symbolize ten thousand years of human history, and represent that history at its spiritual extremes, nearest and farthest from the mercy of God.

¶45. The great phase of art in which Christianity reached its supreme expression is the last phase in our history to possess the characteristics of universality; Primitive, Classical, Oriental and Gothic—these are the only universal types of art. The rest, so far, are derivations from these types. Roman art can only be regarded as a late imitative phase of Greek art—a phase devoid of the vital organic rhythm of the source from which it comes—expressing, not joy, but satisfaction; not equilibrium, but force. It was on the basis of Roman art that the study of aesthetics was first established; it is no wonder that so much art is now incomprehensible to us! The Renaissance was an attempt to throw off the northern elements in Christian art and to revert to the classical type. It was the expression of a certain pagan phase of culture in Europe—an age of princes who preferred luxury to asceticism. But such is the influence of a period or phase on the artists who are born into it, that even those artists whose inspiration remained religious expressed themselves in the predominant fashion. This brings us to a very interesting problem in the history of art—the relation of the individual artist to the general ideals of his period. There are three cycles involved; the period, the generation, and the individual. How do they interact and which is the strongest motive force?

35. Abraham's sacrifice. From an illuminated psalter. English;
about 1175. *Hunterian Museum, Glasgow.*

¶46. It may be suggested briefly that the characteristics of a period are determined in the main by material forces—racial, climatic, economic and social. To illustrate this point in a most elementary manner, a country in which wood is plentiful will develop a wooden architecture and the minor arts connected with wood will reach a high standard of development—as in Scandinavia. Where marble or other suitable stone is plentiful and easy of access, the art of sculpture will develop. But these material causes can never wholly explain the rise and development of a period in art: matter is always the vehicle of spiritual forces. A Gothic cathedral is not merely a building of stone; it is also, in Professor Worringer's striking phrase, 'transcendentalism in stone'. There has been more than one attempt to explain the evolution of the Gothic cathedral in mechanical terms; two round arches crossing make a vault, the ribs of the vault are strengthened and suggest the pointed arch, the pointed arch suggests a means of attaining a greater height, which in its turn involves an external buttress, and the buttress involves a pinnacle, and so on until you have resolved the whole cathedral into a series of solutions of problems in engineering, all starting from the simple accident of crossing two round arches. But that does not explain the overwhelming impression that meets you as you enter this same cathedral; then you are in the presence of a unity that is spiritual, and your feelings are roused by a sense of beauty that includes more than the solution of an engineering problem.

¶47. Gothic art grew out of Romanesque art, and Romanesque art was, superficially at any rate, an adaptation governed by northern sensibility, of the elements

of ancient Eastern art. It may be said that the tendency of Romanesque art as it developed into Gothic, and of Gothic art until it reached its zenith, was to become more and more northern in character. That, after all, is what one would expect, but the process was infinitely complicated by another factor—the Christian Church. That Church was, during most of the Gothic period, in a very real sense universal. It was not only one Church, but its officials spoke one language and were, for all practical purposes, interchangeable throughout Europe. This held true, not only of high dignitaries like bishops, but also of humbler clerks, and especially of those endowed with some special gift useful in the propagation of the Gospel. This internationality of the Church involved a tendency towards the standardization of Church art, especially since the Church was inclined to lay down very definite rules from time to time as to the manner in which religious subjects should be treated. There existed, therefore, all through the Gothic period the hieratic art of the Church, tending towards symbolism, intellectuality, conventions of all kinds; but there also existed a subterranean art which was the art of the common people, vigorous, unlearned, even barbaric. The Egyptian pattern was repeated. Many of these lay artisans were, of course, employed under the direction of the clerics, and they had to conform to the instructions given to them by their high-brow masters. It was only when they got out of sight of the clerk of works, and were free to follow their own impulses, that they indulged in those delightful fancies which we can often find in some inconspicuous corner of a cathedral. ¶48. I make this distinction between a hieratic and a popular Gothic art because I think that it is in the latter

that we shall find the unadulterated northern element which was at work all the time modifying foreign forms to native needs. Unfortunately, though little enough survives of Gothic church art, practically nothing at all can be found to represent the popular art of the Middle Ages. It was never regarded as art and never valued as such. In material and finish, mediaeval pottery has none of the qualities normal to works of art; it is crude and unsophisticated. But in the rhythmic force of their outlines, in their suggestion of mass and volume, in the direct statement of formal values, I know nothing to compare with the best earthenware vessels of the Middle Ages except certain pottery and bronze vessels of the Chou dynasty in China (1122-255 B.C.) and certain pieces of Negro sculpture. Extremes meet: in these objects we have only the simple expression of a will to form. In the dumb dismembered statue illustrated in *Figure* 36, all the grace and transcendent spirituality of a great religion are embodied in stone. And yet the pottery is not unworthy of such sculpture. We may go further and say that without the capacity to make the pottery, the age could not have achieved the sculpture. One is elemental and simple, the other spiritual and complex; but both possess that formal unity without which no art is possible.

¶49. The indigenous popular art of England never gained an ascendancy over the art of the Church in the Middle Ages, but nevertheless profoundly modified it. As this process of leavening went on, the hieratic art tended to lose its international character, and to take on local peculiarities. During the twelfth and the thirteenth century, it is almost impossible to distinguish between the arts of France and England. But gradually

36. Stone figure. English; late 13th century. *Winchester Cathedral*.

minute differences become accentuated; style, which had been an impersonal thing, becomes individual. A quality I can only describe as sweetness creeps into English art—a tender perception of the beauty of intimate things (leaves, tendrils, flowers, animals and children). Later this tendency ran to seed in sentimentality, but while it lasted, seasoned with realism and humour, it was something unique in the evolution of Western art. But of this art hardly a single work survives unscathed. Our cathedrals are mournful shells of their former magnificence; churches that were jewels of intimate beauty are now bleak and desolate conventicles; and what English painting, English poetry, English music and dancing lost by that dreadful and vindictive plague of the spirit known as Puritanism, even the imagination cannot conceive.

¶50. The art of the Italian Renaissance is such a vast subject, and has been so often and so thoroughly dealt with, that only the briefest reference will be in place in these notes. Let that be a plea for intimacy. We are intimidated by the countless canvases of the Italian masters, and in a real danger of reacting so violently from our boredom, that we shall close our minds to the unique experience of Italian art. We can begin in a small way, without this risk, if we confine ourselves to the drawings of the Italian masters. We are thus in more direct contact with the personality and skill of the artist. A painting has so often been retouched, if not repainted; its colour has inevitably faded; time has dropped a veil over its freshness. Even if it did not suffer from these incidental defects, the plain man may well feel a little overawed in the presence of a masterpiece into which the artist has put all his intelligence and skill. A picture

37. Virgin and Child. Marble relief by Agostino di Duccio. Italian;
15th century. *Victoria and Albert Museum.*

like Piero della Francesca's 'Flagellation' (*Figure* 17) calls for more than a simple sensuous reaction if we are to get the best out of it; it calls for an intellectual analysis. We want to know what was in the painter's mind, why he subordinated the actual scene of the Flagellation to the three mysterious figures in the foreground, how, in spite of its oddities, the picture succeeds so amazingly well in conveying the form and atmosphere it intends. But in a drawing we are puzzled by none of these questions. We are in direct contact with the sensibility of the artist, and we are thrilled by that very fact.

¶51. There is more, however, in the drawings of the Italian masters than this appeal to sentiment. One may legitimately speak of the art of drawing, meaning to imply that drawing is in itself a distinct art, and not merely a preliminary to painting. Ruskin once commented on the fact that in all the galleries of Europe you will not find a single childish or feeble drawing by one of the great masters—all are evidently masters' work. And he gave the explanation that while we moderns have always learned, or tried to learn, to paint by drawing, the ancients learned to draw by painting. 'The brush was put into their hands when they were children, and they were forced to draw with that, until, if they used the pen or crayon, they used it either with the lightness of a brush or the decision of a graver. Michelangelo uses his pen like a chisel; but all of them seem to use it only when they are at the height of their power, and then for rapid notation of thought or for study of models; but *never as a practice helping them to paint*.' The words I have emphasized seem to me to indicate the essential condition of an understanding of these old

masters' drawings. They constitute a separate art, distinct from painting, ancillary to it in that they provide a means of rapidly noting moments of vision or of

38. Study of a horse. Drawing by Pisanello (1397/9-1455). *Louvre, Paris.*

thought which can later be translated into painting, but having no immediate relation to the process of painting. We do not regard shorthand as a useful preparation for the art of writing.

¶52. The charm of a great master's drawing is partly the extraordinary skill and sureness of its execution; the pen or crayon is being used with a delicacy which, as Ruskin says, is the delicacy of the more habitual brush. There are other qualities which are purely qualities of line: the element of decisiveness, due to the fact that the stroke of the pen or crayon is swift and irrevocable; the instinctive selection of the few essential lines; the dependence on rhythm instead of structure. Drawings differ, of course, in their aim, and therefore in kind; they vary from the rapid seizing of some aspect of life, some sudden flash of vision, as in Carpaccio's snapshot of a 'Procession', to the accurate and exacting study of some detail, as in Pisanello's studies of animals (*Figure* 38). But all these varieties of drawing have in common a certain concentration of vision. The artist, and in his turn the spectator, is looking at one thing at a time. Most paintings involve a dispersal of attention: we look first at the figure on the left, then at the group on the right, then at the landscape in the distance, and at the bridge in the landscape, and finally light with a sense of triumph on the minute figure of the donkey crossing the bridge. We inevitably analyse an organized painting. Then we try to synthesize—to relate in some general structure all the details which the roving eye has gathered together. We find linear rhythms, spatial balance, harmony of colour. The success of the picture depends upon its final fusion or cohesion in the mind of the spectator. Actually, of course, the process is much more instinctive and swift than a clumsy description of it in words would imply. And there are paintings in which the vision is as concentrated as it is in any drawing—just as there are complicated drawings which require as much analysis

as a painting. But normally the drawing has this distinction, that it is the complete realization of a fragment of life—a fold of drapery, the profile of a face, the contour of a muscle, the structure of a flower: it is this, and it is also the clearest signature that the artist has left us. A study of drawings is not only the necessary basis of all scientific art criticism; it is the best training for the private sensibility. The distinctive mannerisms of the artist are most clearly revealed in his drawings, and this is particularly the case with the great Italian masters. Their drawings are leaves torn from their commonplace-books, and in his commonplace-book a man writes (or did, until it became fashionable to publish them) only his intimate thoughts. He has no consciousness that the world is looking over his shoulder. He writes, or draws, to please himself, to explore the recesses of his own mind. We feel this to be true particularly of those great artists of the Renaissance whose minds were consumed by intellectual curiosity: of Leonardo, who was equally interested in a unicorn and a foetus, a cannon foundry and a wild flower, a human face and a fold of drapery: of Signorelli and Pollaiuolo, always trying to arrest the moving figure in some significant attitude; of Michelangelo, testing the solidity of some aspect of the visible world. So enticing is this art of drawing, that the danger is we may never turn to what is the primary work of the artist, his painting or his sculpture. That is why it is so important to realize that drawing is a distinct art, and that when we pass to painting or to sculpture it is to discover a different set of values.

¶ 53. Another approach to the art of a period like the Italian Renaissance is by way of modern sensibility. In what order shall we range those famous names, Leo-

nardo, Raphael and Michelangelo? Every age has its own order, depending on the temporal phases of its sensibility. What is the quality in Uccello's art that makes it so appealing to modern sensibility, and does he share this quality with other artists of the Renaissance? What distinguishes this quality from the traditional standards by which art has been judged?

Uccello is often called the discoverer of perspective, but, if not qualified in some way, this claim is rather absurd. Uccello did not discover perspective, but he was perhaps the first artist to take a conscious delight in its potentialities. He deliberately used perspective, not merely to give verisimilitude to his painting, but to build up his design or pattern. 'The Rout of San Romano' in the National Gallery is a good example of his method: the main balance in this picture is that between the receding line of upright lances and the receding folds of the distant landscape. In keeping with this conscious use of perspective is a deliberate and somewhat arbitrary use of colour. We feel that Uccello is definitely using colour for its decorative effect, even if this use defeats the realistic effect. This is evident in the charming 'Hunting Scene by Night' in the Ashmolean Museum, Oxford.

The quality, then, that distinguishes Uccello is a certain conscious use of the means at his disposal. He was not, that is to say, an artist who painted subjectively, at the dictation of his feelings: he painted consciously, deliberately, according to a pre-determined intellectual scheme. He shares this quality with certain other artists of the Italian Renaissance—with Andrea del Castagno, with Cosimo Tura, and above all with Piero della Francesca. These artists have profoundly

different perceptions, but all are distinguished by what might be called an *a priori* method. Piero della Francesca, indeed, might be called the first Cubist, and a painting like the 'Flagellation' at Urbino has a perfectly geometrical structure of recessed cubes. Piero is a precursor of modern sensibility: an artist who gives his sensations a predominantly intellectual organization. That this is no mere modern fancy is indicated by the fact that he was actually the author of a treatise on geometry.

It is this intellectual quality in painters like Piero della Francesca and Uccello that constitutes their appeal to modern sensibility. For the main tendency of modern art, in spite of certain expressionistic excesses, has been towards a re-integration of the intellect. That is why, contrary to the expectations of the great majority of art critics, abstract art still survives, and is the formal method of contemporary artists such as Ben Nicholson and Naum Gabo, who may reasonably be regarded as typical exponents of modern sensibility. But what is meant by the re-integration of the intellect? Merely the right to use the intelligence as a basis for art. Intellectual concepts can never be regarded as the primary material of art; nor can the unorganized emotions of the subjective painter. In painting, as in poetry, concepts or emotions serve rather as points of departure for that complete organization of sensibility which is the work of art. That organization is either deliberate or instinctive; in either case it is a complete whole capable of engaging the whole range of our feelings.

¶54. Between the idealism of the Renaissance and the intellectualism of to-day we find various phases of

39. Tunny-fish in glass. Venetian; 17th century. *Victoria and Albert Museum.*

fantasy and realism. Realism is one of the vaguest terms in the vocabulary of criticism, but that does not prevent its very frequent use. It is curious, however, to observe that it has never been the accepted label of a school of painting. The word has perhaps most exactitude in philosophy, where, either as historically the opposite to nominalism or, more generally, as a name for a certain theory of knowledge, it indicates a belief in the objective reality of the external world. Literary criticism no doubt first borrowed the term from philosophy, and immediately the use of it became inexact. A realistic writer is one who professes to avoid any selective bias in his transcription of life, giving us the scene or the character as the eye sees it. But actually, as all art involves selection (if only for reasons of space and economy), the realistic writer is generally one who emphasizes a certain aspect of life, that being the one least flattering to human dignity.

Art criticism is still further removed from philosophical exactitude, being in its origins and development but an extension to art of the categories of literary criticism. The kind of art which we might strictly call realistic would be one that tried by every means to represent the exact appearance of objects, and such an art, like a realistic philosophy, would be based on a simple faith in the objective existence of things. The Impressionism of the nineteenth century was such an art, but actually the Impressionists united a scientific realism of method with a somewhat idealistic view of life which might be described as lyricism. For realism in the generally accepted sense we must go to the Netherlandish School of painting, particularly as represented by Rubens and Pieter Brueghel.

137

¶55. In a paper read to the International Congress on the History of Art, held at Brussels in 1930, Monsieur Georges Marlier made a distinction which clarifies matters a good deal. He distinguished between realism understood as the 'textual' or literal imitation of the real and realism understood as the representation of scenes from low life. In referring to the realism of Flemish painting most people will almost unconsciously assume the former sense to be meant. But as Monsieur Marlier showed in a review of Flemish art from the fifteenth century to the present day, such a conception of realism has rarely existed. Flemish art has been marked by the persistence of a definite tradition, but whether we think of the fifteenth century, with its submission to the arbitrary conventions of mediaevalism, or of the strain of fantasy that characterized the sixteenth century, or of the 'homeliness' of Rubens, Jordaens, and their followers, or of the strange visionary style of more recent painters like James Ensor and Frits van den Berghe, we are compelled to admit that nowhere does the Flemish tradition aspire to a literal transcription of the visible scene. What it does lack is the pomp and elegance of courtly art; it is rather the art of a bourgeois people, dictated by bourgeois needs and bourgeois aspirations. It is interesting to take a commonplace subject like the Adoration of the Magi and to compare the treatment of it by typical artists of the Italian and Netherlandish Schools. Take, for example, the fine rendering of the subject by Vincenzo Foppa, in the National Gallery. The Virgin herself is represented as a type of ideal woman, extraordinarily dignified and serene; the Magi are types of veneration, valour and chivalry; the very grooms and attendants are sweet or noble in their pro-

portions. Turn now to the same subject as treated by the Netherlandish School. There is the famous altarpiece in the National Gallery on which Mabuse has lavished all the richness and exuberance which a period of luxury could desire. And yet the Virgin is here no longer an ideal type, but recognizably a Flemish housewife; the Magi are noble enough, but their features, evidently studied from the model, betray the cares and common lusts of life; there are angels suspended in adoration above the holy group, but below, right in the fore-ground, is a broken pavement, and two curs, one gnaw-ing a bone. Mabuse is exceptional in his country for his magnificence; when we come to a painter like Pieter Brueghel or Hieronymus Bosch, there is no longer any compromise with idealism of any sort. The figures are not merely taken from life: they are deliberarly selected from low life (*Figure* 41). The scene is squalid in its setting; the group is made up of men as gross and as unintelligent as may be.

What is behind a gesture like this of Brueghel's? Per-haps no more than a stubborn common-sense. Brueghel was a peasant himself; so were Joseph and Mary, and all about them. Brueghel wished to affirm that fact: and he realized that in affirming the fact he magnified the deed. The pathos, the charity and the glory of this scene are nowhere so evident as in this deliberate adherence to the ideal of realism. For realism, in the end, is an ideal: it is the only ideal which is without an element of condescension towards mankind.

¶ 56. But we need still further refinements of definition before we can fully appreciate the tradition of Flemish painting. For example, the word 'naturalism', which might be brought into service, is soon found to be

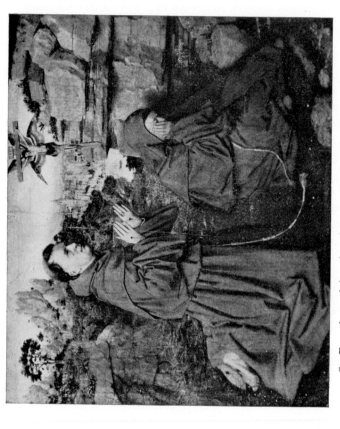

40. St. Francis receiving the stigmata. By Jan Van Eyck; about 1438.
Pinacoteca, Turin.

quite inadequate to describe the intention of the early masters of this school. Our paradox might perhaps be made a little more precise by saying that in this art the *actual* is the ideal. A painter such as Van Eyck or Memlinc does not, like his Italian compeers, abstract types from the actual or natural world until he reaches a highest common denominator which is the ideal. He boldly takes the typical in the sense of the commonplace, and by a process which can only be described as 'loving care' he so studies and depicts his subject, that it becomes in all its lowliness the highest expression of the painter's idealism. Jan Van Eyck's painting of 'St. Francis receiving the Stigmata', belonging to the Pinacoteca at Turin (*Figure* 40), may be taken as an illustration. The picture may be dated between 1430 and 1440. For its period, the landscape background is extremely detailed and naturalistic; in the actual painting every frond of a fern or petal of a flower is carefully represented. Yet the landscape as a whole is an ideal unity carefully composed for the occasion; it is the actual made ideal. But turn to the figure of St. Francis himself. If the painter had been a realist in the ordinary sense of the word, we should expect a dramatic attitude, features all contorted with pain or ecstasy, livid wounds. But here we have, not indeed a waxworks' saint deprived of all psychological significance, but a calm and living image most evidently a portrait of an actual person.

The same point could be illustrated by any of the great masterpieces of early Flemish art; by the famous altarpiece by the Van Eycks in Saint Bavon, Ghent; by the less famous but perhaps greater masterpiece of Jan Van Eyck at Bruges—The Virgin with St. Donatian and St. George, where the Virgin is any work-a-day

wife and decidedly ugly, the child on her knees rickety and under-nourished, St. George a rollicking young soldier, and the donor, a certain George van der Paele, who kneels between St. George and the Virgin, one of the most 'actual' portraits in all European art; and after Van Eyck, we can turn to Memlinc, an even greater painter, in my opinion, because in some ways more profound; but one also who painted the actual, because he found he could by that means best express the ideal. The Flemish painters seem to assert that the divine can only be discovered in the midst of humanity. Brueghel the Elder perhaps carries this paradox to its extreme limits, and in his 'Flight into Egypt', in the Antwerp Gallery, the figures of Joseph and Mary are hard to distinguish among the crowd of travellers besieging an inn. Similarly in his 'Fall of Icarus' at Brussels, which was one of the memorable pictures at the London Exhibition of 1930, the canvas is mainly occupied by a man ploughing in the foreground, and a ship in sail on the sea; the luckless Icarus scarcely frets the waves at the foot of the distant cliffs.

With the Brueghels, as with Hieronymus Bosch who went before them, and was their inspiration, we are in the presence of a further refinement on realism. The realism has become fantastic. Just as in one direction, starting from the actual, we can reach an abstraction which is the ideal type of all actuality, so in the opposite direction we can reach a type which is the denial of all reality—an inverse ideality, a nightmare of extremes, of all possible distortions that can be imagined on the basis of actuality. The tendency of pictures of this kind is to become merely anecdotic or encyclopaedic, and Brueghel as a matter of fact did paint pictures which

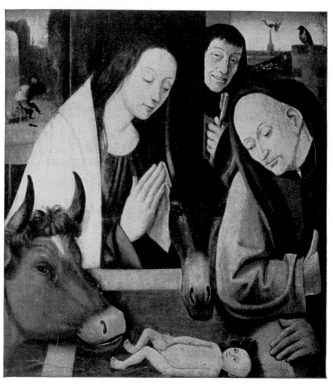

41. The Adoration of the Shepherds. By Hieronymus Bosch (1460-1516). *Musée des Beaux-Arts, Brussels.*

gathered together on one canvas a collection of popular legends or proverbs.

¶57. Rubens, who can be seen at Antwerp as nowhere else, is the culmination of the Flemish tradition and its greatest representative. He is something more—a very significant figure in the history of art, and a little confounding to all romantic notions of inspiration and genius. With Rubens we may safely venture on the question of the banal in art.

'Too much of a good thing' is merely another way of saying 'boredom', and most people, if pressed, would admit to being bored with Rubens. It is the tragedy of great artists who give their life to the production of an immense series of works, that they end by defeating their own aim. It may be our own weakness, but we give our hearts to Piero della Francesca or Vermeer of Delft, whose works are few in number and uniform in excellence, and at the best we give but a cold admiration to a superman like Rubens, whose works number something like 1500 and whose excellence is so varied that while his best pictures are among the greatest that have ever been painted, his worst are so bad that they can hardly be distinguished from those of his pupils and imitators. If we had only the fifty greatest masterpieces of this painter, we should not question his supremacy; having fifteen hundred, we are not satisfied because the last of them is not perfect.

All this is perhaps obvious enough, but it is necessary to state the obvious in order to deny it. Not only the greatness of Rubens as a painter, but his significance as a representative genius, depends on this very quality of easy abundance. He began life as a page-boy at the age of fourteen; at seventeen he was studying painting, and

at twenty had already acquired a mastery of the art. He travelled in Italy for about eight years, and although he no doubt picked up many ideas there, he had little to learn that was essential to his genius. Eugène Fromentin, whose *Maîtres d'Autrefois* contains the best pages ever written on the subject of Rubens, sums up the matter in a neat sentence. On his return, he says, 'on lui demande à voir ses études, et, pour ainsi dire, il n'a rien à montrer que des œuvres'. He never hesitated on his triumphal progress. However much we may regret his lack of self-criticism, it is to that he owed his surety. He was quite simply a man of action, and he painted as other men fenced, or fought, or made business. Quite frankly, art was his business. Once established, he had his fixed price, and the kind of picture he painted depended on the amount he was paid. He did not vary his quality—not consciously—but the size and complication of the picture were strictly determined by the contract.

Nor did he confine his activities to his painting. In this, too, he is a sharp contradiction of all romantic theories of genius. As is well known, he was a considerable diplomatist, the accredited representative of his country in many delicate affairs, and always as triumphant in this rôle as in his painting. He lived a private life of luxury, or, rather, of largesse; he needed ample space, comfort, possessions. And yet, again to the discomfort of romantic notions, he was strictly regular in his habits; faithful to his two successive wives, simple and straightforward with his friends, a kind father to his large family. 'Sa vie est en pleine lumière,' says Fromentin so well again; 'il y fait grand jour comme dans ses tableaux.' There is nothing to question or suspect in

this open life, Fromentin concludes, except the mystery of its incomprehensible fecundity.

Of his paintings, it is impossible to say anything very original. I can only underline a few facts which have probably been observed scores of times before. There is, in the first place, the astonishing impress of his personality, evident already in his earliest works, before he went to Italy, and still the same in his last work, painted when he was more than sixty. 'Personality' is one of those words so often creeping into criticism which are badly in need of definition. But without defining it, we can recognize it; we can say that a predilection for such and such a range of colours, for such and such a type of physiognomy, for such and such a form of composition —that these things express the unity of being which every man of genius must achieve. In Rubens this unity is so secure—he is so sure of his gait and his goal—that he cannot do wrong; every stroke of the pencil and brush expresses the man in his balance and progression.

Then there is some quality which I can only come to by defining it negatively. It is a certain lack of idealism, at times of intensity. He had the sense of glory— the sense of a certain grandeur in the expense of spirit. He knew that in the end the life of the mind is the life of the body, and that all mental life is vain that is not able to transform itself into bodily activity. But there is no 'message' in that doctrine—no comforting fantasy, no blinding legend, no escape from life.

So we see that Rubens links up with that general characteristic of Netherlandish art which I have already distinguished: the actual is the ideal. But Rubens carries this characteristic on to a higher plane. A painter like Memlinc is interested in his subjects because

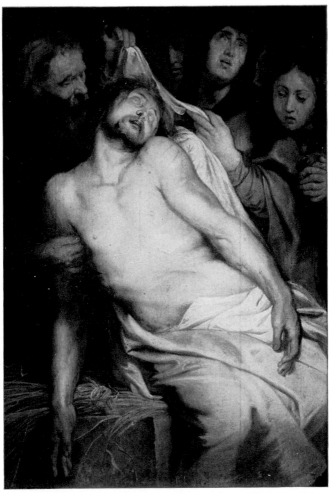

42. The Dead Christ. By Rubens (1577-1640). *Musée Royal des Beaux-Arts, Antwerp.*

he knows that in spite of their holiness they were men like us. Rubens seems to say rather that these saints are holy, these men are famous, just because they were men. To use his wife, Helen Fourment, as a model for the Virgin was not a gesture of worldliness, or scepticism; it was merely a banality—a statement of the factual. It was a realization that the greatest moments of life come, not to those who wait for them, not to those who deserve them, but to those who happen to be in the way.

In one instance Rubens seems to falter: in his portrayal of Christ. Perhaps he felt the presence of something alien to his genius; perhaps he conceded too much to the romantic idealism of his public. Only in the great Crucifixion scenes does the inherent realism of the subject compel Rubens to leave aside all compromise; and in one picture at least, the 'Dead Christ', the utmost pathos and horror are expressed precisely because the face is that of any dead and battered corpse (*Figure* 42).

¶ 58. Near to Rubens, in any consideration of aesthetic values, we must place El Greco. There are differences of personality, which in effect make for different mannerisms, even a different style. The similarity is one of spiritual attitude, and even of plastic vision. They shared the same sense of glory, and even had the same sense of space and movement. The genius of El Greco, like that of Rubens, is above national distinctions; it is universal, like Shakespeare's, but not myriad-minded. It has only one of Shakespeare's dimensions, but this is the highest, the tragic. There is a quality in El Greco which always reminds me irresistibly of 'King Lear', and in one picture at least, 'The Burial of Count Orgaz', the painter reaches a depth of religious pathos unknown to the poet. His life had something of the largeness and

splendour of Rubens', but he was more wilful, more uncompromising, than Rubens. He had a more individual vision of the world, and he painted to please himself, not his clients. The odd thing is, that in spite of official rebuffs he was immensely popular. There was undoubtedly something in his tragic conception of life sympathetic to the Spanish soul. Though not a Spaniard, he is more essentially Spanish than Velazquez.

Velazquez was 'an artist of the world', but Rubens and El Greco, though men of the world, were artists of a rarer sphere. They do, to some extent, express the general sensibility of the time—the movement, the plastic freedom of the Baroque spirit. But their tragic sense of life could never descend to the merely technical fantasies of the Baroque style.

¶59. It is a little surprising in a book on Rococo[1] to find among the illustrations such very different artists as Watteau and George Morland, Chardin and Goya, Greuze and Hogarth. Can such incompatibles really be driven into one fold? Certainly the exigencies of a universal history of art might explain this apparent inconsistency. After the Renaissance the Baroque, and that brings us down to 1715 or 1720. From about 1760 we can give definite names to certain new stylistic tendencies—Classicism and Romanticism. The intervening period—at first sight a period of apparent confusion—has one outstanding style, the Rococo. It is but natural that this style should give its name to the period, for though it was not dominant it was at least singular. But the really surprising thing is that, when once we have accepted the label and defined the characteristics of the

[1]*Die Kunst des Rokoko.* By Max Osborn. (Berlin: Propyläen Verlag.) (Vol. 13 of the *Propyläen History of Art.*)

art it includes, we find that practically everything of the period fits into its place. The style in its purity was an extreme, but it was also the apex. There is little of value in the art of the period that does not in the end reveal itself as an aspect of the Rococo spirit.

Rococo is the last manifestation in Europe of an original style, unless we claim that there is a specifically modern style. The various styles that prevailed from the last quarter of the eighteenth century to the first quarter of the twentieth century were essentially derivatives, affairs of culture and education rather than of the emergence of a genuine spiritual form.

But the more we study the Rococo style the more it serves to typify the moods and the vitality of one of the greatest periods in European history. 'Rococo' is derived from the French word *rocaille*, meaning the pebble and rock work with which an artificial grotto is decorated. Why a word of such derivation should have come to denote this particular style of art is rather a mystery—grottoes of the kind implied were at least as characteristic of the preceding Baroque period; and 'baroque' itself, as a word, has a similar derivation, coming from the Portuguese *barroco*, meaning a large rough pearl of the kind used in florid jewelry of the period—but how the word came into general use for the art of the period is again a mystery. Whatever the tortuous paths of their derivation, both words are extraordinarily apt, as Herr Osborn points out, in their onomatopoeic values: 'barock' with its dark and loaded sound implying well the heavy, swollen, over-nourished forms that must be urged into movement to make their impression, and 'rococo' with its three equal syllables, the last two identical, sounding like an elusive delicate tinkling of

subdued bells—graceful and fugitive yet informed by laws.

The revival of interest in Baroque art began in Germany, where the publication of Alois Riegl's *Die Entstehung der Barockkunst in Rom* in 1907 had a decisive influence. Riegl's book is a study of the origins of the Baroque style, and perhaps the first book in which that style is adequately defined and separated from the Renaissance categories. To an historian like Jakob Burckhardt, whose great work on the Renaissance appeared in the 'seventies of last century, the Baroque style was the degeneration and disruption of the classical Renaissance style. Heinrich Wölfflin, whose *Renaissance und Barock* appeared in 1888, first made a clear historical distinction between the two styles, and his definition of baroque as 'movement imported into mass', though not comprehensive enough, was an advance on the quite negative attitude of Burckhardt.

¶ 60. The word 'Baroque' implies the odd, the whimsical or the extraordinary. There are two directions in which a work of art can depart from the normal; one is the way of Classical art, which is the way of idealism—ideal proportions, ideal harmony—in short, ideal beauty; the other direction is the way of fancy, which is a denial of reality, a contradiction of all its laws and *raisons d'être*. Both succeed in giving aesthetic pleasure, and which you prefer is probably a question of your own particular temperament. It is certainly prejudice which stands in the way of most people's appreciation of Baroque art, and it is a prejudice, as Riegl tried to show, which is contrary to our real nature as Northerners. For between Northern art and Baroque art there is a bond of natural sympathy such as does not exist between Northern and

Classical art. In Northern art the emphasis is always on the expression of spiritual states (or what Roger Fry has called 'psychological volumes'); we see this clearly exemplified, not only in the Gothic cathedral, but in painters like Rembrandt and even Turner. In Classical art, and particularly in the Classical art of the Italian Renaissance, all the emphasis is on the exploitation of the material, on the external handling of the object by the artist (that is why rules are so important). Now in the Baroque style, Italian art approaches the Northern type of art—that is to say, it begins to represent spiritual states, or psychological volumes. But it still clings to its love of material exploitation, and the whole difficulty or strangeness of Baroque art springs from this contradiction. It is psychological in intention, but materialist in means.

Michelangelo has been called the father of Baroque art, and the style can be actually traced to him. Primarily he was a sculptor, and so called himself, but it is in his architecture that he most clearly reveals himself as a Baroque artist. If we consider such typical works of his as the tomb of Giuliano de' Medici in S. Lorenzo, Florence, and the vestibule of the Laurentian Library in the same city, we shall find architectural compositions in which the various members—pillars, windows, entablatures—no longer fulfil any structural purpose, but are used entirely for aesthetic effect. We may particularly notice that certain recesses are designed for the sole purpose of making a shadow, or for throwing a feature into severe relief. In short, we have an architectural composition obeying the laws, not of architecture, but rather of painting or sculpture; and the whole of the Baroque style, as it affects architecture,

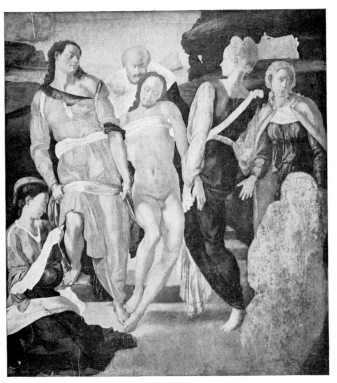

43. The Entombment. By Michelangelo. About 1495. *National Gallery, London.*

may be described as misplaced ingenuity. If you are a purist, and believe that all arts should obey laws which are proper to their material and function, then I do not see how you can possibly condone the Baroque style. If, on the other hand, you believe that success in pleasing the sensibilities is the only criterion, then this attempt to make a plastic composition in stone will not offend you. In any case you, the hypothetical sceptic, will have to put up with the awkward historical fact that, however misapplied it may have been, the Baroque genius became identified with a wide Catholic movement of thought. It became the art of the Counter-Reformation, and wherever that movement spread to—from Rome to Vienna, South Germany, the Rhine, Spain, Mexico, Portugal, Paraguay, Peru, and even Peking (where the Summer Palace was built by Jesuits)—it became the dominant style, and allowed the human spirit, freed from the bonds of classicism, to luxuriate in endless entrancing fantasies.

¶61. Rococo had its birth in France, and reached its supreme development in Germany. If anyone is to be named the actual originator of the style, the honour should be shared by two Parisian architects, Robert de Cotte and Gilles-Marie Oppenord, both pupils of Jules Hardouin-Mansart, the famous architect of Versailles. It was de Cotte who finished the Grand Trianon and the chapel at Versailles, whilst his chief work was the Hôtel de la Vrillière in Paris. Oppenord was a Dutchman by birth who had studied in Italy; and Max Osborn, in the book already mentioned, rightly says that this latter fact is not without significance, in view of the undoubted relationship that exists between the late Italian Baroque style with its aspirations towards

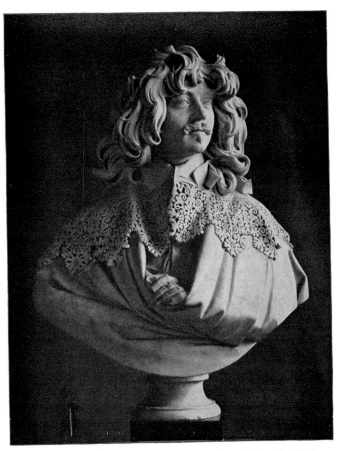

44. Portrait of Mr. Baker. By Lorenzo Bernini (1598-1680).
Victoria and Albert Museum.

freedom of movement and the new style in which that full freedom was attained.

Rococo begins as a style of interior decoration. Baroque had developed to a point at which the interior had become a sham replica of the exterior—colonnades, architraves, and all the panoply of a Baroque façade reversed on the inner side of the building. The discovery of de Cotte and Oppenord really amounted to no more than a recognition of the fact that the conditions determining the material of external decoration no longer applied to these decorations inside the building: in short, that within the shelter of four walls you could use a plastic stucco instead of stone. Once given this plastic medium, the will to freedom knew no bounds, and the characteristic mannerisms of the Rococo style were evolved.

It would be a mistake, here as elsewhere in the history of art, to impute a change of style to a discovery of material. On the whole it is probably truer to say that the emergent 'will' to some spiritual manifestation (in this case towards 'freedom' in contradistinction to classical restraint) is the first factor and the one that determines the change-over to a new material. The will to freedom had already half-revealed itself in southern Baroque architecture before it found itself in the Rococo of de Cotte and Oppenord. Perhaps, like the Gothic will to transcendentalism in stone, it had to come north to find its intellectual ally, its practical solution. Indeed, it has been suggested by Professor Worringer—and it is a brilliant suggestion—that Rococo is really the re-emergence, after the foreign imposition of the Renaissance, of the northern spirit in art, first fully typified in Gothic. Rococo is the embodiment in art of restless

movement, and this same restlessness was the northern contribution to the Gothic complex. There is more than a casual similarity between the linear motives of an illuminated page from a tenth or twelfth century missal and the ormolu mounts on a commode by Charles Cressent or François de Cuvilliés. It is a case of extremes meeting, but it may be suggested that extremes meet always on common ground.

¶62. The characteristic developments of Rococo in France were confined to interior decoration. For some reason this country hesitated to carry the style to its logical conclusion, which was the conversion of external materials to internal style. Juste-Aurèle Meissonier's lively design for the façade of St. Sulpice was rejected in favour of the dry classical design of Jean-Nicolas Servandoni. In France the style remained intimate, perhaps not without reason. For while in Germany Rococo became a rage, and a sacred rage, to the extent that of all the styles that have left their mark on that country, this is the most typical and national, yet even in Germany the essence of Rococo and its purest manifestation may be found in miniature things, above all in that essentially Rococo material, porcelain. The whole spirit of Rococo is distilled and crystallized in a single figure by that master of *Kleinplastik*, Franz Anton Bustelli, an Italian who modelled for the Nymphenburg factory between 1754 and 1763 (*Figure* 45). Kändler at Meissen is hardly less significant, but Bustelli is the darling of the epoch.

It is perhaps a far cry from a porcelain figure that one can hold in the hand to the palaces of Nymphenburg or Brühl, but if we lose anything between the two patterns, the monstrous and the miniature, it is something of the

157

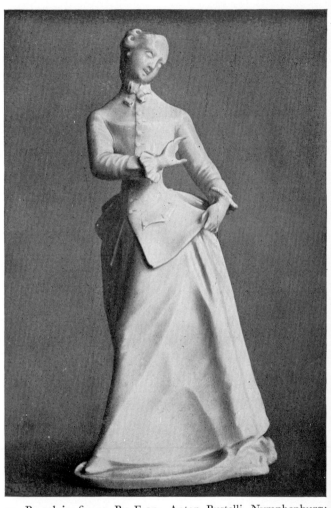

45. Porcelain figure. By Franz Anton Bustelli. Nymphenburg; about 1760. *Museum für Kunst und Gewerbe, Hamburg.*

peculiar spirit of Rococo. In fact, with the French caution as an example before us, may we not ask whether after all the Germans took a step too far in their application of the Rococo style to every expression of creative energy? We have defined Rococo as the will to freedom in art, but is that an adequate definition? Freedom for what purpose? We can only reply, freedom to be amusing, and that is an exact enough description of the Rococo spirit. It seeks the freedom to achieve an aesthetic effect without utilitarian considerations. It is an abstract art, an art for art's sake. So long as it is confined to decorative art, no harm is done, and much pleasure is given to the pure in heart. But a Rococo room, to put it in its most lowly light, must be the very devil to dust, nor does Rococo architecture in general ever for long escape from an air of tawdry decay.

There are no restraints on the Rococo spirit in the material conditions of canvas painting, and when once we are possessed of the key to the Rococo spirit, the dissimilarities of Watteau and Morland, Chardin and Goya, Greuze and Hogarth coalesce to render to our spirits the same impression of freedom. It is the same wish to be free to amuse that animates all the painters of this period, and while it is difficult at first to admit that one should be amusing on a tombstone or an altarpiece, you have not grasped the secret of Rococo until you have seen what a reasonable ambition after all that is. It is an affirmation of life even in the presence of death.

¶63. The history of landscape painting is of peculiar interest because it is not a continuous history; it is practically a modern history. There are wall-paintings in Egyptian tombs and at Rome and Pompeii which can

be classed as landscape paintings because they repre-
sent rocks and plants and trees in a naturalistic manner,
but they no more conform to our general idea of this
type of painting than, say, a Chinese wall-paper. They
were meant as a background for life (or death) and not
as objects for separate aesthetic contemplation. It is
always dangerous to generalize about anything so
perishable as painting, but with this reserve in mind we
may say that landscape painting in Europe was a
peculiar invention of the Renaissance. How it evolved
from the background of the normal figure subject is a
familiar story. It was in works of the Venetian School
especially (such as Cima and Tintoretto) that the land-
scape element was gradually allowed to dominate the
incident represented in a painting.

Perhaps the earliest mention of landscape as a separate
branch of painting is Dürer's reference in 1521 to Patinir
as 'Joachim the good landscape painter'. If a point has
to be fixed for the beginning of modern landscape paint-
ing, it might as well be Patinir (1485-1524), whose en-
chanting miniature-like pictures are fully imbued with
the essential landscape quality. What that quality is, I
will try to state; and in the first place I would say that
it has nothing to do with the quasi-scientific interest in
the morphology of rocks and plants which inspired the
only possible predecessor of Patinir in this branch of art
—Leonardo da Vinci. Even Patinir was not conscious
enough of the integrity of his subjects to dispense with
some human interest, and would introduce a Virgin
and Child, or a Flight into Egypt, to give an obvious
sanction to his recondite interest. I think the quality I
mean was first definitely and openly sought after by no
less a painter than Rubens, and if I were asked to select

a landscape painting that above all others represented the distinctive qualities of the genre, I would pass by Corot and Constable and Claude and take Rubens' 'Landscape in Moonlight', in Lord Melchett's collection. It was this picture that Reynolds, in his Eighth Discourse, took as an illustration of the principle that in painting a part must be sacrificed for the good of the whole. 'Rubens,' he wrote, 'has not only diffused more light over the picture than is in nature, but has bestowed on it those warm glowing colours by which his works are so much distinguished. It is so unlike what any other painters have given us of moonlight, that it might be easily mistaken, if he had not likewise added stars, for a fainter setting sun. Rubens thought the eye ought to be satisfied in this case above all other considerations: he might, indeed, have made it more natural, but it would have been at the expense of what he thought of much greater consequence—the harmony proceeding from the contrast and variety of colours.' Words that would sound strange coming from the mouth of a President of the Royal Academy to-day; words that are the complete justification of so much in modern art excluded from the Royal Academy!

To give a more definite name to the quality that distinguishes landscape painting, I think it would have to be called 'poetry'—though I must admit that this is not a very definite quality; it involves, too, the critical sin of crossing the terminology of two arts. But in landscape painting, first Patinir and then Rubens, and afterwards and quite openly Poussin, Claude and Corot, were aiming at the conveyance in their paintings of a particular state of sensibility for which there is no better word than 'poetic'. It is even the excess of poetry, a

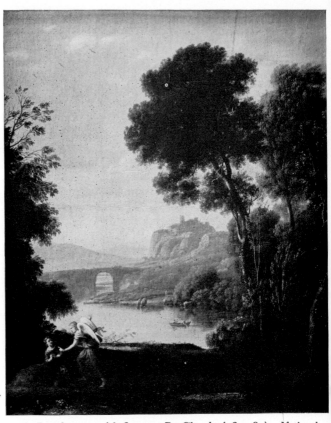

46. Landscape, with figures. By Claude (1600-82). *National Gallery, London.*

quality which poetry would express, but lacks the means:

> Ah! Then, if mine had been the Painter's hand,
> To express what then I saw; and add the gleam,
> The light that never was on sea or land,
> The consecration, and the Poet's dream. . . .

Landscape painting is essentially a romantic art, an art invented by a lowland people who had no landscape of their own. Later in the seventeenth century, with Elsheimer and Berchem, it became specifically romantic, a deliberate creation of 'atmosphere' for its own sake, rather than a revelation of a precise experience. In Claude and Poussin the 'poetry' is definitely allied to literary modes; Claude paints a landscape and calls it the 'Decline of the Roman Empire'; he deliberately seeks an association of literary and plastic ideas. Constable came, like Wordsworth after Thomson, to restore the poetic worth of realism and naturalism. Turner embraced almost every previous mode of landscape painting, and had an imagination robust enough to make his own synthesis. Corot was a milder, more evanescent Rubens, but still a poet. With the Impressionists and their successors we seem at first to have returned to the morphology of Leonardo, only to discover in the end that poetry has more modes of being than we had thought of.

¶64. Landscape painting is very typical of the English tradition, but no one has ever given a good definition of this tradition, and I could wish that some foreigner would do it for us. It is inconceivable that Gainsborough and Constable and Turner could be anything but Englishmen, and yet it is very difficult to say what quality they have in common which makes them so inalienably English. It concerns, perhaps, their common

attitude towards nature, and a key to this attitude can be found in another art, in English poetry. The secret is in Wordsworth's counsel, 'Let nature be your teacher', as well as in Constable's phrase, 'the pure apprehension of natural fact'. It is an attitude of *trust* in nature—an attitude far removed from the aggressive *Sachlichkeit* of German art and the sardonic *réalisme* of French art. The passivity of the artist is essential. You cannot take nature by storm. That is partly the secret of the English tradition; there is also a quality which is perhaps not so creditable. Again, it is not easy to define exactly, but I think it is an outcome of the English love of comfort. The English 'nature' is purely apprehended, but it is not thickly populated. What I mean to imply is that for the English artist nature is in some sense a refuge from life. It might be argued that it is the function of art to provide such refuges; that is the romantic doctrine. But it would be at once more 'realistic' and more 'classical' to ask of art something more—to ask for courage and for vision. We do not find these qualities in the *bourgeois* and self-satisfied art of Reynolds and Gainsborough; we do not find them in the humbler art of Constable. They blaze out in Blake and Turner, but these are just the artists we might hesitate most to include in the English tradition. '*Bourgeois*' is hardly what the *Dictionary of Modern English Usage* calls a bower-bird word—it has done hard service for too long—but it can be very offensive. I confess I have adopted the Marxian use, as it might be called; by '*bourgeois* art' I mean all art that is merchandise—art that is all commission, cash-transaction and contempt. Gainsborough painted portraits at sixty guineas apiece and hated it. He wrote to his friend Jackson:

'I'm sick of Portraits, and wish very much to take my viol-da-gam and walk off to some sweet village, where I can paint landskips and enjoy the fag end of life in quietness and ease. But these fine ladies and their tea drinkings, dancings, husband-huntings, etc., etc., etc., will fob me out of the last ten years, and I fear miss getting husbands too. But we can say nothing to these things, you know, Jackson, we must jogg on and be content with the jingling of the bells, only damn it I hate a dust, the kicking up a dust, and being confined in harness to follow the track whilst others ride in the waggon, under cover, stretching their legs in the straw at ease, and gazing at green trees and blue skies without half my taste. That's damned hard. My comfort is I have five viols-da-gamba, three Jayes and two Barak Normans.'

If this is not *bourgeois* in the normal meaning of the word, I do not know what the word has ever meant. But in this sense all tolerable people are *bourgeois* at heart, even William Blake, who is the best foil for Gainsborough. The vice is not in Gainsborough (nor in Reynolds). It was the age that was at fault, and it was at fault precisely because it was led by a silly, selfish and complacent society that had no better use for great artists than to make them mirror its own vanity and self-satisfaction. When we consider that England had in Gainsborough the greatest artist in all Europe since Rubens, it is a pity that it could not give his genius a free rein.

¶65. It is, I know, possible to argue that that would have been the ruin of Gainsborough. It is the fate of the artist to follow in the track whilst others ride in the waggon; he works best who works under pressure. Marvellous as are the positive virtues of Gainsborough,

his limitations are obvious. He had no general culture, and very little imagination. He worked directly from the object to the canvas, and was only moved by this immediate contact. He could not *invent*. His attempts at allegorical subjects are all failures. He could not even compose; he avoided composite subjects, and even a double portrait like 'Eliza and Thomas Linley' has no cohesion. What, then, must we conclude? Why, that it takes more than sensibility and skill to make a great artist. Blake is the reverse of Gainsborough. He had no natural skill and scarcely any of the painter's peculiar sensibility. He did not react directly from the object, because he rarely if ever had an object before him. His subjects were given to him by his imagination, and the very real emotion which he generated and expressed was not sensuous, but intellectual.

It is, however, a useless type of criticism that cannot accept an artist for his own merits. One may tremble to conceive what the vision of a Blake united to the skill and sensuousness of a Gainsborough would result in, but nature is not likely to oblige us with such a super-man. For the immediate occasion it would be more appropriate to particularize some of Gainsborough's positive virtues. There is firstly what might be called his naturalness, his unaffectedness. He had no theories about art, not even academic ones (which is where he parts from Reynolds). He painted what he saw, and painted it in a passion. He painted rapidly and surely. He neglected all the precautions, and yet succeeded completely in his aim. Reynolds had to impute this success to 'a kind of magic'. It was an instinctive use of the medium. 'Gainsborough's hand is as light as the sweep of a cloud, as swift as the flash of a sunbeam,' said Ruskin, and that

is the best way of describing his qualities. If we look at the details of his portraits, we can make wonderful discoveries of expressionistic technique—miniatures that anticipate all that Constable, Corot and Cézanne had to teach us. In a landscape proper the same instinctive fervour pervades the whole canvas, but now concentrated to render the romantic essence of the English scene. We can never tire of such art because it demands nothing but enjoyment; it cannot cloy because it is concise and passionate, not diffusely sentimental. One of his biographers, Sir Walter Armstrong, has a phrase that sums up his genius. 'Gainsborough,' he says, 'was the first to concentrate all his powers on the translation of his own continuing emotion into paint, and to make the vigour, heat and unity of his own passion the measure of his art'. It is that 'continuing emotion' which still keeps his pictures as fresh and fascinating as on the day they were painted.

¶66. As for Blake, he is but poorly represented in our public collections, and perhaps for that reason his fame has been built up too exclusively from his work as a poet, and what little has been generally known of his paintings has been the basis of a great deal of misunderstanding and underestimation. Perhaps the misunderstanding is the most serious part of the trouble, for it implies positive errors, and not merely neglect. From a few fragmentary impressions of Blake's designs there has grown up a legend of Blake the incorrigible amateur, Blake the prophet of the Gothic and Romantic revivals, Blake the mystic (and we have good cause to know that mystics make bad painters); and there has been a comfortable self-assurance at the back of most idle minds that, at any rate, the fellow was more than

half mad. One of these false impressions expresses a half-truth—the common recognition of a Gothic quality in Blake's paintings. Blake himself recognized his affinity with the unknown artists whose work he had so closely and intimately studied during his two years' work for Basire on the Gothic monuments in Westminster Abbey and other old churches. But, nevertheless, it is just this element in Blake that has been so generally misunderstood. Some have assumed that a Gothic mannerism was actually acquired from the study of Gothic masterpieces. Mr. Osbert Burdett, for example, goes so far as to say: 'Lost in the corners of these old churches, Blake's romantic imagination was completely Gothicized, and for the future he closed his mind to every other influence, or interpreted it by the light of these impressions." This sentence seems to contain two dubious assentions—one which says that Blake's imagination was romantic in kind; the other implying that Gothic art is romantic, or such as would appeal to a romantic mind. It will be more convenient to deal with the second assertion first, for then we shall see to what extent a different conception of Gothic art will illuminate the art of Blake.

Blake himself said: 'Grecian is Mathematic Form: Gothic is Living Form. Mathematic Form is eternal in the Reasoning Memory: Living Form is Eternal Existence'; and these words reveal his profound understanding of the essentials of Gothic art. Gothic art is linear art, and it is living. In its origins it arises from the animation of the abstract geometrical art of Northern Europe by the sensuous Oriental transcendentalism of Christianity. The art retains its linear emphasis (the lin-

[1]*William Blake* (Macmillan, 1926) p. 22.

ear emphasis of Celtic and Anglo-Saxon art), but, instead of the cold formality of a geometrical pattern, adapts this sense of form to the expression of a living, natural sensuous feeling—a feeling for life, for nature, for the divine unity of the visible world. In Gothic art at its zenith we find a great depth of feeling and imaginative creativeness given form and definition by an absolute adherence to the precision of linear outline. The greatest force flows through the most definite channels; and that is why it is possible to claim that Gothic art, in spite of its confused origins and in spite of its chaotic developments, is the greatest type of art yet achieved by man.

'Nature has no Outline, but Imagination has.' That was Blake's profoundest realization, and it led him, naturally, to Gothic art, which is imagination outlined. How this truth animated Blake may be seen at every turn of his career as a painter. It inspired his hatred for Reynolds and all that Reynolds stood for. We know what he meant when he said that Reynolds was 'hired by Satan to depress art'. And we can appreciate the bitterness that went to the making of gibes like this:

> When Sir Joshua Reynolds died
> All Nature was degraded;
> The King dropp'd a tear into the Queen's ear,
> And all his pictures faded.

But the clearest expression of his principles comes in that *Descriptive Catalogue* which he wrote for the first exhibition of his tempera painting of the Canterbury Pilgrims. Is this the creed of a 'romantic' artist?

'The character and expression in this picture could never have been produced with Rubens' light and shadow, or with Rembrandt's, or anything Venetian or Flemish. The Venetian and Flemish practice is

broken lines, broken masses, and broken colours. Mr. B.'s practice is unbroken lines, unbroken masses, and unbroken colours. Their art is to lose form; his art is to find form, and to keep it. His arts are opposite to theirs in all things.

'The great and golden rule of art, as well as of life, is this: That the more distinct, sharp, and wiry the bounding line, the more perfect the work of art, and the less keen and sharp, the greater is the evidence of weak imagination, plagiarism, and bungling. . . . The want of this determinate and bounding form evidences the want of idea in the artist's mind, and the pretence of plagiary in all its branches. How do we distinguish the oak from the beech, the horse from the ox, but by the bounding outline? How do we distinguish one face or countenance from another but by the bounding line and its infinite inflections and movements? What is it that builds a house and plants a garden but the definite and determinate? What is it that distinguishes honesty from knavery but the hard and wiry line of rectitude and certainty in the actions and intentions? Leave out this line and you leave out life itself.'

There is one further point to make, both in relation to Blake's art and to Gothic art. If Gothic art is living form, it is not, on that account, representational form. There is no necessary relation between the energies which the inspired artist seeks to embody in definite form and the limitless and indefinite forms of nature. A 'living' line or form is not necessarily 'life-like'; it is merely 'lively'. Indeed, all epochs of original art have recognized a divorce between the forms of reality and the forms of art—which are the forms of the imagination. The actual is simply the unimaginative, and there

is no inspiration in it. And so we find Blake confessing that 'natural objects always did and do weaken, deaden, and obliterate imagination in me'. Imagination, 'mere enthusiasm', was the only reality, the only value. Imagination is a vague term, and enthusiasm can be a disparaging one. Perhaps the fact that Blake rather defiantly adopted the badge of ' enthusiasm' at a time when it was a term of reproach had led to a further misunderstanding of his genius. Mr. Burdett, in this sense, has called him 'the Wesley of the arts'—an unfortunate witticism. Dr. Johnson defined enthusiasm as 'a vain confidence of divine favour of communication', and by his devotion to the works of Lavater and Swedenborg Blake almost earned this opprobrium. If we had nothing but the poetical works to judge him by, and with the Prophetic Books in mind, we might almost concede the epigram—though it is rather hard on Wesley. But it is quite meaningless when we consider the paintings. Here Blake was not so nakedly original; he did abide by a tradition, though he went far to find it. He had a discipline, but it was self-imposed, self-discovered, not given by the society he lived in.

Unless we are wedded to two gross errors—a conception of art as merely physical and objective, and the explanation of art by reference to a specific aesthetic emotion—we must recognize that in its plainest manifestations art always embodies some interpretation of life, whether poetic, religious or philosophical. Blake was inspired by such a vision, a vision that was too mystical to be wholly communicable. It was mystical in this deplorable sense because it was divorced from the prevalent tradition, which means from the common understanding of men. Blake's instincts led

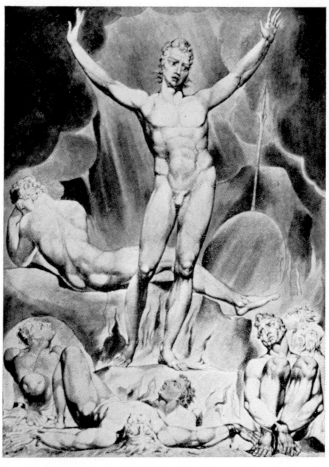

47. Satan arousing the Rebel Angels. Water-colour drawing by William Blake. Dated 1808. *Victoria and Albert Museum.*

him to a way of feeling which had prevailed five hundred years before his time; and though he could give forceful and precise expression to his feeling, this brought him no nearer to the age he lived in. But we to-day are nearer to Blake because we are nearer to the Gothic spirit. The distinctive characteristic of all that is alert and representative in modern art is for the bounding outline and against chiaroscuro, for the imaginative interpretation of the actual and against mere reproduction, for the transcendental and against the materialistic. This is as evident in Cézanne and Derain as in Picasso or Léger; and these artists have a greater affinity with the anonymous artists of the Gothic period than with any artists of the intervening period. Blake alone of post-Gothic artists is comparable with them, and that is because, as I have already said, he is Gothic, not only in conception, but even in detail. The magnificent series of 'Illustrations to the Bible' is perhaps the best evidence of this (*Figure* 47). There is a magnificence and boldness in their design, a wild energy in their invention, a bare force of colour, for the like of which we must go to the manuscripts and windows of the twelfth and thirteenth centuries. His conception of 'Elijah about to ascend in the Chariot of Fire' takes up its fiery motive and burns with a clear intensity. There is also a graceful tempera painting of 'Adam naming the Beasts', technically more ambitious, and less successful, than the water-colours, which is very characteristic of the Gothic spirit I have so much insisted on; this may be particularly observed in the treatment of Adam's locks, the general pose of body and uplifted hand, and the very Gothic oak leaves above his head. The unfinished Dante drawings, at which he was still working on his death-bed, while

still preserving this Gothic spirit, reach out to a different kind of sensibility, and show that Blake could match his imagination to Dante's, and, as if to support this wider imaginative appeal, could give to his designs a subtle intellectual structure and formal organization: and this is, perhaps, a quality that appeals to modern minds more directly than the too esoteric significance of the Biblical designs.

¶67. We have been busy with Blake, and some day we must re-value the genius of Turner; at present we are still intimidated by the eloquence of Ruskin. Ruskin wrote so much and wrote so effectively about Turner, that Turner's reputation has actually been a little over-shadowed, as in a cloud of golden dust. The dust has settled now, but we have not yet learned to look back again at this magnificent giant of English painting—a lonely giant, perhaps, with no great following in his own country, but none the less the greatest we have.

Ruskin's words must be repeated: 'Turner is an exception to all rules, and can be judged by no standard of art. In a wildly magnificent enthusiasm, he rushes through the aethereal dominions of the world of his own mind—a place inhabited by the *spirits of things*; he has filled his mind with materials drawn from the close study of nature (no artist has studied nature more intently)—and then changes and combines, giving effects without absolute causes, or, to speak more accurately, seizing the soul and essence of beauty, without regarding the means by which it was effected.'

Turner was born on April 23, 1775, and died on December 19, 1851. His father, to whom he was deeply attached and with whom he lived for fifty-five years, was a barber in London; his mother, for whom he had no

love, was a woman of violent temper who eventually went mad. Turner had no conventional education worth mentioning, and all his life remained an illiterate—a fact which may have sharpened his visual sensibility. Already at the age of nine he showed a remarkable talent for drawing. By the time he was thirteen it was already agreed that he should become an artist, and he began a series of apprenticeships to draughtsmen, engravers, and architects which, though of a menial nature, ensured a long and consistent practice in the fundamental techniques of his craft. The early appearance of his talent suggests a natal endowment of genius; but Turner was never an artist who relied on his genius. He fully realized that genius cannot achieve greatness without discipline, and discipline in art is the cultivation of an effortless technique. Certain effects which he obtained—the representation of mist, of foam, of swirling water—still baffle our analysis.

The capacity for such self-imposed discipline is no doubt a quality of temperament, of physical disposition: so, also, we may suppose, was another characteristic of Turner—his insatiable curiosity, his empiricism, his restless search for the facts of nature. He braved the fiercest storms at sea (*Figure* 48), climbed the most inaccessible rocks, endured hardships as great as any explorer, in his determination to observe and record the subtlest and rarest of natural phenomena. Never was a life more completely devoted to purely professional activities.

In physique, Turner was short, hawk-nosed, with small hands and feet: he liked to compare himself with Napoleon, and falsely claimed to have been born in the same year. His character was complex, and in discussing it one should bear in mind Acton's profound *pensée*: 'Good

and evil lie close together. Seek no artistic unity in character'. Ruskin, who became his inspired advocate, when asked by a biographer to describe the main characteristics of Turner, made a list which ran: 'Uprightness, Generosity, Tenderness of Heart (extreme), Obstinacy (extreme), Irritability, Infidelity'. All we know of Turner's life confirms the truth of this diagnosis, but we must add and emphasize a certain secretiveness and misanthropy which made him asocial and eccentric. He had an early disappointment in love, and never married. He did not mix in polite society: he preferred the company of sailors and of what the Victorians called 'drabs'—the female patrons of the London gin-shops. But all this side of his life was carefully hidden. An Associate of the Royal Academy at the age of twenty-four, a full Academician four years later, he realized that his reputation (and his sales) depended on his presumed respectability.

His character no doubt determined his choice of landscape as a main pre-occupation—there is evidence that he might have been a successful portrait-painter had his inclination been that way. He first perfected himself in the typically English art of water-colour, and he became the greatest master the world has ever known of this particular *genre*. But it remained for him a means to another end—a method of annotation and exploration to be embodied in the greater art of oil-painting. He was too inarticulate to give a coherent account of his ambitions, but there is no doubt that he had the deliberate intention of rivalling and of excelling such painters as Claude and Poussin. One of his most Claudian compositions he left to the National Gallery on condition that it was always to be hung side by side with a Claude: he did not fear the comparison.

176

In spite of what has been called his illiteracy, we must now remark that Turner was essentially a 'poetic' painter. It is not merely that he loved and interpreted certain themes from classical mythology: he was completely devoted to that romantic conception of nature, and particularly of landscape, which was characteristic of the whole period, and which in England received its supreme literary expression in the poetry of Turner's contemporary, William Wordsworth. That romantic conception was given a theoretical and indeed metaphysical justification in the magnificent writings of John Ruskin, especially in the long work, *Modern Painters*, which is a whole system of aesthetics arising out of and justifying the work of Turner. The romanticism in question was not, as is too often supposed, a movement of an idealistic or conceptual character: on the contrary, it was based on an almost scientific exactitude of observation, and in England at any rate is closely linked to a native empiricism. But the facts thus provided by observation are then transformed by the faculty of imagination and the result is *poésie* in its widest and profoundest signification. Ruskin describes the process in these words:

'Such is always the mode in which the highest imaginative faculty seizes its materials. It never stops at crusts or ashes, or outward images of any kind; it ploughs them all aside, and plunges into the very central fiery heart; nothing else will content its spirituality; whatever semblances and various outward shows and phases its subject may possess go for nothing; it gets within all fences, cuts down to the root, and drinks the very vital sap of that it deals with: once therein, it is at liberty to throw up what new shoots it will, so always that the true juice and sap be in them, and to prune and twist

them at its pleasure, and bring them to fairer fruit than grew on the old tree; but all this pruning and twisting is work that it likes not, and often does ill; its function and gift are the getting at the root, its nature and dignity depend on its holding things always by the heart. Take its hand from off the beating of that, and it will prophesy no longer; it looks not in the eyes, it judges not by the voice, it describes not by outward features; all that it affirms, judges, or describes, it affirms from within.' [1]

This was written more than a hundred years ago (1846), and though it was not at the time realized, and has never been sufficiently appreciated, Ruskin was in such passages presenting the world with a new theory of art, a theory that was to become the basis of the modern movement. Turner has been called 'the father of impressionism', but he could with equal justification be called the father of expressionism. We are not now, perhaps, so fond of the word imagination, 'this penetrating, possession-taking faculty' which for Ruskin was 'the highest intellectual power of man'. But therein lies our timidity, our failure to reach in any one master the truth, authority, and inevitability of an artist like Turner.

Within his chosen genre, Turner's work is of immense range and variety, and in output he is among the most prolific of all painters. Though he had a profound influence on the French Impressionists and the German Expressionists, the appreciation of his genius is not widely diffused, and this is because the paintings are concentrated in a few galleries in Great Britain and the United States. Turner's work, perhaps the greatest revelation ever made of the power and majesty of nature, remains for the most part undiscovered by the world at large.

[1] *Modern Painters*, Vol. II (Section II, Ch. 3)

¶ 68. By 'nature' we mean the visible world of appearances, but by so defining it we do not simplify the problem of the artist's relation to nature. It is simpler to limit ourselves to a definite example, such as a landscape. There are then two problems to consider. First, what is the distinction between art and nature? Is there any essential difference between the beauty of the actual

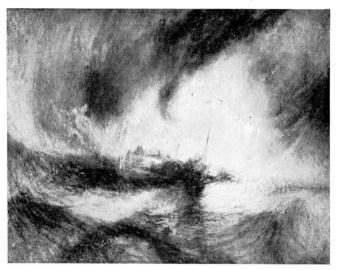

48. Snow-storm: Steamboat off a harbour mouth. 1842. By J. M. W. Turner (1775-1851). *National Gallery, London.*

landscape and that beauty as represented in an artist's picture? If we answer this question in the affirmative, as I think we must, then we are faced with the problem of deciding what is the function of the artist who comes between us and nature.

If art were merely a record of the appearances of nature, the closest imitation would be the most satisfactory work of art, and the time would be fast approach

ing when photography should replace painting. It has already replaced the kind of reproductive art (portraits and topographical views) upon which the majority of artists once depended for a livelihood. But as a matter of fact not even a savage would be deceived into thinking the photograph an adequate substitute for the work of art. Nevertheless, it is not easy to explain this preference without involving ourselves in a complete theory of aesthetics. Most simply we might say that the artist in painting a landscape (and it is true of whatever the artist does) is not wanting to describe the visible appearance of the landscape, but to tell us something about it. That something may be an observation or emotion which we share with the artist, but more often it is an original discovery of the artist's which he wishes to communicate to us. The more original that discovery is, the more credit we shall give the artist, always assuming that he has technical skill sufficient to make his communication clear and effective.

What is it, then, that the artist discovers in nature, and that he alone can communicate to the world? It would be best to take the actual evidence of some great artist, and for this purpose there is none better than John Constable. In the *Life of Constable*, written by his friend and fellow-artist, C. R. Leslie, there are many aphorisms and observations on the art of painting which come direct from the lion's mouth, and these are of the greatest interest. Though an artist's reflections on art are always interesting it does not follow that they are always true, because the ability to express oneself well in one medium does not always imply the ability to express oneself well in any other medium—above all not in that most difficult and ambiguous of mediums, the

written word. But there was a simplicity and directness about Constable's character which was reflected in his literary judgments, and these show great insight into the nature of the art he practised. The following passage comes from the prospectus of an album of engravings of his work called *The English Landscape*, published in 1829:

'In art there are two modes by which men aim at distinction. In the one, by a careful application to what others have accomplished, the artist imitates their works or selects and combines their various beauties; in the other, he seeks excellence at its primitive source—nature. In the first he forms a style upon the study of pictures, and produces either imitative or eclectic art; in the second, by a close observation of Nature, he discovers qualities existing in her which have never been portrayed before, and thus forms a style which is original. The results of the one mode, as they repeat that with which the eye is already familiar, are soon recognized and estimated, while the advances of the artist in a new path must necessarily be slow, for few are able to judge of that which deviates from the usual course, or are qualified to appreciate original studies.'

¶69. According to Constable, there were two things to be avoided, 'the absurdity of imitation' and bravura, 'an attempt to do something beyond the truth'. What is essential is 'a pure apprehension of natural fact'. 'We see nothing truly until we understand it.' But to understand nature—that is not an easy accomplishment. 'The landscape painter must walk in the fields with an humble mind.' He must study nature, not in the same spirit, but with all the seriousness and application of the scientist. 'The art of seeing nature is a thing almost as much to be acquired as the art of reading the Egyptian

hieroglyphics.' The true comparison is, of course, with the poet of nature, and it is curious that the extraordinary parallel between Constable and Wordsworth is not more often dwelt upon. They were almost exact contemporaries, and what each did in their respective arts is almost exactly the same. Both rid their arts of derivative or 'eclectic' mannerisms, both went back to the natural fact and built up their work on an intuitive

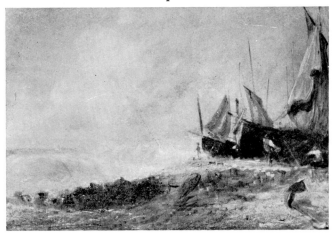

49. A Sea Beach. By John Constable (1776-1837). *Courtesy of the Museum of Fine Arts, Boston, U.S.A.*

apprehension of that fact, and both accomplished a revolution in their respective spheres. Incidentally both represent the spirit of the English landscape with an unrivalled intensity, and I can imagine no book that would be so representative of English beauty as a selection of Wordsworth's poems illustrated by some of Constable's pictures.

The development of European art onwards from Constable, though inspired by his work as by the work

of no other artist, departed from his principles in one important particular. Constable attached great importance to what was then the fashion to call 'chiaroscuro'—'the soul and medium of art' he called it. He further defined it as 'that power which creates space; we find it everywhere and at all times in nature: opposition, union, light, shade, reflection, and refraction, all contribute to it', and so certain was he of its necessity that he could despise not only an 'unnatural' painter like Boucher, but also the Chinese 'who have painted for 2000 years and have not discovered that there is such a thing as chiaroscuro'. With our greater knowledge of Eastern art, we begin to see the limitations of Constable's point of view. The absence of chiaroscuro in Chinese art is not due to any incapacity or backwardness; it is due merely to the fact that the Chinese artist, in his apprehension of nature, does not discover this particular spatial quality. Instead of light and shade, he finds linear rhythm, and this seems more essential to him than the adventitious effects given to objects by anything so shifting and transient as the sun's rays. His preference is really for something elemental and stable. It is from this point of view that we should examine some of the more recent developments in art which seem in such 'flat' contradiction to Constable's axioms about art and nature. And it was Constable himself who said that 'a true taste is never a half-taste'.

¶70. After Constable, Delacroix. It is a natural transition. With the passage of time this painter is seen to be more representative of his period than almost any other figure—certainly more significant than Chateaubriand or Victor Hugo. The only comparable genius is Byron, by whom he was greatly influenced, but whom he sur-

passed in energy and profundity. Delacroix was what we may fairly call a universal genius, and it may seem on enquiry that the term 'romantic' is too narrow to define him, unless we take another alternative and re-define 'romanticism'.

Eugène Delacroix was born in 1798, and it is now admitted that he was the illegitimate son of Talleyrand. Even in infancy his lot was remarkable, for in turn he had narrow escapes from being burned, drowned, poisoned, and hanged. He was well educated and des-tined for the diplomatic service, but an artistic tem-perament soon manifested itself. It seems he might have developed equally well as painter, musician or poet, and though he retained an acute sensibility in all these arts it was as a painter that he found he could adequately express himself. Physically he was very feeble: he could only digest one meal a day, and he had a grievous chest complaint. But his spiritual energy was limitless, and sustained his frail body for sixty-five years.

His appearance was very striking, and there are several famous descriptions of him. Gautier, who met him for the first time in 1830, notes his pale olive com-plexion, his flowing black locks, his fierce feline eyes and pointed eyebrows, his fine and delicate lips, a little drawn back over magnificent teeth, his powerful chin—altogether a physiognomy of 'ferocious beauty, strange, exotic, almost disturbing'. Baudelaire describes his tem-perament as a 'curious mixture of scepticism, politeness, dandyism, ardour, cunning, despotism, and finally a certain species of kindness or moderated tenderness which always accompanies genius'. At the same time, in appearance, says Baudelaire, he was simply an en-lightened man, a perfect 'gentleman' without prejudices

and without passions, and in this respect he compares him with Mérimée—the same apparent coldness, slightly affected, the same icy cloak covering a shame-faced sensibility and ardent passion for the good and the beautiful. Like many men of genius, one of his chief occupations was disguising his genius, such a step being necessary to secure a little time to himself.

Delacroix travelled a good deal, though he always avoided Italy on principle; he felt, and felt rightly, that his genius was so opposed to that of the Italian masters that to come up against them would compromise him. His genius was essentially nordic. In 1825 he visited England, and became an enthusiastic Anglophile. Indeed, four Englishmen, Shakespeare, Byron, Constable and Bonington, were the decisive influences in his life. In Shakespeare and Byron he found that type of creative imagination which was his true inspiration, and in Constable and Bonington (above all in Constable) he found painters who could reveal to him a technique adequate to express his mode of imagination. He was an admirer of the English school in general, and could never forgive the neglect in France of such artists as Reynolds, Gainsborough and Hogarth, and even minor artists like Wilkie, Etty and Haydon, in whom he himself found something to imitate and admire.

Two other journeys had a deep influence on him. In 1832 he went to Morocco and Spain, and in 1838 to Belgium and Holland. From the South he brought back a certain voluptuous sense of colour: in the North he encountered the full genius of Rubens. Rubens was ultimately his real master; only in that Flemish fury and animal abundance did he ever find the counterpart of his own abounding spiritual energy.

At the age of twenty-three he painted himself in the character of Hamlet. At twenty-four he began to keep a journal, and this journal is a document of extraordinary interest—not only a volume of confessions rivalling Rousseau's in frankness and self-revelation, but the repository also of some of the most profound criticisms of art and literature ever published. Baudelaire put first among his qualities the universality of his interests. As well as a painter in love with his métier, Delacroix was, he wrote, a man of general education, unlike other modern artists, who were for the most part no more than painters—sad specialists, of every age, or pure workmen, some making academic figures, some fruits, others animals. Delacroix loved everything, knew how to paint everything, and surrendered his mind to every kind of impression. But in the philosophy and criticism expressed in his journal he reveals the baffling duality of his genius, for here all his praise is for order, reason, and clarity—in one word, classicism. Baudelaire sees in this a characteristic of all great artists, who feel compelled, as critics, to praise and analyse with all voluptuousness the very qualities of which as creators they have most need, and which are the antithesis of what they possess in abundance. All this merely shows how difficult, in the case of a talent like Delacroix's, it is to use party labels like 'romantic' and 'classic'. For inasmuch as a genius depends on the physical and emotional features of the one type, he will seek to create the intellectual features of the other type.

Delacroix was one of the most prolific of painters, but he was isolated in his activity, even secretive. He had an immense capacity for work, and after devoting all the daylight to his work in the studio, or on the great wall-

paintings to which so much of his time went, he would still return in the evening to his absorbing passion, and he would have thought that day ill-spent, says Baudelaire, which did not include an evening over the fireside, sketching by lamplight, covering paper with his dreams and projects, noting aspects of life which chance had thrown in his way, or sometimes copying the designs of other artists far removed from him in temperament. He had a passion for making notes, for sketching at any odd time, even when paying visits to his friends. 'The truth is', confessed Baudelaire, 'that in the last years of his life, all that might be called pleasure had disappeared from his life, a single, avid, exacting, terrible passion having taken its place—work—which was no longer merely a passion, but would have been better described as a fury.'

In a fury he painted. He despised the meticulous exactitude of David and Ingres. He was no pedant, and one of his most characteristic sayings was: 'The true Rome is no longer in Rome'. When he began to paint a subject, he would make all the necessary preparations most carefully, and perhaps paint many preliminary studies; but when it came to the final picture, all these would be cast aside, and he would paint, as he said, with his imagination only. There is a very interesting passage in his journal where he speaks of his methods and though it is too long to quote in full I cannot refrain from repeating these revealing sentences:

'This process of idealization goes on almost unknown to me, when I repaint a composition based on my imagination. This second edition is always compared with a necessary ideal and corrected; thus comes about what seems to be a contradiction but which really explains

how a too detailed execution like that of Rubens, for example, cannot interfere with the imaginative effect. This execution is based upon a perfectly idealized theme; the mass of details which slip in, owing to the imperfection of the memory, cannot destroy that simplicity, of quite a different interest, which has first been found in the expression of the idea; and, as we have seen in the case of Rubens, the freedom of the execution makes up for any inconvenience due to the prodigality of details.'
(*Journal*, October 12, 1853.)

Paint was like another vital element to him, and perhaps only Rubens before him and Matisse after him have used paint in the same direct way—that is to say, not as a medium into which thought is deliberately translated, but as an instinctive activity accompanying the very process of thought. The distinction may seem a subtle one, but it is perhaps comparable to that between formal composition and improvisation in music, always assuming that the player who improvises has first disciplined himself by arduous formal exercises. Musical analogies are appropriate enough in Delacroix's case, for he was devoted to music, and often spoke of his palette as though it were a scale on which he composed harmonies. As a colourist he owed much to Constable, and he was the first to admit it; but he went beyond Constable, and the methods used by Constable for the analysis of nature Delacroix used for an imaginative synthesis of his own creation. Nature is only a dictionary, he was fond of saying; we go to nature for the right tone, the particular form, just as we go to a dictionary for the proper sense of a word, its spelling or etymology; but we do not regard the dictionary as an ideal literary composition which we must copy, and no

more should we regard nature as a model to be copied by the painter. The painter goes to nature for suggestions, especially for his 'key-note'; but the harmony which he builds up on this basis is the work of his imagination alone.

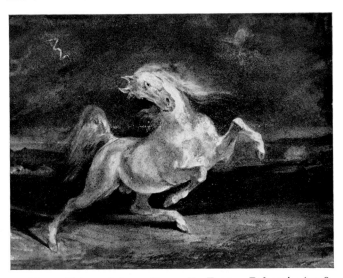

50. Horse frightened by a Storm. By Eugène Delacroix (1798-1863). *Museum, Budapest.*

Compared with Constable, whose colour is of the morning of the world, Delacroix is fuliginous and sultry. Time has not been kind to his canvases, and one is conscious of a general duskiness which was not perhaps part of the painter's original intention. But in this gloomy matrix the brighter colours, especially the reds and blues, gleam like jewels. Delacroix's colour must not be judged by any preconceived standard, natural or otherwise, but accepted as the expression of a personal

intuition, a harmony justified by the intensity of the imaginative conception controlling it.

Delacroix's paintings fall into three or four distinct groups. There are his portraits, remarkable for their astonishing psychological perception, often bordering on caricature (such as those of Paganini and Georges Sand); there are his historical pieces, large ambitious subjects drawn from the romantic literature for which he had so much sympathy; there are a few landscapes, of pure lyrical content; and finally there is another group, most typical of all, in which we see two beasts locked in combat, or if not two beasts, then man and beast, or man and angel, or simply man and man. There is no doubt that in this manner Delacroix was exteriorizing (whether consciously or unconsciously does not matter) an inward conflict, which we may describe quite simply as the conflict of reason and imagination, in the very tension of which struggle Delacroix himself found the creative principle to operate.

¶71. The influence of Constable on the general development of European painting did not end with Delacroix. After Delacroix came Edouard Manet, and the revolution which is often for convenience associated with his name is one of the most complete in the history, not merely of painting, but of all human activities. Actually Manet is only the point at which a slow and inevitable movement culminates; if we must credit one man more than another with the inception of this great change in our lives (for in the end it amounts to that, for the world has been revealed to us in a new light), it is the crazy Englishman who suddenly stepped out of the studio into the wind and the rain. But Constable was not a conscious revolutionary; he was rather the stubborn

kind of individualist who, discovering in himself a new range of sensibility, unwittingly transforms the world. He was as naïve as Henri Rousseau, though infinitely more skilled. Manet was anything but naïve. He was as individualistic, as craft-conscious, as Constable; but the realism which Constable had reached by a purely objective study of the visible scene, Manet adopted as a subjective ideal. As quite a young man he announced that he would paint what he saw, and not what others liked to see. He soon realized that the problem was a technical one, and he at once embarked on a long and arduous study of the methods of the great masters; finding above all in Spain and in the paintings of Goya and Velasquez, some indication of the methods he must adopt.

It is perhaps an adequate summary of the Impressionist movement to say that it held a prism up to nature. Beginning with Leonardo, a tradition had grown up in Europe whereby the plasticity of an object, its depth or tridimensionality, was rendered by gradations of shade, or, in plain words, by varying amounts of black paint. Painting became, not a copy of nature, but a trick whereby the general effect of nature was represented. The conventions of a Baroque artist like Caravaggio in the matter of light and shade are really every bit as arbitrary as the conventions of a modern Cubist; the only difference is that Caravaggio wants to give us something more dynamic than reality, the Cubist something more static. The one intensifies, the other abstracts.

Impressionism was moving towards the static, though Manet himself would have hated to think so. But 'we murder to dissect', and you cannot analyse without at

the same time arresting. Manet himself was so human in his sympathies that he was never prepared to sacrifice the humanity of his subjects for the sake of a surface realism, much less for the sake of a scientific dogma. This prudence is not so obvious in the case of some of his followers. The extreme was reached in the pointillism of Georges Pierre Seurat and Paul Signac. These two painters studied the problem of light and colour in a thoroughly scientific manner. They reduced their palette to the primary colours of the spectrum, and secured the effect of light and shade, as well as their secondary colours, by the apposition of minute spots of the primary colours. Manet had shown what could be done by the use of pure colour, but it was Seurat and his fellow post-Impressionist who actually defined colour for us, made us realize its full meaning and significance, and, incidentally, spread a retrospective gloom over the painting of three centuries. In their enthusiasm they went too far; they were so absorbed in their scientific problem that they forgot that art after all is an artistic problem—by which I mean that whatever laws the artist evolves for the transference of his individual impressions from within to without (for the objective expression of his private sensibility) he must nevertheless reach a final result which is single and direct in its appeal. He must not expect the spectator to judge the finished picture by the amount or kind of effort which has gone to its making. He must not only clear away all his scaffolding, but the building must be such a spontaneous unity that it looks as though it had never had any. Many post-Impressionist pictures are like certain kinds of lacework or Chinese ivories which we cannot look at dispassionately because we cannot avoid think-

ing of the lacemaker's eyesight or the ivory carver's in-
human patience.

Paul Valéry, in one of his aphorisms, speaks of the in-
decisive nature of painting, and says that it would be
comparatively simple if its object was to give the illusion
of the visible scene, or to amuse the eye and the mind
by a kind of musical distribution of colours and forms.

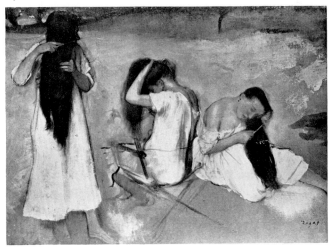

51. Women combing their hair. By Edgar Degas (1834-1917).
About 1875-6.

But actually the process is much more complicated. In
any great picture you will find a whole system of values,
some scientific, some formal, some spiritual. 'The artist
assembles, accumulates and composes *in a material
medium* a number of desires, intentions and conditions
received from all points of his mind and being. Now he
thinks of his model; now of his colours, his oils, his tones;
now of the flesh itself, and now of the canvas which
takes his paint. But all these independent attentions are

of necessity united in the act of painting, and all those distinct moments—dispersed, followed up, recaptured, held in suspension, lost again—all grow into a picture under his hands.'

Nothing is more subtle, more successful in the pursuit of the evanescent, than the typical Impressionist and post-Impressionist painting. It is the perfect expression of the *lyricism* or complexion of nature, that beauty which comes and goes with the fluctuations of light. It is a minor poetry, but so sweet that we cannot imagine the world forgoing it. Pioneers like Seurat and Signac will be held in honour; others, like Manet, Monet, Camille Pissarro, and Pierre Bonnard (to mention only some famous names), will grow more obvious and acceptable with the years. But it is already evident that they do not reach beyond lyricism, beyond surface beauty, to the magnificent *banality* of the grand manner.
¶72. But there is Renoir. Renoir is almost banal. No artist of the last hundred years was so free from self-conscious reflections on his activity as Renoir. He even disliked the word 'artist', and preferred to be called a painter. His characteristic sayings reflect his modesty and his lack of pretence in all that concerned his craft. 'I have spent my life amusing myself by putting colours on canvas,' he would say. Or, 'I think that perhaps I have not done so badly because I have worked so hard.'

Auguste Renoir was born at Limoges in France in 1841. He died at Cagnes in 1919. He was the son of poor parents, and for the most part self-taught. At the age of twelve he became a porcelain painter, and I think that some of the qualities of the style he first learned persisted throughout his whole development. This style was definitely personal; no artist can be so certainly identi-

fied without a signature. And yet he was the most traditional of the great artists of his time. Perhaps his early apprenticeship to a craft taught him the value of application, care, and finesse. All art begins in the willing devotion of the faculties to an arduous duty. Incidentally this craft of porcelain painting had some influence in the formation of his individual palette, because colours on the intensely white opacity of that material take on a sensuousness which was the effect that Renoir succeeded in rendering on canvas. It may be, too, that the associations of porcelain painting (and of fan painting, to which also Renoir applied himself) with the *bergerie* of Boucher and Watteau directed Renoir's sensibility towards the characteristic achievements of French eighteenth-century painting. Renoir is the final representative of a tradition which runs directly from Rubens to Watteau.

And yet Renoir is also one of our conquerors. He is with Cézanne and Manet and the post-Impressionists and not with Puvis de Chavannes, the pre-Raphaelites and the Royal Academy. Merely in the commercial sense, he is probably the most appreciated of all nineteenth-century artists. In 1878 some of his pictures are known to have been sold for forty or fifty francs; in 1928 one of them passed to America for the amazing sum of 125,000 dollars. But these figures should not intimidate us; they bear no relation to aesthetic values. Indeed, there is no doubt that certain adventitious aspects of Renoir's art—the fact that more often than not he painted women, the 'prettiness' of his palette, the simplicity of his subjects—tell more in his favour than those aspects of form and feeling which constitute the real strength of his art.

But in Renoir's case it would be a mistake to emphasize the formal element. Some of his pictures, and

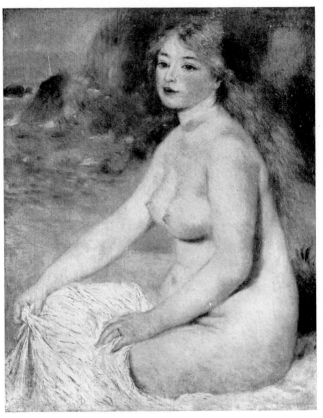

52. Woman bathing. By Pierre Auguste Renoir (1841-1919). Dated 1881.

the 'Umbrellas' in the Tate Gallery is one of them, are no doubt marvellously composed, but others have no composition at all. He was not one of Mr. Wilenski's

'architectural' painters; generally in his paintings one is aware not of structure, but of surface. Renoir had an extraordinary sensibility for the surface of things, and particularly the surface of delicate flesh (*Figure* 52) and of the petals of flowers. Flowers and the flower-like flesh-tones of a woman's or a child's body—Renoir hardly ever painted anything else; and it is said that he would turn from a half-finished painting of a nude to paint roses, many roses, until he had learnt from this exercise how to render the subtle sheen on the model's skin.

Renoir led a quiet and retired life. He was content with his garden and the company of his family. And yet scarcely any other painter of the last century so faithfully reflects the life and spirit of his period. When the curious student of the future turns to the paintings of this period to learn something of the visual aspects of its life, he will find scarcely anything of significance in Cézanne, or Gauguin, or Van Gogh; he will find many curious side-lights in Monet, Degas and Toulouse-Lautrec; but only in Renoir will he find the colour and the gaiety and the character of everyday life. In that sense Renoir is the most representative painter of his age. ¶ 73. Yet in the true sense of the word, not so representative as Cézanne. One day the generation to which I belong awoke out of its childhood to hear a tremendous scuffle going on, and when we asked what it was all about, the answer we got was: 'It's that fellow Cézanne'. The painter himself, it appeared, had been dead four years, but a representative group of his works had for the first time been shown at the Grafton Gallery exhibition of post-Impressionist paintings. The aesthetic notions of most people were thoroughly outraged, and though the invaders made some progress, the struggle was still

53. Woman with book. By Paul Cézanne. About 1900-4.
Formerly in Vollard Collection.

going on when another and more serious war distracted our attention. My own feeling is, that those of us who had been too young to take sides in the critical war of 1910 came back in 1919 to find Cézanne among the accepted masters, and there he seemed to us to be in his natural position. Perhaps by then it was possible to take the long view, and Cézanne appeared merely as the logical outcome of a tradition already historically established in Constable and Delacroix. Ambroise Vollard's *Paul Cézanne* was published in 1919, and that book created for us a legendary figure very much in the manner of Boswell's Johnson. It is true that M. Vollard has been criticized: he has been accused of making Cézanne a kind of village idiot. The criticism is just on the assumption that a village idiot cannot at the same time be a great artist, though actually 'village idiot' is much too strong a phrase to be used for M. Vollard's characterization of Cézanne. What we are really given is the figure of a gruff countryman, not conscious of, and therefore not ashamed of, his provinciality, a man despising wit but master of a vigorous Rabelaisian humour, apparently childish in all the affairs of life, but supremely intelligent in all that concerned his art. With all its inconsistencies, the Cézanne that emerges from the anecdotes of M. Vollard is a convincing portrait of the artist.

There was obviously something very complex in this simple nature: he was a strange combination of arrogance and humility, of frankness and repression, and in this conflict we may find an explanation of his development as an artist. As an arrogant young man, eager to give expression to a rather flashy baroque exuberance, he is perfectly understandable; but it is hard to be

baroque out of season, so to speak. Delacroix did it, and did it magnificently; but then Delacroix had an inspired mastery of his medium never possessed by Cézanne. It was Delacroix who described himself as always painting 'spellbound like the serpent in the hand of the snake charmer'. Cézanne was spellbound by the poetry or lyricism of his visions, but not at first by the touch of his brush on canvas. His early paintings, some of which were reproduced in Roger Fry's study of the artist (*Cézanne: a Study of his Development*), are interesting in view of his subsequent career, but I doubt if they would ever have been heard of had not a will of tremendous force animated this strange youth.

Cézanne found that it is the most difficult thing in the world to give direct expression to visionary conceptions. Unchecked by an objective model, the mind merely flounders over an expanse of canvas. It may achieve a certain force, a certain vitality; but it will lack, not only verisimilitude, which matters little, but that knitting together of form and colour into a co-ordinated harmony which is the essential of great art. Cézanne came to realize that to achieve such a harmony the artist must rely, not on his vision, but on his sensations. To realize the sensations—that became the watchword of Cézanne. It amounted to a self-imposed conversion: a spiritual renewal. The dynamic vision of the romantic had to be transformed into the static vision of the classical.

'Look here, Monsieur Vollard', said Cézanne, one day, 'painting is certainly what means most to us. I believe I become more lucid before nature. Unfortunately, with me, the realization of my sensations is always very painful. I can't attain the intensity which is developed in my senses; I don't get that magnificent richness

of colouring which animates nature. Nevertheless, in view of my colour sensations, I regret my advanced age. It is sad not to be able to take many specimens of my sensations and ideas. Look at that cloud—I would like to be able to paint that. Now Monet, he could do it. He has the muscles.' I think all Cézanne is in that speech:

54. Landscape near Pontoise. By Paul Cézanne.
Formerly in Loeser Collection, Florence.

his humility (he was only arrogant before men, not before nature), his immense patience (he would exact literally hundreds of sittings for a portrait), and that tentative assertion of the highest function of the artist ('Je crois que je deviens plus lucide devant la nature'). On another occasion, in conversation with Mr. Joachim

Gasquet, Cézanne said: 'Everything we see is dispersed and disappears. Nature is always the same, but nothing remains of it, nothing of what we see. Our art should give to nature the thrill of continuance with the appearance of all its changes. It should enable us to feel nature as eternal.' This belief that behind manifold appearances there is the one enduring reality, and that it is the artist's function to discover such a reality—this is a metaphysical conception of painting; but it is a conception which brings the painter's art into relation with all that is greatest in poetry and philosophy.

¶ 74. Cézanne was solid from the first, and as we get farther away from the nineteenth century, the figure of Vincent Van Gogh seems to separate itself from the shifting reputations of the period and to stand secure by the side of Cézanne. To a great extent this is not due to any exceptional advance in the appreciation of his painting, but to a more intimate knowledge of his character. The three volumes of his letters to his brother[1] are an astonishing revelation of the tragic grandeur of this painter's humble life. The public can hardly be expected to read the whole story, full as it is of details which would only interest a fellow-craftsman, but a selection would make one of the most impressive and best-loved books in modern literature. Here is a veritable Painter's Progress, but with no Celestial City at the end of it, only chaos and dark despair—the madness and self-inflicted death of a genius in a cold and uncomprehending world. It is a gloomy and desperate record, but out of it there emerges the glory of a great spiritual struggle, the triumph of an infinite patience, and the beauty of an immortal achievement.

[1]Published by Messrs. Constable (London), 1927-29.

It has been said in depreciation of Van Gogh that he remained all his life a draughtsman—that he painted his pictures as other men draw their sketches, that his ideas were only black-and-white ideas. That, I think, is to regard art from an angle that is too exclusively technical—as though we were to say that Shakespeare remained all his life a blank-verse dramatist, never reaching the epic splendour of an Ossian. Although an artist's selected medium may make some difference to the *range* of this expression, it does not alter its quality, and a genius can do more with a broomstick than a misguided amateur with all the resources of a magnificently equipped studio. This element which we sometimes call genius, sometimes personality, and which always in the end defeats any pretence of exactitude in criticism, can be studied in the case of Van Gogh as well as anywhere. But in studying it we do not explain it.

Van Gogh began his career normally enough—as a business man, apprenticed to a firm of picture dealers. He even bought a top-hat. But then he fell deeply in love with his landlady's daughter, without winning her love in return, and from that time his character is changed. He becomes thin and dejected, and then begins to draw. From drawing he turns to reading, especially the Bible. He thus achieved some kind of sublimation, and at the age of twenty-two he had set before him this ideal of Renan's:

'To act well in this world one must give up all selfish aims. . . . Man is not on this earth only to be happy, he is only there to be simply honest, he is there to realize great things for humanity, to attain nobility and to surpass the vulgarity in which the existence of almost all individuals drags on.'

It is not possible to understand the life and the painting of Van Gogh unless it is realized that this vision remained with him to the end. 'To be simply honest'—these words describe his whole activity, but how difficult it was! There is a letter written to his brother in 1880, in which he reveals the hopeless drift of his spirit:

'You must not think that I disavow things; I am rather faithful in my unfaithfulness, and though changed, I am the same, and my only anxiety is: how can I be of use in the world, cannot I serve some purpose and be of any good, how can I learn more and study profoundly certain subjects? You see, that is what pre-occupies me constantly, and then I feel myself imprisoned by poverty, excluded from participating in certain work, and certain necessary things are beyond my reach. That is one reason for not being without melancholy, and then one feels an emptiness where there might be friendship and strong and serious affections, and one feels a terrible discouragement gnawing at one's very moral energy, and fate seems to put a barrier to the instincts of affection, and a flood of disgust rises to choke one. And one exclaims, "How long, my God!".'

To be simply honest, and to live in comfort—Van Gogh found these two things incompatible. All he asked for was a roof over his head, a bed and the absolute necessities. 'We must live', he said, 'almost like monks or hermits, with work for our master passion, and surrendering our ease.' But all he met with was failure, and his life degenerates into one repeated whine for money —money enough to buy, first paints, and then bread. The miserable nature of his end is well known. But he died trying to be simply honest.

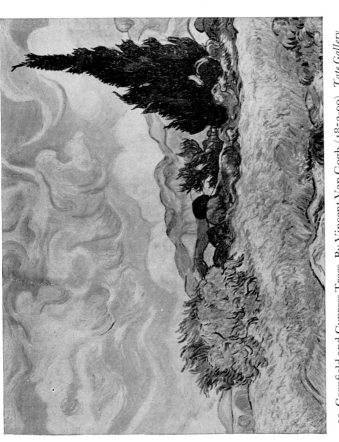

55. Cornfield and Cypress Trees. By Vincent Van Gogh (1853-90). *Tate Gallery (Millbank), London.*

This preoccupation with the purpose of life gives to Van Gogh's work a character altogether different from that of his great contemporaries—Manet, Cézanne, Gauguin and Renoir. His real compeers are Rembrandt and Millet, both of whom he greatly admired. He was drawn naturally to the life of labouring people. 'I can very well do without God', he confessed, 'both in my life and my painting, but I cannot, ill as I am, do without something which is greater than I, which is my life— the power to create. . . . And in a picture I want to say something comforting as music is comforting, I want to paint men and women with that something of the eternal which the halo used to symbolize, and which we seek to give by the actual radiance and vibration of our colourings.' If that statement had ended on the word 'symbolize' it would have been merely sentimental, but a man cannot at one and the same time be sentimental and 'simply honest', and to be simply honest Van Gogh realized that it was essential to discover a mode of self-expression; and the more earnestly and honestly he sought that mode the more he was driven to strength of form, to purity of colour, to renewed contact with reality—to all those qualities which make up the strangeness and the vitality of his art.

¶ 75. The fate of Gauguin is not so certain. He was not so honest with himself as Van Gogh. After Van Gogh's *Letters*, the *Journals* of Gauguin seem insufferably splenetic. He was choked with conceit. Gauguin, it should be remembered, was a self-taught artist. He was born in 1848 in Paris, and in his childhood spent some years in Lima; he was thus baptized in tropical sunlight. He travelled a good deal in his teens, but at the age of twenty-three he became an Exchange broker. He also

became an enthusiastic amateur painter, and got into touch with Pissarro. His early water-colours do not possess any particular merit. They are sensitive, and already betray an interest in pure colour values, but they are such as we might expect from any intelligent dabbler with a knowledge of what the Impressionists were doing. But his passion for art grew beyond normal bounds. In 1881 he threw up his post, and in 1882 went off with Pissarro to paint in Normandy and Brittany, leaving to his wife the task of bringing up his family. Pissarro as a child had been to the Antilles, so he and Gauguin could exchange memories of exotic lands of colour and sunlight. Gauguin developed that longing for the primitive which was to determine his whole career. At first he sought it in remote Brittany, and it was there that he first came into contact with Van Gogh. Then, in 1887, he suddenly left for Martinique, and visited Pissarro's Antilles. The next year he was back in France, and then came the tragic partnership with Van Gogh at Arles, ending with Van Gogh's suicide. Gauguin returned to Brittany, but in 1891 he visited Tahiti, and though he came back to France for a year or two, he was no longer happy in the over-civilized atmosphere of Europe. He returned to the South Seas in 1891 and remained there until his death in the Marquesas in 1903.

It is difficult to be dogmatic about Gauguin. No one doubts the depth of his feelings; his sensibility, especially for colour, was acute. He knew, too, what he wanted to achieve by his painting, and his will was strong. His talent was never facile. He confesses in his *Journals* that 'wherever I go I need a certain period of incubation, so that I may learn every time the essence of the plants and

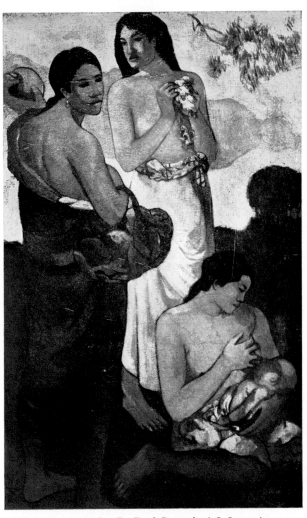

56. Maternity. By Paul Gauguin (1848-1903).
Private Collection, New York.

trees—of all nature, in short, which never wishes to be understood or to yield herself'. But that is the right attitude of a painter before nature, though it is perhaps a little disconcerting to find such humility in Gauguin. He was not humble, as his life shows, and as any reader of his *Journals* may discover. But there is a distinction, as Gauguin himself points out, between humility and the pride of humility. Gauguin's pride was not his humility. It is also difficult to describe him as romantic. Superficially it looks as though this love of the primitive, this desire to become savage, to escape from civilization and society, was an extreme form of romanticism. But the *Journals* are harsh, sardonic, in some sense realistic. Gauguin fled to the South Seas for sensual rather than for idealistic reasons. He was greedy for colour, for luxuriance, for natural gaiety. He felt that out of such materials he could create an art that was more solid, even more classical, than the pale ecstasies of the Impressionists.

That Gauguin in some way failed to create a classical style is generally admitted. The reason given for his failure usually involves the word 'decorative'. When once we begin to describe an artist's work as decorative, we are really finding excuses for it. Gauguin himself had a formula which we might apply:

> Art for Art's sake. Why not?
> Art for Life's sake. Why not?
> Art for Pleasure's sake. Why not?
> What does it matter, as long as it is Art?

And so art for the sake of decoration—what does it matter, as long as it is art? To describe a painting as decorative is to imply that it is lacking in a certain value which we might as well call human (since the divine is

not in question). When we compare Gauguin and Van Gogh, we are struck immediately by this difference: the Dutchman is full of love for his fellow beings, and seeks always to embody that love in his art, just as, he recognized, great artists like Shakespeare and Rembrandt had done. Perhaps it will be said that that was a literary ambition, not relevant to the painter's vision: what does it matter, as long as it is art? But art is not an abstraction; it is a human activity, only realized through the medium of a personality. The quality of that personality will suffuse the abstract qualities of art, and the value of the art will depend on the depth of the human feeling. That consequent solidity is something that Van Gogh possesses in abundance, but which Gauguin, throughout all the appealing beauties of his work, still manifestly lacks.

¶ 76. After Cézanne, Van Gogh and Gauguin, Henri Rousseau is the most significant precursor of modern art. He was born at Laval (Mayenne) in 1844, the son of an ironmonger. At the age of fifteen he enlisted in the Army and served for five years as bandsman in the Mexican Campaign in 1862-1867. In the war of 1870 he rose to the rank of sergeant, and at the conclusion of peace was given a post as customs-officer in the Paris *octroi*. He began to paint in his spare time, and in 1880 retired from the customs to devote himself full-time to his art. This does not mean that it was a late-born impulse in him. He had cherished the desire from early life, but waited until he felt able to devote himself entirely to his art. Then for the rest of his life he lived in abject poverty, in complete creative absorption.

But he was not unhappy, for he soon had a group of intelligent admirers round him. He was known to Alfred

Jarry, the poet who wrote *Ubu-Roi*, and Guillaume Apollinaire, a greater poet, was an early and a faithful friend. Apart from his work, Rousseau was an attractive personality. He lived the life of an ordinary working-class man, and so empty is that life of incident that his biographers have to rely on various anecdotes to fill out

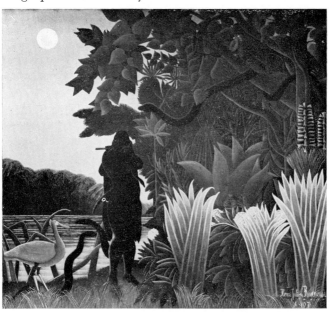

57. The Snake Charmer. By Henri Rousseau (1844-1910).
Louvre, Paris.

their pages. All these merely illustrate one theme; the man's perfect naïveté. I say 'perfect' advisedly, and am not sure that it ought not to be 'perfected'. For there is no doubt that Rousseau became aware of the nature of his asset, and sedulously cultivated it. In a less genuine case, this would soon have ended in affectation, but

Rousseau was endowed with a vivid sensibility. In Mexico his mind had been stored with an exotic imagery of birds, beasts and flowers, and when, twenty years later, he began to paint, he painted these tropical forest scenes direct from memory, and in his memory these elements had arranged themselves in bold decorative designs, as though the subconscious mind had been at work all the time, sorting and selecting the significant among the stored impressions. The method which experience and instinct thus indicated as the right one, he followed in all his painting. He said that nature was his only master, and this was true in the sense that he had no academic masters; but he only took his raw material from that source; his design was the gift of his imagination alone. There is something childlike in his paintings, and that is in their essence. There is also an accomplishment in them that is far beyond the range of a child. He was simple, but he was also profound, with that profound understanding of life which is a complex of sensibility and experience, and has nothing to do with culture or intellectual capacity.

¶ 77. Pablo Picasso is often described as the most 'significant' of living painters, but it is difficult to know what is implied by this fashionable word. Is a significant painter necessarily a good painter, a man whose sense of beauty is expressed in forms that will endure because they have universal value? Or is a significant painter merely one who appeals to the co-opted jury of snobs which in most ages secures a judgment for any odd and outrageous escape from banality? It is not easy to say, and in the case of Picasso especially, the protean nature of his activity precludes any summary answer. He has, at all costs, avoided a manner. He can be as

human and as caustic as Toulouse-Lautrec, as careful as Ingres, as massive as Michelangelo and as sentimental as Greuze; and he can be completely abstract and devoid of any value beyond the bare physical reaction to form. Yet Picasso himself has declared that he never changes; that we must seek the same principles of design in all his pictures; the same values, the same objectivity.

Picasso was born at Malaga in Spain in 1881. He therefore belongs to a younger generation than Matisse, who was born in 1869. I mention Matisse because some people might regard him as a still more significant painter, and certainly he does not give rise to the same feelings of doubt and unconfessed dismay. The reputation of Matisse is secure, even though the significance of his art is by no means fully recognized. But it carries with it a sense of achievement; it is a tradition, the tradition of Cézanne, carried to a deeper intensity, a completer realization of the painter's vision. Picasso, however, is the beginning of a new tradition, and half his fascination is his capacity for arousing our sense of wonder.

Though France has absorbed him (he settled there in 1903), it has never assimilated him. He has preserved his native integrity, and this, as Mr. Uhde pointed out in his book (*Picasso et la Tradition Française*), is more Germanic than French. 'Germanic' is perhaps a strange word to use, but Mr. Uhde sees an underlying similarity in the Greek, Spanish and German genius: their common tendency to express a longing for the infinite, for the transcendental. We can agree that in its superficial aspects, at any rate, the manner of Picasso is 'sombre in its colouring, essentially tormented in its inspiration, vertical in its tendency, romantic in its tonality, em-

58. Le Repos du Modèle. By Henri Matisse (1869-1954).
1916. *Philips Memorial Gallery, Washington, D.C.*

bodying in its totality the Gothic or Germanic spirit'. Picasso himself would scarcely approve such a generalization. Like every modern artist, he is necessarily an individualist: 'I paint what I see' is one of his sayings. But Mr. Uhde would perhaps reply that there is no such thing as an individualist; we all express the complex organizations into which we are born as a dependent unit.

There exist some reflections on art which are attributed to Picasso himself. They were originally contributed to a Russian review, and afterwards translated into French and published in the second number of a magazine called *Formes*. Some of his remarks are directed at his critics. For example: 'Art has neither a past nor a future. Art which is powerless to affirm itself in the present will never come to its own. Greek and Egyptian art do not belong to the past: they are more alive to-day than they were yesterday. Change is not evolution. If the artist modifies his means of expression, that does not mean that he has changed his mind.' Again: 'Cubism in no way differs from other schools of painting. The same elements and the same principles rule in all.' And, in further explanation of Cubism, there are these maxims: 'Nature and art are two entirely dissimilar phenomena.' 'Cubism is neither the seed nor the germination of a new art: it represents a stage in the development of original pictorial forms. These realized forms have the right to an independent existence.' 'There are painters who transform the sun into a yellow spot, but there are others who, thanks to their art and intelligence, transform a yellow spot into the sun.'

It may be, as Picasso says, that intentions have no value in art. The only business of the painter is to paint, and the work of art will take him by surprise. 'Je ne

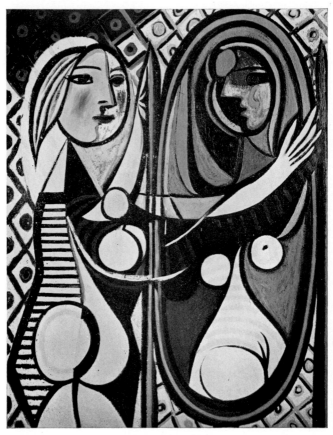

59. Young girl at the mirror. By Pablo Picasso (b. 1881). 1932. *Museum of Modern Art, New York (Gift of Mrs. Simon Guggenheim).*

cherche pas, je trouve.' But, speaking not for the painter nor for the artist, but for the spectator who is asked to admire, we must, in these circumstances, ask to be protected from the painter's personality. There are paintings by Picasso, mostly of his 'blue period' (1903-5), that affront us with their sentimentality; there are others, more recent, that have no discoverable organization at all. It is sometimes possible to think that the fierce intellectuality of some of his most geometrical abstractions is but reaction from his more sentimental mood. But, apart from these excesses, there is a body of work of almost endless variety. The abounding energy which it reveals would alone be evidence of genius, for only a wise man, as Blake would say, could so persist in his folly.

¶78. Along with Picasso we ought to consider Marc Chagall as a representative modern artist. In a recent book, *Marc Chagall et L'Ame Juive*, René Schwob goes so far as definitely to proclaim him the most important living painter. Chagall was born at Vitebsk, in Russia, in 1887, of Jewish parents. He was for a time a pupil of Bakst, the costume designer famous for his work for the Russian ballet, in St. Petersburg, but in 1910 he came to Paris, and he has declared that Paris has been the true school of his art and of his life. He returned to Russia in 1914, and remained there through the period of war and revolution, until 1922. During that period he founded an academy of art at Vitebsk. He then returned to Paris, where he has continued to work.

Chagall's work, though it is likely to puzzle and even to offend those who find 'subversive tendencies' in everything unfamiliar, must be sharply distinguished from the work of Matisse and Picasso. That, indeed, is the

60. Barbara. Bronze By Jacques Lipchitz (b. 1891). 1942.
Buchholz Gallery, New York.

main theme of Mr. Schwob's book; and he, with an enviable freedom in the use of a difficult word, does not hesitate to describe that distinguishing quality in Chagall as 'love'. Matisse and Picasso, he says, have become so absorbed in the technique of their art that they must be charged with a certain inhumanity. Their art is intellectual, but Chagall, with a directness and fluency which is quite characteristic of his race, paints from the heart. He is, in fact, a lyricist in paint, and his pictures have their analogies in poetry. He is not afraid of being called 'literary'.

¶ 79. There are two interesting points to take up here. The first is the question of race. It may be old-fashioned to believe in the racial factor in art, or in anything else but politics, but though art in a very real sense is universal, and has had a very complex history of interrelations and influences which has passed over epochs and races unnumbered, nevertheless certain types of art have characterized certain types of people; and if we take a broad distinction, such as that between the Aryan and Semitic races, we find a very marked difference in their modes of aesthetic expression. The Semites, in fact, are not expressive at all in plastic modes—that is to say, they are not original or 'creative' in them. Relatively speaking, there is no Jewish art. By origin the Jews are a desert race, nomadic, quickly reacting to physical experience. But the major arts belong to sedentary peoples, to those who settle in cities and form a stable civilization, an atmosphere of refinement. Nomadic races are only capable of a popular art, expressed in mobile objects, and popular art of this kind has an affinity with the art of Chagall. But Chagall has declared that it does not satisfy him, and precisely because

61. At dusk. By Marc Chagall (b. 1887). Dated 1938-43.
Private Collection, Paris.

it is too exclusive it excludes the refinements of civilization.

The Jewish race, though it is still dispersed and in a sense nomadic, has now found a 'national home' in Palestine (Israel). The Jew still retains the essential mobility of temperament, the inquietude, that distinguished his forefathers; but he is hemmed in, repressed. So, late in the day, he takes to plastic art; and the art he creates is a distinctive art. It has not the same respect for form as Aryan art; it avoids the definite and static. It is essentially romantic, and is not ashamed of its romanticism. It sees in painting, not a means of interpreting the outer world, but a means of expressing the inner self. That is why it uses the essential types of individualist art—lyricism and symbolism.

¶ 80. Symbolism is merely the art of selecting analogies for abstract ideas (a dove to represent peace) and is familiar enough in poetry. But lyricism in painting sounds like a dangerous confusion of categories. Actually, in using the word 'lyricism' we are using an analogy. Lyricism in poetry is a certain *direct* manner of giving expression to an emotional state: we do not, that is to say, attempt to rationalize the expression. We have regard only for the emotional equivalence of the words; their literal meaning may even be absurd;

> Go and catch a falling star,
> Get with child a mandrake root,
> Tell me where all past hours are,
> Or who cleft the Devil's foot. . . .

So in painting, if we like to transpose this method, we shall get something like the art of Chagall—an art in which harmony emerges from an iridescent shimmer of

colours, colours that work upon our emotions as inexplicably as the sound of words in a lyric; colours which belong, not to any scene in nature, but to a world of unconscious fantasy, a world of fiddlers and robins, of sinister old men and the Eiffel Tower, of dilated suns and patient labouring animals,[1] a world of images, capable of symbolizing the fertility of the artist's vision and of expressing his creative joy.

¶80a. 'Expression' is a significant word in modern art. It can imply no more than is implied in the phrase I have just used about Chagall—an outward demonstration of inner feelings. But in such a demonstration everything will depend on whether we respect the feelings and ignore the outward world to which they are addressed, or respect the outward world (its customs and conventions) and accordingly modify the manner of our expression. On the former supposition a whole school of modern art has sprung up to which 'expressionism' has been given as a label. It is a fundamentally necessary word, like 'idealism' and 'realism', and not a word of secondary implications, like 'impressionism' or 'superrealism'. It denotes one of the basic modes of perceiving and representing the world around us. I think that perhaps there are only these three basic modes—realism, idealism, and expressionism. The realistic mode needs no explanation; it is, in the plastic arts, the effort to represent the world exactly as it is present in our senses,

[1] Of everything, as the Dormouse said, that begins with an M—such as mouse-traps, and the moon, and memory, and muchness. And the retort with which the Hatter brought that particular conversation to an end might also be quoted for the benefit of some critics of modern art. 'Did you ever see such a thing as a drawing of a muchness?' asked the Dormouse. 'Really, now you ask me,' said Alice, very much confused, 'I don't think—'. 'Then you shouldn't talk,' said the Hatter.

without attenuation, without omission, without falsity of any kind. That the effort is not so simple as it sounds is shown by a movement like impressionism, which questioned the scientific basis of normal or conventional vision, and tried to be more and more exact in its rendering of nature. Idealism, which is perhaps the mode of representation most followed in the arts, starts from a basis of realistic vision, but deliberately selects and rejects from the plethora of facts. According to Reynolds's classic definition, 'There are excellences in the art of Painting beyond what is commonly called the imitation of Nature . . . all the arts receive their perfection from an ideal beauty, superior to what is to be found in individual nature'. The artist's eye, he says in this same Discourse (the third), 'being enabled to distinguish the accidental deficiencies, excrescences, and deformities of things, from their general figures, he makes out an abstract idea of their forms more perfect than any one original'.

Idealism, it will be seen, has an intellectual basis; it is this intellectual dignity which, Reynolds felt, alone distinguishes the artist from the mere mechanic. Realism, we may say, is based on the senses; it records as truthfully as possible what the senses perceive. But there is another division of man's psyche which we call the emotions, and it is precisely to the emotions that the other fundamental type of art corresponds. Expressionism is art that tries to depict, not the objective facts of nature, nor any abstract notion based on those facts, but the subjective feelings of the artist. As a method it would seem to be just as legitimate as the other two, and at various times and in various countries it has been the most common and most accepted form of art.

The greatest examples of idealistic art are those that belong to the tradition of Greek classicism: Praxiteles, Pheidias, Donatello, Raphael, Poussin, Reynolds, Cézanne. To people with an intellectual bias, such is the supreme type of art. What such people are not prepared to recognize is that certain types of modern art, such as cubism and abstract art generally, are also, in Reynolds's words, abstract ideas of things more perfect than any one original, and therefore entitled to rank as idealistic art.

Greek art has its realistic phase, but this type is more familiar in Egyptian and Roman art; it is one phase of the Italian Renaissance, but is most typical of the art of Germany and the Netherlands. It received a powerful impetus from the English naturalistic school (especially Constable) and became pedantic and even absurd in the impressionist movement.

Expressionist art is, by definition, individualistic, and its appearances are not so neatly confined to periods and countries. To some extent it is more typical of Northern races, because Northern races tend to be more introspective. On the other hand a purely Mediterranean individual like El Greco is an expressionist, and no art is more expressionist than that of the Negroes of tropical Africa. There is much expressionist art in Spain (the work of a sculptor like Morales, for example) and it is not difficult to find it in Italy. But the most consistent types are found in the North—the supreme example being the Isenheim altarpiece by Grunewald now at Colmar. An artist like Brueghel hovers between expressionism and realism, but Bosch and many of his followers are definitely expressionistic.

¶8ob. The German tradition in art, like the English tradition with which it shares common origins, is funda-

mentally romantic. But romanticism, which was universal in its manifestations, took on different aspects in different environments. In Germany this difference is perhaps best described by the word 'transcendental'— even realism, in the paintings of Max Beckmann (1884-1950), was to become 'transcendental'. There are many superficial traits that distinguish the German or Northern tradition in art from the Mediterranean or French tradition, but essentially it is tradition itself against which the Northern sensibility reacts, turning inwards to the promptings of the individual conscience, in art no less than in religion and philosophy. Art itself becomes, as Conrad Fiedler (the friend of Hans von Marées and Adolf von Hildebrand) said, a visual mode of cognition, a metaphorical activity which strives to express man's relation to the universe. Virtually any pictorial means are permissible—the realism of Adolf von Menzel (1815-1905) and Hans Thoma (1839-1924), the symbolism of Arnold Böcklin (1827-1901) and Hans von Marées (1837-1887), the impressionism of Lovis Corinth (1858–1925), Max Slevogt (1868-1932), and Max Liebermann (1847-1936), down to the abstract expressionism of Wassily Kandinsky (a Russian active in Germany for most of his life) and the latest abstractions of Fritz Winter (b. 1905), Theodor Werner (b. 1886), and Ernst Wilhelm Nay (b. 1902). In all this development, in spite of a variety of mannerisms, one always returns to the word 'expressionism' to characterize the essential quality of Northern art.

Expressionism, like most of the terms which have been used to define historical phases of art, is an ambiguous term, but its literal meaning is in this case the most exact meaning. Expressionistic art is an art that gives outward

release to some inner pressure, some internal necessity. That pressure is generated by emotion, feeling, or sensation, and the work of art becomes a vent or safety-valve through which the intolerable psychic distress is restored to equilibrium. Such a release of psychic energy is apt to lead to exaggerated gestures, to a distortion of natural appearances that borders on the grotesque. Caricature is a form of expressionism, and one that most people find no difficulty in appreciating. It is when caricature is carried to the pitch and organization of a composition in oils, or a piece of sculpture, that a spectator educated in the tradition of classical restraint and idealism begins to revolt.

An expressionist of this other, romantic tradition does not claim that all expression is art, though that happens to be the phrase by which Croce has defined art. But as used by Croce, and as used in this paragraph, expression is not the spontaneous utterance of feeling so much as the recognition of images or objects that embody feeling. This distinction, which is fundamental to Croce's aesthetics, will perhaps help us in the present connection. Here is a summary from one of the clearest expositions of the theory:

'To begin with,' writes Mr. E. F. Carritt in *What is Beauty?* (Oxford University Press, 1932), 'perhaps we ought to distinguish this "expression" from other things with which it is commonly confused. First, it is not symptom. There may be many signs or consequences of feeling, perhaps peculiar to an individual, or perhaps recognizable by doctors or other beholders, which are not expressions. A scream or a cry need not by itself be expressive of pain, though it is usually a sign of it. It might enter into a dramatic expression of pain. Neither is

62. Woman combing her hair. By Max Beckmann (1884-1950),
Dated 1928.

sweating nor change of the pulse expression. An expression is a sensuous or imagined object in which we *perceive* (not infer) feeling. Secondly, expression is not communication. Expression may be confined to ourselves. . . . A mere symptom, such as a scream, might communicate our terror to others, either in the sense of blindly infecting them with it or of letting them know we had it: yet it need not be expressive. Lastly, expression is not symbol in the proper sense of that word. . . . A symbol . . . is an *artificial* sign, of which the meaning is something agreed upon and is a meaning which we should not know unless we knew it had been agreed upon.'

The expression which *is* art, in Croce's sense—the contemplation of feeling (recollection in tranquillity) rather than the mental activity accompanying feeling itself—is a much wider concept than the one I have put forward now. Expression in this wider sense is the basis of idealism and realism as well as of expressionism. But I think we might say that in the type of art which is specifically expressionism, the form of expression is nearest to the source of feeling. Feeling is contemplated, but not within a philosophical frame of reference that lays down what the world is, or what it should be.

¶ 80c. Expressionism, as a distinct movement in modern art, arose spontaneously as a manifestation of various artists and groups of artists throughout Germany during the decade that immediately preceded the war of 1914-18. To say that the movement was spontaneous does not imply that it had no connexion with previous movements. It sprang quite organically from that movement in the applied arts known as Jugendstil in Germany and as Art Nouveau in France and Belgium. This movement in its turn was historically and organically related to the

arts and crafts movement initiated by Ruskin and Morris in England, and by the architect Mackintosh in Scotland. Kandinsky's early work is intimately related to the Jugendstil, and Kandinsky was to become the dominant force in German Expressionism. Kandinsky (1866-1944), as already noted, was of Russian origin, but he lived in Munich from 1896 onwards and studied with the leading Jugendstil artist of the period, Franz von Stuck.

Kandinsky, in association with another Russian painter who had come to Munich, Alexei von Jawlensky (1864–1941), quickly absorbed the influences of French painters such as Cézanne and Matisse, and by 1910 the work of Picasso, Braque, and Rouault had been shown in Munich. But by this time Kandinsky had reached his own conception of the future destiny of art, and had formulated his beliefs in a book, *The Art of Spiritual Harmony*, which was written in 1910 but not published until 1912. Inspired perhaps by certain types of Jugendstil ornament, Kandinsky arrived at an original conception of non-objective painting which was to develop between 1910 and 1913. He remained comparatively uninfluenced by the contemporary development of Cubism in Paris and arrived at an 'art of internal necessity' in which colour and line were used as means of representing 'spiritual' states of mind. In the course of this experimental development Kandinsky anticipated all the degrees of abstraction that art was to undergo in the next forty years, including the *tachisme* or action-painting of the present day. Out of the many possible paths thus opened, he himself chose one which led to compositions of an extremely precise, carefully calculated, harmony. Of all types of modern painting,

Kandinsky's comes nearest to a plastic equivalent for music.

¶80d. Meanwhile in other parts of Germany developments of a somewhat different nature were taking place. Submitting to the common influences of the Norwegian, Edvard Munch, of Gauguin and of van Gogh, artists such as Paula Modersohn-Becker (1876-1907), Emil Nolde (1867-1956), and Christian Rohlfs (1849–1938) were developing a figurative type of expressionism. These three artists were individualists, working for most of their lives in isolation; but they were not alone in the tendency they expressed, for in 1905 a group which was to be called *Die Brücke* (The Bridge) was formed in Dresden. The leaders were Ernst Ludwig Kirchner (1880-1938), Erich Heckel (b. 1883), and Karl Schmidt-Rottluff (b. 1884), and they were later joined by Max Pechstein (1881-1955), and Otto Mueller (1874-1930). The Brücke lasted for only eight years, but in that short time it had created a new style. Historically the style may correspond to the style of the Fauves in France, but the German painters carried their expressiveness to a limit of violence and even of brutality which is quite distinct from the harmonious expressiveness of a Matisse or a Derain. Only Rouault among the French painters, and Belgian painters like Constant Permeke, Gustave de Smet, Frits van den Berghe, and Floris Jespers come near to the powerful dynamism of the Brücke group.

Very different in this respect was the group that formed round Kandinsky and Jawlensky in Munich in December 1911, which chose 'Blaue Reiter' (the Blue Rider) as a name. Jawlensky's style may perhaps be associated with the style of the Brücke, but the most

important new members of the group, Franz Marc (1880-1916), August Macke (1887–1914), and Paul Klee (1879-1940) were to be strongly influenced by the 'Orphism' of Robert Delaunay (with whom both Macke and Klee had direct contact) and by the oriental lyricism of Matisse. In 1914 Macke and Klee went to Tunis, an experience which intensified this oriental predilection. Marc had a strong feeling for the vital forms of animal life, and he and Macke were both inspired by natural beauty, by the play of sunlight on flowers and foliage, all of which they wished to concentrate and clarify on their canvases. Alas, both artists were killed in the First World War, and of the great treasure of joy and inspiration which they could have contributed to our civilization, only a few tantalizing specimens remain.

¶81. Paul Klee was born at a village near Berne (Switzerland) in 1879, the son of a music master. He studied in Munich, travelled in Italy and Tunis, and before the 1914-18 war lived mostly in Munich or Paris. In 1921 he became a professor at the Bauhaus, a kind of official 'laboratory' of experimental art established originally at Weimar, and transferred in 1925 to Dessau. I have seen architectural drawings by Klee of a precision and beauty that would satisfy the severest academic tests. Klee was a supreme draughtsman; perhaps it is necessary to affirm this before considering the nature of his work.

Klee must be dissociated from all modern art movements, and particularly from such labels as Cubist, Expressionist or Futurist. He is sometimes claimed by the French group known as the Surréalistes, but if there is any question of relationship, it is the Surréalistes who

have derived from Klee, not Klee from the Surréalistes. He is the most individualistic of modern artists. Like Chagall he has created his own world—a world with its own strange flora and fauna, its own laws of perspective and logic—and in this world he lives and has his being. To the English, with their love of solemn nonsense, their Lilliputs and Wonderlands, this world should make an especial appeal. Yet there is nothing deliberately funny or satirical about Klee's art; it is instinctive, fantastic and naïvely objective. At times it seems child-like, at times primitive, at times mad; but it is none of such things really, and we can best approach Klee's art by trying to distinguish it from these recognized types.

Some of Klee's drawings might easily be mistaken for children's drawings. They resemble them in their simplicity, their fine nervous lines, their unexpected observation of significant detail, their charming fantasy. But there is one all-important distinction: the Klee drawings have wit; they are addressed to an intelligent public, they have a design on us. A child draws (at least when he draws well) only for himself. He may surprise us by the beauty and oddness of his perceptions, but he himself is convinced of their normality, of their naturalness. Very much the same distinction holds between Klee's art and the art of primitive man; the art, say, of the Bushman. The Bushman has, indeed, a motive, connected with his animistic or magical cults; and he is conscious of an audience, his tribe. To that degree the primitive artist differs from the child; he differs from Klee in his want of sophistication. Klee's audience is not a magical one—not even a religious one. It is, however much he may regret it, in the main a highly intel-

63. The Twittering-machine. By Paul Klee. Dated 1922.
Museum of Modern Art, New York.

lectual audience. This may not consciously influence Klee's art, but Klee himself was an intellectual, and the art of a man is inevitably influenced by the quality of his mind. This gives us the key to the difference between Klee's art and the art of lunatics. The lunatic's mind may be stocked with intellectual images; his lunacy may be consistent with an extremely interesting fantasy; it will, however, lack a sense of development. The fantasy of a lunatic is static, or at least it revolves round a fixed point; the fantasy of Klee is an endlessly unfolding fairy-tale.

I do not know for certain, but I should guess that Klee, like the Surréalistes, was not without some knowledge of modern psychology: his art is so consistent with it. A psychologist like Freud divides the mind into three provinces; the conscious, the preconscious, and the unconscious. The preconscious is that part of the mind which is latent but capable of becoming conscious; the unconscious is that part which is dynamically repressed and only capable of becoming conscious by a therapeutic treatment which succeeds in removing the forces of repression. We are concerned here with the preconscious, for that is the great reservoir of verbal images or memory-residues from which an artist like Klee draws his fantasy. We all know that the mind is stored with countless records of past perceptions, which may, when the right association is accidentally struck, be brought to the surface again, sometimes in colours all the more vivid from having been hidden so long from light. What we may do accidentally in the course of our conscious thinking, an artist may do accidentally in the course of drawing. But Klee does not wish to bring this world of the preconscious into consciousness. Rather he

wants to suggest the exclusive nature of that subliminal world—to dwell there, and to forget the conscious world. He wants to escape to the world of memory-residues, of disconnected images, for that is the world of fantasy, the world of fairy-tales and myths. The art of Klee is a metaphysical art. It demands a

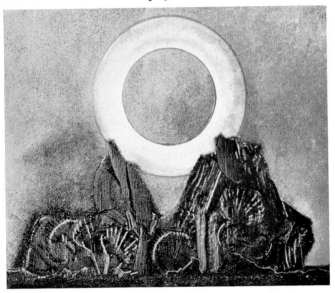

64. Sun and Forest. By Max Ernst (b. 1891). 1926

philosophy of appearance and reality. It denies the reality or sufficiency of normal perception; the vision of the eye is arbitrary and limited—it is directed outward. Inward is another and a more marvellous world. It must be explored. The eye of the artist is concentrated on his pencil; the pencil moves and the line dreams.

¶81a. As a movement, Surréalisme, or Super-realism, is

235

totally distinct from all other contemporary schools, and indeed makes a complete break with all the accepted traditions of artistic expression. Inevitably, therefore, it arouses the bitterest opposition, not only in academic circles (generally content to dismiss it as an absurdity), but even from those painters and critics who are normally accepted as modernists. But such blind opposition has so often proved wrong in the past that we should at least make an attempt to understand what these determined artists are driving at, and for this purpose we might take Max Ernst and Salvador Dali as representative.

Max Ernst was born at Brühl, near Cologne, in 1891. From the beginning his art betrayed a tendency towards symbolism and towards what might be called a disintegration of the intellect or reason, which is one aspect of symbolism. The artist, whether poet or mystic or painter, does not seek a symbol for what is clear to the understanding and capable of discursive exposition; he realizes that life, especially the mental life, exists on two planes, one definite and visible in outline and detail, the other—perhaps the greater part of life—submerged, vague, indeterminate. A human being drifts through time like an iceberg, only partly floating above the level of the consciousness. It is the aim of the Surréaliste, whether as painter or as poet, to try and realize some of the dimensions and characteristics of his submerged being, and to do this he resorts to various kinds of symbolism.

For symbolism is not the simple affair that it is ordinarily supposed to be. In mathematics we say: Let $x=$ the unknown quantity, and x is called a symbol. Perhaps we might say that Surréalisme is the x of painting:

it represents an unknown quantity. But such an explanation will not satisfy many people. They want to know why, in painting, x is such a complex symbol. It is complex because symbolism is complex. Symbolism, to begin with, can be either abstract or concrete. It is abstract when it makes use of arbitrary forms which bear no relation to objects of experience or phenomena of nature, but which are entirely absolute, just as the letter x is absolute and arbitrary. A circle, for example (to take a simple example), might be regarded as a symbol of perfection, of completion, or even of the underlying principle of the cosmos. A pyramid is a symbol of stability; a wavy line, of grace; and so on. Much abstract painting of the cubist school is based on formal symbolism of this kind, and it might be argued that the harmony of Greek art, in so far as it is based on a numerical canon, is formal symbolism of the same kind. But in the usually accepted sense symbolism employs concrete imagery, constructing irrational fantasies out of the disjointed elements of rational experience. These elements, however, may be assembled in either a conscious or an unconscious manner. Certain objects, though they may have originated as symbols in the unconscious, have long been recognized for what they symbolize, and pass from age to age as accepted counters. The snake, the goat, fire, wine and bread may be given as examples. Modern psychology has revealed the significance of most of these symbols, and has revealed, moreover, the symbolic significance of much of the imagery we customarily find in dreams and in works of the imagination. To a great extent Surréalisme derives from this branch of modern psychology; at least, it finds its justification in it. It seeks deliberately to create

237

valid symbols, and the art of a Surréaliste like Max Ernst will make use of both abstract and concrete symbols.

Many critics, too occupied with the symbolic content of paintings such as Max Ernst's, do not stop to consider their aesthetic merits, and condemn them outright as being psychology or literature, anything but painting. Thereby such critics reveal their limitations, for, if for a moment they would forget the symbolism, they would discover (granted an unprejudiced sensibility) an endless charm in the colour and texture of the actual painting. For Max Ernst is above all an artist in the limited sense—a man who paints with taste and sensibility. He uses these gifts to convey his vision—his symbolic vision—just as Blake used his poetic sensibility to convey his symbolic vision. After a century or so we have arrived at the point of accepting the genius of Blake; in the same mood we should be able to accept instantly the comparable genius of Max Ernst.

¶81b. A vivid realization of the supernatural world was, of course, common to the whole of the Middle Ages, but most of the pictorial representations of it stop at the grotesque and the horrible. Bosch went beyond, to the irrational. Most of his paintings of this kind are too detailed to reproduce well, but a mere enumeration of some of the incidents is enough to convey the exceptional nature of his fantasy. The best example to take is the large altarpiece in the Escorial, a triptych showing a Venusberg or Garden of Delights in the centre, with Paradise on the left and Hell on the right. In the middle panel, for example, we find in one section a scene by a river bank; under the water is an egg from which a round window has been cut; the window is extended outwards as a tube of glass down which a man peers at

a mouse just entering the tube. From the other end of the egg grows a strange plant whose flower expands into a veined bubble within which is seated a pair of naked lovers. At the side of the flower another figure caresses a giant owl, whilst above, other naked figures sit in attitudes of despair on giant woodpeckers, bullfinches and other birds. In Hell we see a naked figure spread-eagled

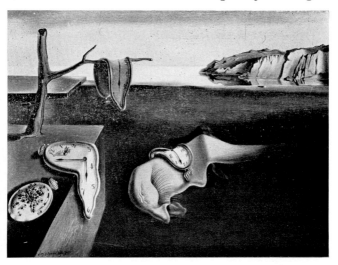

65. Landscape: the Persistence of Memory. By Salvador Dali (b. 1904). Dated 1931. *Museum of Modern Art, New York.*

on a harp; the harp grows out of a lute, round which a snake twines and binds in its coils a naked man. In a pulpit a bird-headed monster is seated, its feet in jugs, eating a naked corpse from which fly off blackbirds; the feet of the corpse grip what looks like an inverted powder-horn. Below the pulpit hangs a bubble, from which a figure half-emerges above an open pit. A man caressing a pig is disturbed by a fabulous insect with

239

human limbs and with a crest from which a severed human foot is hanging. This is only a haphazard selection from literally hundreds of equally fantastic details. By comparison the fantasy of Salvador Dali is feeble, or, shall we say, sparing.

Those who are not inclined to take Dali seriously will probably draw a distinction between the nature of the inspiration in each case. It is doubtful, however, if such a distinction is worth much. Dali, for example, paints a lady's shoe with a glass of milk standing inside it—he often uses the lady's shoe motive. Those who are familiar with the writings of psycho-analysts will remember that the shoe is one of the most frequent of the sexual symbols that are said to occur in dreams; and most of Dali's motives are recognizably symbols of this sort. It will be said, therefore, that Dali is constructing deliberately, objectively, the kind of fantasy which came to Bosch naturally, subjectively. Only Dali himself could say to what extent he is deliberately making use of Freudian symbolism; but I doubt if his use of it is any more deliberate than Bosch's use of similar symbolism (for no psycho-analyst could fail to characterize much of Bosch's symbolism as sexual). I think the most we could say is that Bosch would not have had a psychological vocabulary to describe what he was doing, and that to the extent to which our thoughts depend on our vocabulary Bosch was innocent of his intention. But in the modern jargon, both Dali and Bosch are resorting for their fantasy to the unconscious; it does not seem to matter very much how they get there.

The similarity between the two artists is still closer. The aim of the super-realists, as Max Ernst has said, is not to gain access to the unconscious and to paint its

contents in a descriptive or realistic way; nor is it even to take various elements from the unconscious and with them construct a separate world of fancy; it is rather their aim to break down the barriers, both physical and psychical, between the conscious and the unconscious, between the inner and the outer world, and to create a super-reality in which real and unreal, meditation and action, meet and mingle and dominate the whole of life. In Bosch's case, a quite similar intention was inspired by mediaeval theology and a very literal belief in the reality of the Life Beyond. To a man of his intense powers of visualization, the present life and the life to come, Paradise and Hell and the World, were all equally real and interpenetrating; they combined, that is to say, to form a super-reality which was the only reality with which an artist could be concerned.

I am not suggesting that what in Dali takes the place of Bosch's theology is an equally adequate sanction for his kind of painting; apart from a desire to 'debunk' what they call the legend of the artist's special genius or talent (for apparently anybody with an accessible unconscious can become a super-realist artist), and apart from a desire to destroy the whole of the bourgeois ideology of art, the Super-realists cannot be said to have any theology or beliefs of any kind. I am merely suggesting that the proved permanence of Bosch's art should warn us against a too hasty dismissal of Dali and the Super-realists in general. And I am leaving altogether out of the question the problem of 'literary' values; for the Super-realists, like Bosch, are unashamedly literary, and are quite willing to dispense with the formal and abstract values which the majority of modern artists regard as the fundamental values in art.

¶81c. Surrealism as a coherent movement did not sur-
vive the Second World War, but its basic doctrine of
'automatism' had penetrated deeply into the artistic
consciousness of Europe and America. André Breton
once defined Surrealism as 'pure psychic automatism,
by which it is intended to express, whether verbally or
in writing, or in any other way, the real process of
thought. Thought's dictation, free from any control by
the reason, independent of any esthetic or moral pre-
occupation'. This definition would cover, not only the
work of those artists who were closely associated with the
Surrealist movement, such as Max Ernst and Dali, Hans
Arp and Yves Tanguy, André Masson and René
Magritte, Joan Miró and Alexander Calder, but also
certain phases of Picasso's work, the early 'meta-
physical' style of Giorgio de Chirico, and some of the
sculpture of Henry Moore. The Surrealist movement
began to take shape in 1919 (its first Manifesto appeared
in 1924), but it had a direct precursor in the Dadaists,
a group of nihilistic artists thrown together in wartime
Zurich, a group which included Arp, Tristran Tzara,
and Hugo Ball. But before the First World War another
group had been formed in Italy, the Futurists, founded
by Filippo Tommaso Marinetti in 1909. This group had
rebelled against 'the tyranny of the words harmony and
good taste' and declared its intention of expressing 'the
vortex of modern life—a life of steel, fever, pride, and
headlong speed'. At the same time in Munich Kandin-
sky, as we have seen (¶80c), had painted the first non-
representational or 'abstract' compositions, and the Blue
Rider group had by 1914 reached the point of 'abstract
expressionism'. This drive towards the expression of 'the
real process of thought' (Kandinsky called it 'the expres-

242

sion of an inner necessity') had therefore been a long-matured and widely distributed phenomenon, of general historical significance, and it was manifested, not only in the plastic arts, but also in poetry, drama, music, and philosophy. The psychoanalytical doctrines of Freud and Jung seemed to offer a scientific explanation of it, and the social unrest of the period was its natural background.

We still live in the historical period that has seen all these artistic manifestations of revolt and unreason, and since the Second World War they have merely changed their names. The Surrealists were dispersed during the war—some of them (including André Masson and André Breton) sheltered for a time in the United States. There then arose in that country a movement associated generally with the name of Jackson Pollock (1912-56) which has been called 'Action Painting'. It is so-called because the painter, by various devices, tries to work *in* his picture, to work on it from various angles, and to fling his paint on to the canvas with expressive gestures. In fifteenth-century Japan there had been a painter with a 'flung-ink' technique, Sesshu (1420-1506), and the action painters of America perhaps derived some inspiration from his work and from the East in general, where calligraphy had always been an art of expressive gesture.

Meanwhile in Paris a similar movement to be known as 'tachisme' had arisen (*tache* = blot or stain). There were artists in Paris also influenced by oriental calligraphy (Henri Michaux, Pierre Soulages), but the main support for this new movement came from painters who had no other desire but to develop a 'pure psychic automatism'. Where they differ in method from the original

243

surrealists is in their rejection of all pictorial imagery. They try to circumvent the symbols that lie in the ante-room of the unconscious and to reach a deeper level where 'the real process of thought' is as yet unformed. Their paintings are projections of this deeper level of awareness, and for this reason they call their art 'in-formal'.

This movement is now universal—it is particularly active in Japan—and its significance cannot be ignored. Its products have a certain uniformity, which can also be called a certain universality, and the aim is no longer destructive, as it was with the Dadaists. From the Futurists it inherits its 'dynamism'; from Surrealism its automatism; and from the Expressionists a desire to represent 'an inner necessity' in symbolic form. Its characteristic 'informality' is no doubt a convenient shelter for many artists who lack the skill to be con-structively formal. But to those who can appreciate the force and vitality of this latest movement in art it will seem but the latest proof of the indestructible nature of that will to form which, as we saw at the beginning of this book, has always been the biological justification of the aesthetic activity—'the indetermination of matter seeking the rhythm of life'.

¶ 81d. In the sixteenth century it was customary to debate the pre-eminence of the arts, particularly as be-tween painting and sculpture. The more commonly ac-cepted opinion is represented by Benvenuto Cellini, who thought that sculpture is eight times as great as any other art based on drawing because a statue has eight views, and they must all be equally good. A painting, he said, is nothing better than the image of a tree, man, or other object reflected in a fountain—the difference between

painting and sculpture is as great as between a shadow and the object casting it.

Leonardo, on the other hand, thought that painting is superior to sculpture because it is more intellectual. By this he meant that as a technique it is infinitely more subtle in the effects that it can produce, and infinitely wider in the scope it offers to invention or imagination. Michelangelo, when the question was referred to him, in his wise and direct way said that things which have the same end are themselves the same, and that therefore there could be no difference between painting and sculpture except differences due to better judgment and harder work.

No one at that time, or until our own time, would have challenged Michelangelo's assumption that the aims of painting and sculpture are the same. But to-day not only do we make a fairly clear distinction between the aims of different arts, but we even accept the possibility that within a single art, like sculpture, artists may have quite different intentions. It is one of the characteristics of the modern period that art, like science, has split up into quite separate activities. There may still be some general value towards which all art strives, but even that is doubtful. In the sixteenth century artists could be united on their conception of beauty, just as philosophers of the time could be united on their conception of truth. To-day there is no such basic unity, either in art or in philosophy.

Michelangelo, however, recognized two types of sculpture—a true one and a false one. 'By sculpture I mean', he once wrote, 'the sort that is executed by cutting away from the block: the sort that is executed by building up resembles painting.' The sort that is executed by build-

ing up is known as *modelling*, and in spite of Michelangelo's greatness and integrity, sculpture after his time degenerated rapidly because it relied on 'building up' instead of on 'cutting away'. Naturally, statues were not left in the clay—that was admitted to be too fragile. The sculptor's maquette, or model, was reproduced, generally by other hands, either by being cast in bronze, or by being reproduced to scale by mechanical methods in marble. The sculptor, if conscientious, might give the reproduction a final touch, but the general practice was to leave well alone.

Rodin was the first sculptor to revolt against this degenerate state of the art, and though he remained essentially a 'modeller' rather than a 'cutter', nevertheless he made modelling a precise medium of expression, a science of volume and proportion, of rhythm and movement, of light and shade. But one can still say that his aim was the same as the painter's—the same as that of Rembrandt, for example, a painter for whom he had a profound sympathy. The renaissance of modelling which he began has been carried on by other modern sculptors —Bourdelle, Maillol, Epstein, and Ehrlich—and if I do not speak so much about this aspect of the art, it is not because I despise it—on the contrary, I would say that in actual achievement contemporary modellers have more to their credit than the cutters. But then they have had a much longer course and were building on a well-established tradition. The art of direct cutting is at once more arduous and more 'lost'—in the sense that its principles had to be recovered, not only from a remoter antiquity, but from centuries of confusion between the two techniques. It is not too much to say that this other type of sculptor had to create a new vision of reality—a

vague phrase which may become clearer as we proceed.

The new impetus was to come from two directions—perhaps three if we include that general desire for artistic integrity which insisted on direct cutting as the proper technique of sculpture. The other two directions were quite distinct, one being the discovery and appreciation of various types of primitive art—Negro sculpture, prehistoric Greek and Mexican sculpture, Early Christian or Romanesque sculpture—the other being the impact on art of our mechanized civilization. These two influences have sometimes been blended in a quite confusing way, as they were also in the early phases of cubist painting. The work of sculptors like Brancusi, Archipenko, and Laurens, executed in the decade 1910-1920, often has a distinct mechanistic 'flavour'. I use this inappropriate word because the work of these artists remains fundamentally humanist—if not actually related to, or inspired by the human form, it nevertheless counts on the emotional associations which sculpture has usually had with such motives.

Utterly different is the type of sculpture known as *constructivism*. This had its origins in Russia before the Revolution, and was inspired by the desire to renounce all associations with natural phenomena, and to create a 'new reality', an art of 'pure' or 'absolute' form. Some of the early works of the constructivists are superficially like machines or mechanical instruments. 'Constructed' of metals, plastics, glass, and other industrial materials, and using geometrical forms, they aim at creating by such means a dynamic interrelation of solid masses, planes, and space which will be in perfect tension. Whether such forms are 'beautiful' in the usual sense is perhaps arguable, but if we read what a humanistic

247

sculptor like Rodin has to say about his art we find him using exactly the same terms—planes, volumes, tension, equilibrium. Cubic factors like the plane and volume, he once said, underlie the laws of all life and all beauty. Nothing is so apparently remote from a figure of Rodin's as a construction of Gabo's, but one can use the same language about both objects.

Constructivism, like cubism in painting, has shed its superficial mechanism, and must now be considered as an art of pure form. As such it presents enormous difficulties to the average lover of art, but I am convinced that this is a temporary phase of public taste, due to habitual associations and prejudices. The same 'objector' will experience no difficulty (or will not confess to any) in the appreciation of architecture. But exactly the same faculties are involved in the appreciation of constructive art. Some of the early works of Malewich and Tatlin were indistinguishable from architectural projects, and were sometimes called such. An intimate relationship still exists between the 'constructions' of the sculptor and the 'constructions' of the architect: the difference is that the sculptor is not bound to any utilitarian purpose and can therefore evolve forms that are aesthetically 'pure' (*Figure* 69).

Let us return, finally, to the development of that other impetus which I mentioned as decisive in modern sculpture—that which comes from a consideration and understanding of various types of primitive art. It is now generally realized that although Primitive Man may have been much less intelligent than we are, nevertheless he was not inferior to us in artistic powers. The cave-drawings of the Old Stone Age are as sensitive and as powerfully evocative as anything created in subsequent

periods, and certain types of Negro sculpture are evocative and powerful in another way. There is no doubt that some human artefacts (I refrain for the moment from calling them works of art) have the capacity to embody collective emotional forces. That is to say, an idol or a totem-pole can be carved in such a way that it evokes feelings of pity or terror, of piety or mystery. We do not know how this comes about—the primitive artist does not consciously strive to represent such qualities: he is moved by unconscious motives and powers of intuition. But what he produces has this super-rational or, perhaps, sub-rational capacity: it stands as a symbol of powers and dimensions beyond the human understanding.

It has always been recognized—at least by romantic critics—that the source of art's appeal lies in these unconscious regions. A work of art cannot be constructed rationally—even the constructivists admit that truth. But can the work of art, designed to appeal to the civilized people of the modern world, recover the power which animates the primitive work of art (not only for primitives, but for so-called civilized people)? It is the belief of many artists to-day that it can, and Picasso in painting and Henry Moore in sculpture have developed their art in this belief. It may be that we have to surrender some of our civilized inhibitions in order to appreciate such works of art: they speak to us in a language which is not the language of the intellect, nor even the language of that refined sensibility which is the product of our humanistic tradition. Such works of art make a direct appeal to the unconscious levels of our mental life. They are not necessarily less artistic on that account, for we find that in order to reach those unconscious levels,

the artist has to use the same laws of construction as any other kind of artist. The underlying laws of art remain the same, in all types and at all times. But the aim is not the same. That is where we depart from the Renaissance conception of art as expressed by Michelangelo. We use the laws of art, the techniques of art, for very different purposes—sometimes to express the appearance of things, sometimes to express the reality of things, sometimes to embody ideals, sometimes to explore the unknown, and sometimes even to attempt to create a new order of reality. All these uses of art are legitimate, and all have been illustrated in the development of modern sculpture.

¶82. Since the fifteenth century sculpture has been a lost art in England. Perhaps it has been a lost art in Europe generally, for it is possible to argue that the whole Renaissance conception of sculpture was a false one. Each branch of art should have its peculiar principles, determined by the nature of the material worked in, and by the function which the finished work is to fulfil. But in the sixteenth century such principles, which had animated the sculpture of the Middle Ages, were forgotten. It is easy to see now why they were forgotten. The classical art of Greece and Rome was rediscovered, and it made an enormous appeal to the new humanism of the period. But instead of re-enacting the spiritual experiences of the men who had produced this classical art, the sculptors of the Renaissance sedulously copied its external appearances—with concessions, of course, to the superficial sentiment of their own time. To that general statement many qualifications, in any fuller discussion of the subject, would have to be made. It would have to be made quite clear, for example, that

66. Horse in green marble. Chinese; probably T'ang dynasty (618-906). *Victoria and Albert Museum.*

certain sculptors, such as Donatello, Desiderio da Settignano, Agostino di Duccio, and even Leonardo da Vinci, who, looking backwards from a modern standpoint, may seem to stand at the dawn of the Renaissance and to imply it, yet from a true historical standpoint are much more convincingly explained as a fruition of the Middle Ages; they are the refinement of Gothic rather than the primitives of a new age. Again, in the Baroque and Rococo periods there are elements which, though they strain the principles of sculpture to breaking point, yet do justify themselves by their triumphant mannerisms. But whatever merits we may admit in the Renaissance, Baroque and Rococo sculpture of the Continent, they do not concern my present argument, for England never contributed anything notable to these schools. We may say without exaggeration that the art of sculpture has been dead in England for four centuries; equally without exaggeration I think we may say that it is reborn in the work of Henry Moore.

Mr. Moore would be the last person to claim complete originality for his work. He was born at Castleford in Yorkshire in 1898—and his work has benefited by the experiments of older men, notably Jacob Epstein, Eric Gill, and certain foreigners such as Brancusi and Zadkine. But Henry Moore, in virtue of his sureness and consistency, is at the head of the modern movement in England. Whatever may be the reaction of the average man to the originality of these works of art, he will be bound to recognize in them the expression of a consistent purpose of great force, a personal will to dominate material and form which refuses to be balked by any conventions. It is not easy, however,

to accept the strange accents of such individuality; even if one possesses what, without any intention of being priggish or superior, may be called 'a modern point of view', one must still work oneself slowly into this world of strange forms; they are not obvious—why should they be? Has any great work of art, at the moment of its appearance, been obvious to the passer-by?

To appreciate—to begin to appreciate—the work of Henry Moore (*Figures* 67 and 68), it is necessary to go back to the first principles of sculpture discussed in the previous section. What distinguishes sculpture as an art? Obviously, its material and technique: sculpture is the art of carving or cutting a material of relative hardness. So much is implied in the word itself, and no extension of this definition is necessary. When we come to the actual working-out of this process we are faced with the fundamental question: What is the sculptor to carve? For the last 400 years artists have said: We will carve a block of stone or marble into the very image of Alderman Jones, or of Miss Simpkins posing as Venus, of a dying lion or a flying duck; and man has marvelled at the ingenuity with which the artist has accomplished this difficult aim. The aim of a sculptor like Henry Moore has nothing at all in common with this. He has no regard at all for the appearance of the object (if there is one) which inspires his work of art. His first concern is for his material. If that material is stone, he will con-sider the structure of the stone, its degree of hardness, the way it reacts to his chisel. He will consider how this stone has reacted to natural forces like wind and water, for these in the course of time have revealed the inherent qualities of the stone. Finally, he will ask himself what

67. Three standing figures, in Darley Dale stone.
By Henry Moore. 1947-8. *Greater London Council.*

form he can best realize in the particular block of stone he has before him; and if this form is, say, the reclining figure of a woman, he will imagine (and this is the act which calls for his peculiar sensibility or insight) what a reclining woman would look like if flesh and blood were translated into the stone before him—the stone which has its own principles of form and structure. The woman's body might then, as it actually does in some of Moore's figures, take on the appearance of a range of hills. Sculpture, therefore, is not a *reduplication* of form and feature; it is rather the *translation of meaning* from one material into another material. That, it seems to me, is a simple enough statement, not difficult to accept; yet it is the only key that is needed for the understanding of sculpture like this of Henry Moore's, and it is therefore incomprehensible why so much difficulty should be experienced by the ordinary man in the presence of such work.

Another principle is implied in this elementary one; it is much subtler, but still essential to the perfect piece of sculpture, and Moore's greatest success, distinguishing him from most of his contemporaries, lies precisely in his grasp of this principle. If you are translating form in one material into form in another material, you must create that form from the inside outwards. Most sculpture—even, for example, ancient Egyptian sculpture—creates mass by a synthesis of two-dimensional aspects. We cannot see all round a cubic mass; the sculptor therefore tends to walk round his mass of stone and endeavour to make it satisfactory from every point of view. He can thus go a long way towards success, but he cannot be so successful as the sculptor whose act of creation is, as it were, a four-dimensional process grow-

68. Reclining woman, in green Hornton stone. By Henry Moore. 1930.

ing out of a conception which inheres in the mass itself.
Form is then an intuition of surface made by the
sculptor imaginatively situated at the centre of gravity
of the block before him. Under the guidance of this in-
tuition, the stone is slowly educated from an arbitrary
into an ideal state of existence. And that, after all,
should be the primary aim of every artistic activity.[1]

¶82a. Barbara Hepworth is a sculptor whose work, dur-
ing the past fifteen years, has developed to a purity of
'abstraction' which has seemed to the casual observer to
bring her art into close relationship with the geometry of
solid figures. That the formal elements in art can be ex-
plained in accordance with definite laws of number or
proportion was well known to the Greeks, and perhaps
even earlier to the Egyptians, and Plato considered the
possibility of an art based on these laws, rather than on
the direct imitation of nature. At various periods in the
history of art, artists have altogether abandoned repre-
sentational realism, perhaps because they felt that the
world was too much with them (as it may have been in
the New Stone Age or in the age of the Vikings), or
because they felt there was some impiety involved in the
imitation of God's creation (as in the Islamic or Arabic
civilization). But it is only in modern times that a non-
representational type of art has been developed as a
separate and self-consistent style, challenging compari-
son with other contemporary styles (realism, impression-
ism, expressionism, surrealism, etc.). This new move-
ment is popularly known as 'abstract' art, by which we

[1] I have dealt at greater length with the work of this sculptor in
my Introduction to *Henry Moore: Sculpture and Drawings* (Lund
Humphries, 3 vols, 1949-65). Illustrations of the work of a num-
ber of the artists referred to in ¶¶77-82a will be found in the lat-
est edition of *Art Now* (Faber and Faber, 1968).

69. Sculpture (wood) with colour. By Barbara Hepworth. 1944.
Ashley Havinden Collection

mean an art derived or disengaged from nature, the pure or essential form abstracted from the concrete details. The term is not very satisfactory, and several alternatives have been suggested and even adopted by particular schools within this movement (synthetic cubism, neo-plasticism, constructivism, suprematism, etc.), but these labels often indicate a distinct aim (constructivism, for example, disclaiming any relationship to nature, even to the formal structure of matter or the forms assumed by vital organisms), and the general terms, realism and abstraction, serve best to indicate the two extremes of expression in art.

There are abstract artists of dogmatic austerity who would never deviate from their practice of an art of pure form—the Dutch painter, Piet Mondrian, is an example. And there are, of course, many realistic artists who would never dream of painting abstract compositions. There have been abstract artists who have renounced their abstract aims and returned to realistic art: and there have been realistic artists of considerable talent who have suddenly renounced their realism and taken to abstraction. Another group, however, has seen no reason why it should not alternate between the two styles, and it is to this group that Barbara Hepworth belongs.

Her earliest work (1929-32) was naturalistic—based, for the most part, on a close observation of the human figure. Some of these early carvings are of great beauty, but the emphasis on the purely formal elements increases gradually, until finally complete freedom from the model is achieved, and all reference to natural objects is abandoned (the titles, for example, become 'forms', 'discs', 'spheres', 'conicoids', instead of 'mother and child', etc.). After an interval of several years, Barbara Hepworth

once again exhibited work which is predominantly realistic. What is surprising about this recent work is not its realistic character, but its quite extraordinary depth of feeling. Barbara Hepworth has emerged from a phase of abstraction with her sympathy for natural forms greatly enhanced, her technique developed in power and subtlety, and, more surprisingly, a quality of realism of the most intense and dramatic kind.

The new paintings and drawings (many are executed in a technique which combines oil and pencil) fall into two groups—figure studies of the female nude, and hospital scenes. It is the latter which are so powerful and moving in their restraint and intensity. The hospital is, of course, a dramatic setting—we speak of the operating *theatre*, and it is generally from this theatre that Barbara Hepworth has taken her subjects. The pain and the fear are sublimated—absorbed in the creative purpose of the surgeon, gathered into his sensitive hands, into the patient faces of the nurses, who stand in the wings like a Greek chorus. Rembrandt and other Dutch painters were fond of such subjects, but it is not their type of realism of which we are reminded—rather of the austere humanism of the *Quattrocento* in Italy. There is a sense of monumental form which can come only to artists conscious of abstract form. The Italian artists were highly conscious of the abstract art of architecture. In the case of Barbara Hepworth (as in the parallel case of Henry Moore) the monumentality she achieves in her realistic figures is due to the practice of an art of pure form.

Abstract art (I exclude constructivism, which is discussed on pages 247-8) like realistic art, is always in danger of degenerating into academicism. It fails to renew its forces at the source of all forms, which is not so much

nature as the vital impulses which determine the evolution of life itself. For that reason alone it may be suggested that an alternation between abstraction and realism is desirable in any artist. This does not mean that abstract art should be treated merely as a preparatory exercise for realistic art. Abstract art exists in its own right. But the change-over from one style to another, from realism to abstraction and from abstraction to realism, need not be accompanied by any deep psychological process. It is merely a change of direction, of destination. What is constant is the desire to create a reality, a coherent world of vital images. At one extreme that 'will to form' is expressed in the creation of what might be called *free* images, so long as we do not assume that freedom implies any lack of aesthetic discipline; and at the other extreme the will to form is expressed in a selective affirmation of some aspect of the organic world —notably as a heightened awareness of the vitality or grace of the human figure. Some words of Barbara Hepworth's express this antithesis perfectly: 'Working realistically replenishes one's *love* for life, humanity and the earth. Working abstractly seems to release one's personality and sharpen the perceptions, so that in the observation of life it is the wholeness or inner intention which moves one so profoundly: the components fall into place, the detail is significant of unity.'

It is the whole scope of art itself that is illustrated by these two extremes which are now seen to lie within the capacity of a single mind.

70. Bronze ornament. ? Central Asian. *Rutherston Collection, Manchester.*

III

¶83 In these notes I have generally taken the point of view of the spectator. I would now like briefly to consider the process of art from the point of view of the man who is making the work of art. What is he doing? Why does he do it? For whom does he do it? Having answered these questions, we can perhaps then say what the function of the artist is in the community—what art means to us all, and what place should be given to it in our social organization.

¶84. Tolstoy's famous definition of the process of art is expressed in these words:

'To evoke in oneself a feeling one has experienced, and having evoked it in oneself, then by means of movement, lines, colours, sounds, or forms expressed in words so to transmit that feeling that others experience the same feeling—this is the activity of art.

'Art is a human activity consisting in this, that one man consciously, by means of certain external signs, hands on to others feelings he has lived through, and that others are infected by these feelings and also experience them.'[1]

¶85. This theory, even in the very way it is expressed, is very near to Wordsworth's theory of poetry, which says that poetry 'takes its origin from emotion recollected in tranquillity . . . the emotion is contemplated till by a species of reaction the tranquillity gradually disappears, and an emotion, kindred to that which was before the subject of contemplation, is gradually produced and does itself actually exist in the mind'. In other respects, Tolstoy's theory of art is strikingly similar to Wordsworth's theory of poetry, for example, in the common insistence on perfect intelligibility and communicability. Wordsworth's phrase 'a man speaking to men' is the perfect description of Tolstoy's ideal artist, and Wordsworth's plea for a poetic diction relying on 'the ordinary language of men' is echoed again and again in Tolstoy's essay.

¶86. We might compare this theoretical description of the creative process with a precise description by a practising artist. I do not want to claim any special privilege for such utterances, because an artist may, and indeed generally does, talk worse nonsense than the critic. He is not usually detached enough to describe his own psychological processes. But the modern artist has cultivated his powers of self-observation—he has been compelled to do so in self-defence.

Some of Cézanne's comments have already been quoted. No less valuable are the various statements

[1] *What is Art*, Trans. Aylmer Maude. Oxford (World's Classics), 1930, p 123.

which Henri Matisse has published. As long ago as 1908 he contributed some 'Notes d'un Peintre' to a French review, from which I will quote two or three passages:

'Expression for me is not to be found in the passion which blazes from a face or which is made evident by some violent gesture. It is in the whole disposition of my picture—the place occupied by the figures, the empty space around them, the proportions—everything plays its part. Composition is the art of arranging in a decorative manner the various elements which the painter uses to express his sentiments. In a picture every separate part will be visible and will take up that position, principal or secondary, which suits it best. Everything which has no utility in the picture is for that reason harmful. A work of art implies a harmony of everything together (*une harmonie d'ensemble*): every superfluous detail will occupy, in the mind of the spectator, the place of some other detail which is essential.'

Then Matisse describes his procedure in painting:

'If, on a clean canvas, I put at intervals patches of blue, green, and red, with every touch that I lay on, each of those put there previously loses in importance. Say I have to paint an interior: I see before me a wardrobe; it gives me very vividly a sensation of red, and so I put on a red which satisfies me. A relation is established between this red and the white of the canvas. When I put on besides a green, when I represent the floor by a yellow, between this green and this yellow and the canvas there will be still further relations. But these different tones mutually diminish each other. It is necessary that the various tones which I use should be balanced in such a way that they do not destroy one another. To secure that I have to put my ideas into

order: the relationship between the tones will establish itself in such a way that it builds them up instead of knocking them down. A new combination of colours will succeed to the first one and will give the wholeness of my conception. I am obliged to transpose, so it will look as though my picture has totally changed if, after successive modifications, the green in it has replaced the red as the dominant tone.'

That explains very clearly how a particular colour harmony is built up on the canvas. It does not, however, get us beyond the two-dimensional colour schemes of the Japanese colour-print. But a further explanation of Matisse's, given in the same article, will help us considerably:

'The thing is to direct the attention of the spectator in such a manner that he concentrates on the picture but thinks of anything but the particular object which we have wished to paint, to detain him without embarrassing him, to lead him to experience the quality of the sensation expressed. There is a danger in taking him by surprise. It is not necessary for the spectator to analyse —that would be to arrest his attention and not to release it—and there is a risk of setting up analysis by a transposition that is carried too far. The problem for us has become that of keeping up the intensity of the canvas whilst getting near to verisimilitude. Ideally the spectator allows himself, without knowing it, to be engaged by the mechanism of the picture. One should guard against a movement of surprise on his part, even that which escapes his notice: one must hide the artifice as much as possible.'

¶87. It will be seen that there is a great measure of agreement between Tolstoy and Matisse. The difference

may be limited to one word: *communication*. Tolstoy demands that the artist should not only succeed in expressing his feeling, but also in transmitting it. That, I think, was the mistake which landed him into such difficulties. Because, if you put the artist and his feeling on one side, *to whom*, on the other side, must he convey his feeling? Naturally, Tolstoy had to conclude to every man. And if to every man, then art must be so intelligible that the simplest peasant can appreciate it. So good-bye to Euripides, Dante, Tasso, Milton, Shakespeare, Bach, Beethoven, Goethe, Ibsen—in fact, good-bye to almost everything except stories from the Bible, folk-songs and legends, *Uncle Tom's Cabin* and *A Christmas Carol*. A theory is a complicated piece of machinery; it only needs the displacement of one unit or part to make it go wrong, or fall to pieces. The amendment I want to make in Tolstoy's definition, to make it agree with the statement of Matisse, and, more important, to make it agree with the facts, is simple. I would say that the function of art is not to transmit *feeling* so that others may experience the same *feeling*. That is only the function of the crudest forms of art—'programme music,' melodrama, sentimental fiction and the like. The real function of art is to express *feeling* and transmit *understanding*. That is what the Greeks so perfectly realized and that is what, I think, Aristotle meant when he said that the purpose of drama was to purge our emotions. We come to the work of art already charged with emotional complexes; we find in the genuine work of art, not an excitation of these emotions, but peace, repose, equanimity. Nothing is more absurd than the spectacle of an ardent young snob trying to cultivate an emotion before a great work of art, in which all the

artist's emotion has been transmuted to perfect intellectual freedom. It is true that the work of art arouses in us certain physical reactions: we are conscious of rhythm, harmony, unity, and these physical properties work upon our nerves. But they do not agitate them so much as soothe them, and if we must, psychologically speaking, call the resultant state of mind an emotion, it is an emotion totally different in kind from the emotion experienced and expressed by the artist in the act of creating the work of art. It is better described as a state of wonder or admiration, or more coldly but more exactly as a state of recognition. Our homage to an artist is our homage to a man who by his special gifts has taken the heat out of our emotional problems.

¶88. If this were clearly recognized, there would be no question of the status of art in society. Here again the Greeks were wiser than we, and their belief, which always seems so paradoxical to us, that beauty is moral goodness, is really a simple truth. The only sin is ugliness, and if we believed this with all our being, all other activities of the human spirit could be left to take care of themselves. That is why I believe that art is so much more significant than either economics or philosophy. It is the direct measure of man's spiritual vision. When that vision is communal, it becomes a religion, and the vitality of art throughout the greater part of history is closely bound up with some form of religion. But gradually, as I have already pointed out, for the last two or three centuries that bond has been getting looser, and there does not seem to be any immediate promise of a new contact being established.

¶89. No one will deny the profound inter-relation of artist and community. The artist depends on the com-

munity—takes his tone, his tempo, his intensity from the society of which he is a member. But the individual character of the artist's work depends on more than these: it depends on a definite will-to-form which is a force within the artist's personality, and there is no significant art without this intuition of an appropriate form. This might seem to involve us in a contradiction. If art is not entirely the product of surrounding circumstances, and is the expression of an individual will, how can we explain the striking similarity of works of art belonging to distinct periods of history?

¶90. The paradox can only be explained metaphysically. The ultimate values of art transcend the individual and his time and circumstance. They express an ideal proportion or harmony which the artist can grasp only in virtue of his intuitive powers. In expressing his intuition the artist will use materials placed in his hands by the circumstances of his time: at one period he will scratch on the walls of his cave, at another he will build or decorate a temple or a cathedral, at another he will paint on canvas for a limited circle of connoisseurs. The true artist is indifferent to the materials and conditions imposed upon him. He accepts any conditions, so long as they permit him to express his will-to-form. Then in the wider mutations of history his efforts are magnified or diminished, taken up or dismissed, by forces that he cannot predict, and that have very little to do with the values of which he is the exponent. It is his faith that those values are nevertheless among the permanent attributes of humanity.

INDEX

*Illustrations (see author's note on page 11 on reasons for choice) are already
listed in preliminary pages and are not included in index*

269

271

against 'harmonic' tradition, 60; gives impetus to realism, 224; on art of painting, 180–183; on Boucher as 'unnatural' painter, 183; on absence of chiaroscuro from Chinese art, 183; influences Delacroix and Manet, 190–191; *The English Landscape* (album of engravings with prospectus), 181

Constantine, the Emperor, 116
Constructivism, 247, 248, 259
'Content', 41
Coptic art, 94
Corinth, Lovis, 225
Corot, 161, 163, 167
Correggio, as painter of lucent atmosphere, 56
Cressent, Charles, 157
Cresswell, Capt., on Muslim architecture of Egypt, 96
Croce, Benedetto, on 'art as expression', 24, 226, 228; on 'modifications of the beautiful', 24
Cubism, 191, 215, 229; formal symbolism in, 237; as a geometric art, 81; tenets of, 215
de Cuvilliés, François, 157
Czechoslovakian embroidery, 89

Dadaists, destructive aim of, 244; objectives of, 242
Dali, Salvador, 236, 238; symbolism of, 240–2
David, G., Delacroix despises, 187
'Decorative' painting, 209
Definitions of: art, 17; beauty, 18; form, 36; pattern, 35; rococo, 149
Degas, 197
Delacroix, Eugène, life, travels,

influences, 183–6; as colourist, 189; four Englishmen influencing, 183, 185; debt of to Constable, Rubens, 185, 188; journal of, 186, 187–188; compared with Cézanne, 200; nature of romanticism of, 186; three or four groups of paintings of, 190; as universal genius, 184

Delaunay, Robert, 231
Delineation as element in visual arts, 51
Derain, André, 173, 230
Distortion, 29; in Byzantine art, 31; in Celtic and Chinese art, 31; in Greek art, 29–30
Donatello, 224, 252
Drawing as distinct art, 132–133; art of, 51, 53, 132; drawings of Italian masters, 129–33
di Duccio, A., 252
Dürer, A., refs. to landscape painters, 160

Eastern Spanish cave paintings, 72, 73
Egyptian art, 91 seqq.; sculpture, 97; co-existence of popular and hieratic, 94; effect of monasticism, 94; Islamic art in Egypt, 96
Ehrlich, 246
Einfühlung (empathy), 38–40
El Greco, 69, 149–9; as expressionist, 224; 'Conversion of St. Maurice', 62; 'Burial of Count Orgaz', 148
Elsheimer, 'romantic' landscapes of, 163
Empathy, 38–40
English: Gothic art, 126; landscape painting, 163; mediaeval pottery, 42

Ensor, James, 138
Epstein, Jacob, 246; and Henry Moore, 252
Ernst, Max, 70, 235; on aim of Surrealists, 240–1; life and work of, 236; symbolism of, 236–7; compared with Blake, 238
Etty, William, 185
'Expression': in modern art, 222; as ambiguous word, 24; and form, 24; Croce on 'expression as art', 24, 226, 228
Expressionism, expressionist movement, 178, 222, 224; abstract expressionism of 'Blue Rider' group by 1914, 242; influence of Turner, 178; contribution of to tachisme, 244; various manifestations of, 224–8

Fauves, 230
Fechner, Gustav Theodor, research of, on 'golden section', 27
Feeling and understanding, in communication through art, 266–7
Fiedler, Conrad, on art as visual mode of cognition, 225
Figurative expressionism, and 'Die Brücke', 230
Fine and applied art, 89
Finland rugs, 89
Flemish art, essentials of, 138
Foppa, Vincenzo, 'Adoration of the Magi', 138–9
Form: absolute and relative, 61; absolute, as constructivist aim, 247–8; architectural, in painting, 61, 62, 64; defined and discussed, 36, 51; and expression, 24;

in work of Barbara Hepworth, 259–60; of Henry Moore's work, form and structure, 254–7; necessity for, 39; with outline, space and mass, 50; symbolic, 61, 64–5; of typical baroque composition, 62; universal elements of, 25; will-to-form, 25, 267
Formes, Picasso's reflections published in, 215
Fourment, Helen, 148
Fra Angelico, 84
Francesca, P. della, 144; and the 'golden section', and other geometrical organizations, 27, 62; as 'first Cubist', 135; 'Flagellation' by, 130, 135; intellectual approach of, 134, 135
Frith, W. P., 'Derby Day', kinship of with novel, 46
Fromentin, Eugène, Maîtres d'Autrefois, on Rubens, 145–6
Fry, Roger, 152; Cézanne: A Study of his Development, 200; on 'passive receptiveness', 103; on a Mayan statue, 101; on symbolic form, 64–5
Futurism, 242; contribution of, to tachisme, 244

Gabo, Naum, 135, 248
Gainsborough, 163–7; Delacroix's admiration for, 185; defects and virtues of, 166–7
Gaselee, Stephen, The Art of Egypt through the Ages, 94
Gasquet, Joachim, 201–2
Gauguin, Paul, 197, 206, 230; arrogance of, 206, 209; life of, 206–7; work of, 206–10; contacts with Pissarro and Van Gogh, 207; as lacking

274

279